Warhol After Warhol

Warhol After Warhol

Secrets, Lies, & Corruption in the Art World

RICHARD DORMENT

PEGASUS BOOKS
NEW YORK LONDON

WARHOL AFTER WARHOL

Pegasus Books, Ltd.
148 West 37th Street, 13th Floor
New York, NY 10018

Copyright © 2023 by Richard Dorment

First Pegasus Books cloth edition December 2023

ISBN: 978-1-63936-497-8

10 9 8 7 6 5 4 3 2 1

Printed in the United States of America
Distributed by Simon & Schuster
www.pegasusbooks.com

To Hatty,
innocent bystander

Contents

Warhol After Warhol

Chapter 1

A Voice on the Line, 2003

IT WAS LATE AFTERNOON, in January 2003. The voice on the line was well-spoken, polite. The caller introduced himself as Joe Simon, an American film producer and art collector. He was ringing at the suggestion of David Hockney, his neighbour in Malibu. Without asking whether I had time to speak, this stranger launched into the reason for his call. A committee of experts called the Andy Warhol Art Authentication Board had declared two Warhols in his collection to be fake, and he wanted to know why. I was at my desk on the top floor of our house in North London, finishing a review for the *Daily Telegraph*, where I was the chief art critic.

And, at just that moment, I had a deadline. 'No, sorry, stop right there,' I said, explaining that I had no detailed knowledge of Warhol's work and would not dream of offering an opinion on the authenticity of one of his pictures. But my caller steamrolled over my objections, filling me in on the history of the Andy Warhol Art Authentication Board. I held out. No, we could not meet. He should try Christie's or Sotheby's. On he ploughed, ignoring my attempts to disengage. He was not

asking for my *verdict*. He knew I was not an expert on Warhol. He just wanted me to *look* at his pictures and possibly tell him if I could spot any obvious reason why they were not authentic. Still, no. I did not have that kind of knowledge.

Though that was true, it was also disingenuous. I was no expert on Warhol, but I had long experience authenticating and cataloguing works of art. I'm never paid for these consultations, although on rare occasions an auction house has sent me a case of good wine.

Simon did not know this and I certainly wasn't going to tell him; nevertheless, he maintained his steel-plated determination to make me look at his picture. Just to get rid of him, I agreed to meet the following week. Scrawling his address in my diary, I hung up, and instantly forgot about the whole thing.

*

Though I couldn't help Simon, I had written a lot about Andy Warhol, mostly in the *Telegraph*. Every time I wrote about a new aspect of his work, I was dazzled by his genius.

My first encounter with Andy Warhol's work took place when I was eighteen years old. It was in March 1966, during my second year at Princeton, where I majored in art history. Warhol was already a household name, notorious for the *Campbell's Soup Cans* and *Brillo Boxes*. But I knew nothing about the rock band he'd started to manage only two months earlier – the Velvet Underground. One day, an old friend, a student in the music department, told me the Velvets would be performing down the road, at Rutgers University. It was a school night during term time. Undergraduates were not allowed to leave campus without permission. I had a car (also not allowed), so off we went.

In a darkened hall, and through a fog of dry ice, the band's vocalist, Nico (Christa Päffgen), stood under a spotlight,

impassively intoning one of Lou Reed's deadpan anthems to sex and drugs.

I stood stock still, mesmerised. At five-feet-nine-inches tall, with long straight blond hair and a heavy German accent, Nico's husky, expressionless monotone was like nothing I'd heard before.

As she sang, a tall man dressed from head to foot in black leather began to roam back and forth across the stage, aimlessly cracking a bullwhip. This must have been Warhol's studio assistant, Gerard Malanga, performing what I later learned was his 'whip dance' as part of Warhol's experimental fusion of art and music – soon to be dubbed the 'Exploding Plastic Inevitable'.

This, my first, fascinated exposure to what I conceived to be the white heat of the avant-garde, ended early when the university's administration pulled the plug. From then on, however, Warhol was on my radar.

Jasper Johns, Robert Rauschenberg, Frank Stella, Cy Twombly, Claes Oldenburg, Roy Lichtenstein, Brice Marden, Richard Serra, Donald Judd: all these great artists were receiving serious critical recognition in America at that time. Andy Warhol was the exception. He was more famous than any artist on the list, but he was also the joker in the pack. Compared to the heavyweights, his art felt as insubstantial as the helium-filled silver pillows that floated around his 1966 exhibition at Leo Castelli's gallery or bounced lightly off dancers in Merce Cunningham's stage-sets.

Even the iconic works of the 1960s – *Campbell's Soup Cans* and *Brillo Boxes*, portraits of Marilyn, Elvis and Liz – were sometimes dismissed as one-liners. Two of the most influential art critics of the time, Barbara Rose (*Vogue*) and Robert Hughes (*Time*), were at best ambivalent about Andy's work – and that really meant something, because both critics wrote with knowledge and passion about many of his contemporaries.[1]

With his silver wig, dark glasses and pasty face, Warhol looked and spoke like an automaton. In public statements, he played dumb, insisting that this work was as shallow and one-dimensional as he affected to be in his own life. We now know that this was a pose, but the public took him at face value.

By the time I became aware of his work, Warhol had become a brand, someone we felt we knew, without having the slightest notion of what his art was really about or of how profound it could be.

Warhol's first studio space – the Factory, at 231 East 47th Street – achieved near-mythical status right from the beginning. Even if you'd never been there or seen photos, it was easy to imagine what it looked like. In 1963, his assistant and in-house photographer, Billy Linich (always known as Billy Name), covered the walls with aluminium foil, and then kept going with silver paint until every surface, including the pay phone, toilets and furniture, glistened. That transformed a utilitarian work-space into a stage-set for the space age – a glamorous backdrop that swarmed with wealthy uptown social types, slumming it with speed freaks and hustlers, drug fiends and drag queens. The two worlds dovetailed when socialites like Baby Jane Holzer and Edie Sedgwick starred in his underground films alongside a ragtag collection of chattering exhibitionists whom he'd dubbed 'superstars'.

The beautiful nonentities who appeared in them were high on amphetamines, then ubiquitous at every level of American society. Speed initially creates euphoria and hyperactivity. Over time, inner ecstasy gives way to depression and paranoia. In the earlier films, the giddy chit-chat of Edie, Billy Name, Gerard Malanga and Ondine (underground film star Robert Olivo) was frenetic and funny, if not always entirely audible.

The very banality of their on-screen persiflage added to

the visceral impact of an act of sudden violence or psychosis. Ondine's hysterical physical assault on another actor in *Chelsea Girls* or Sedgwick's psychic meltdown in *Outer and Inner Space* mesmerised those who first saw them.

The factor that transforms much of Warhol's film footage into art is the sheer length of time he held his camera on the actors. Decades later, slow-paced reality television programmes would fascinate the public. In the late sixties, Warhol's audiences were transfixed by films in which random fragments from the lives of real people unspooled before their eyes, unscripted and unrehearsed.

Chapter 2

Langton Street, 2003

SEVEN DAYS LATER, at 6.30 p.m., I rang the buzzer to Joe Simon's Chelsea flat. The guy who opened the door looked about twenty-five but was in fact closer to forty. He had floppy blond hair, big white teeth, a broad face and ski-jump nose, and he was wearing pressed chinos, a button-down collar, blazer and loafers. The preppy clothes were of a piece with the unostentatious decor of his flat: good oriental rugs over beige coir matting, antique furniture, a comfortable sofa and easy chairs covered in fabrics by Nina Campbell. I was used to the British aesthetic of shabby chic, so I also noticed that everything in the flat was in immaculate condition.

On the walls of his drawing room hung two framed Warhol *Cow* silkscreen prints. In each, the same cow is shown against a soft blue background in close-up, filling the viewer's field of vision. The effect is hallucinatory and, for reasons I don't quite understand, comforting. Each print was framed individually and inscribed, *Happy Birthday Joey, love Andy.*

Hanging nearby was a more valuable Warhol, his silkscreened portrait of Mick Jagger. There are many prints in this

series, and, with hindsight, I'd say that Simon's was the best I've seen. Others tend to be luridly coloured, with smears of red paint over Jagger's rubbery lips and splashes of turquoise laid like mascara over his eyelids.

Simon's print was different. In it, Warhol left a black-and-white photograph of Jagger intact, then overlaid one side of his face with a semi-transparent geometric shape, with a wash of pale green over the other. Black, white, grey and green: the restrained palette creates a stillness in the portrait that makes it unique in the series. The frame, too, was unusual. It was covered in silver fabric and signed by Rolling Stone Ronnie Wood.

I also noticed a sensitive crayon portrait of Joe Simon by his neighbour in Malibu, David Hockney, as well as Hockney's delightful studies of his two dachshunds, which I found particularly enchanting since we were then besotted with our own miniature dachshund. These prints too were dedicated, *To Joe with love from David*.

You learn a lot about someone by looking at the art they have on their walls. This glimpse of Simon's world made it clear that his personal connection with the artist or the sitter was what drew him to a work of art. But there was something else about the collection that I had not expected: it was quiet, personal, not one acquired to show off or to impress.

Simon got straight down to business. There was no small talk, no flattery, and no pretence on Simon's part that he had ever read my reviews, exhibition catalogues or books. I took that as a positive sign. He told me he was a film producer whose company had worked on projects with Tim Burton, Salma Hayek and Woody Allen, and he mentioned several well-reviewed movies he'd produced, but within minutes he was showing me the two Warhols he wanted to talk about.

The first was the *Red Self-Portrait*, a screen print on canvas

from a series made in 1965. While I was looking, Simon kept up a running commentary, hardly drawing breath as a story spilled out that he must have told a hundred times before. On 9 August 1989, he bought the picture on the recommendation of Michael Hue-Williams, a London art dealer I knew and respected. The picture was 'signed' *Andy Warhol* twice, and confirmed as an authentic by Andy's business manager, Fred Hughes, in a handwritten inscription on the stretcher. But there was a big hitch. What Simon had not realised when he bought the picture, he said, was that the two highly realistic Andy Warhol signatures were stamped facsimiles, not written in Warhol's own hand. Simon said he bought the self-portrait 'because I liked it, but mostly because Michael [Hue-Williams], Fred [Hughes] and Ammann [Thomas Ammann, the Swiss art dealer] all underscored to me the importance of the piece, and Andy's signatures . . . I was dizzy with excitement.'

In 2002, thirteen years after acquiring the *Red Self-Portrait*, and after a bitter break-up with his partner, Simon decided to sell it. A buyer was easily found through a London gallery. Contracts were exchanged and the purchase price paid into the gallery's escrow account. The gallery advised their client of the possibility that the painting would be included in a forthcoming catalogue raisonné of Warhol's paintings, the ultimate confirmation of its authenticity. Such a catalogue is intended to include every picture the artist painted. Each catalogue entry contains basic information – the subject of the picture, the date it was painted, the material it is painted on and its size. If it is signed, dated or inscribed, either by the artist or by another hand, that information is given, as is its provenance – the history of ownership from the moment it left the artist's studio to its present whereabouts, if known, in a private collection or a public museum. If the work has been restored, repaired or relined, that information is added.

To confirm that the *Red Self-Portrait* was to be included in the Warhol catalogue raisonné, the lawyer for Simon's client called the Zurich-based art dealer George Frei, co-author of that catalogue. Frei worked for Thomas Ammann Fine Art, the leading European dealer in Warhol's art.

Although he had seen and photographed the painting in Simon's London house in 1996 without commenting on its authenticity, Frei unexpectedly advised the lawyer not to buy the picture until it had been certified as genuine by the Andy Warhol Art Authentication Board. That advice carried with it the implication that the painting might not be 'right', so Simon released the client from the sale. At the time, he explained, he was simply too busy with different projects to worry about the sale of a painting falling through.

The following month, Hue-Williams took the picture to New York to show the A-list art dealer Larry Gagosian. Before Hue-Williams left, Simon was told that Gagosian's London office had verbally offered him $800,000 for a quick sale. Simon declined. He saw no reason to sell the picture cheap, when, in a few weeks' time, another dealer might offer the full price.

Instead, he took advice from a new friend, Vincent Fremont, who told him to submit both works to the Andy Warhol Art Authentication Board. To his consternation, both works came back from the Board stamped DENIED. He could not understand why, and the Board wouldn't tell him. Simon was asking me to look at it in the hope that I could explain what was wrong, why they had not been authenticated.

As he was telling his story, he started to stutter. His eyes glistened with tears. To spare him embarrassment, I stood up to take a closer look at the picture, which was propped against the wall. The *Red Self-Portrait* is one of Warhol's best-known images. Based on a photo taken in an automatic photo booth in

9

Times Square, it shows the artist's head and shoulders, full-face and slightly from below, very much like the figures in two other important works of the mid-1960s: the mug shots in *Thirteen Most Wanted Men*, which was shown at the New York World's Fair in 1965, and the anonymous actor whose head and upper torso we see in Warhol's underground film, *Blow Job*.

Like the men in those works, Andy assumes the insolent take-it-or-leave-it expression of the criminal or the hustler. As with other portraits of the sixties, out-of-register reds and blacks make the picture's surface look slightly fuzzy, like a colour TV on the blink. Warhol presents himself to the world as a new kind of person – one trapped, as though behind a screen, in some fathomless, unreal televisual space – without physical mass or emotional depth, somewhat like Marilyn or Liz in their portraits. As he once said, 'If you want to know all about Andy Warhol, just look at the surface of my paintings and films and me, and there I am. There's nothing behind it.'

One thing about the work disturbed me from the first moment I saw it: the picture surface was unusual – curiously glossy, without texture or brushwork, and with no hint of the canvas weave underneath the image. It could almost have been a photographic reproduction.

Next, Simon produced the second work he wanted me to see. This was a meticulous arrangement of crisp one-dollar bills pasted onto a small canvas. Though untitled, Simon called it the 'Dollar Bill' piece. Unlike the *Red Self-Portrait*, it was signed, inscribed and dated 1986 – all in Warhol's own handwriting. But the Authentication Board had rejected this work as well. I had never seen anything like it by Warhol, nor had I heard of the assistant who sold it to Simon. But Simon showed me an entry in the published Warhol diaries, in which Warhol says he gave

the collage to his assistant as a birthday present during a dinner at the Odeon restaurant.

The diary entry, dated 21 April 1986, reads: 'And then I had to be creative to think of birthday presents . . . I stuck money in that grandmother-type birthday card, and I did a canvas that had dollars pasted onto it and then I remembered they even made those sheets of money, but this you could just rip money off when you need it, like for tips.'[1]

I could see why Simon believed the piece to be genuine. The repeated image of George Washington on the one-dollar bills; the mere fact that it was made from Warhol's favourite thing, money: all that seemed thoroughly Warholian. It was also meticulously crafted. The bills were glued onto the canvas with deliberation. There were no curled edges, and all the bills were straight. Later, I learned that the serial numbers were arranged in chronological order, from one to forty-one – a detail that suggested the person who made it had taken enormous care in constructing the work. I could not see anything obviously wrong with the collage. It was the *Red Self-Portrait* that did not feel right.

But, as I told Simon on the telephone, I did not know enough about Warhol to say anything helpful, let alone definitive. I could not think of a way to help him find the answers he was looking for. All I could do was to sympathise with his frustration and tell him that he had to assume the Authentication Board was staffed by scholars who would not have denied the authenticity of either work without good reason.

By now, it was almost eight o'clock. I wished Simon good luck and apologised for my inability to help. Driving home, I did not expect to hear from him again.

Chapter 3

'Don't even think about it'

WHATEVER I EXPECTED, Simon had no intention of letting the matter drop. Within days, he telephoned again, and over the next few months he told me in greater detail how he had come to submit his 'Dollar Bill' piece and his *Red Self-Portrait* to the Authentication Board. Much of that story hinges on the role played by Warhol's former studio assistant, Vincent Fremont. As soon as I heard his name, I realised I knew him. We had met in the late 1990s, at the suggestion of Anthony d'Offay, the most important London dealer in contemporary art at the time, to discuss an exhibition proposal for a show of Andy Warhol's portraits from the 1970s. In the end, nothing came of the exhibition, but I remembered Fremont as a pleasant man of about my age, dressed like a classy accountant in a designer suit and spectacles.

Simon had good reason to seek advice from Fremont, who was chief salesman and licensing agent for thousands of paintings, prints, photographs and sculptures bequeathed by Warhol to the Andy Warhol Foundation. When they had spoken on the telephone, exchanged emails, or had face-to-face meetings, Fremont could not have been more helpful. He recommended

Simon submit his *Red Self-Portrait* to the Andy Warhol Art Authentication Board. Once the picture had been approved, he explained, a high-resolution photograph would be taken so that the painting could be included in the board's forthcoming catalogue raisonné. Simon should be sure to include the picture's full provenance with the submission.

Although Fremont had by now seen thousands of prints and paintings by Warhol, he was not working at the Factory during the summer of 1965 when Warhol made the *Red Self-Portrait*. Together with Simon, he went over every detail of the painting and its history. Simon told him that he had shown the painting to Andy's executor, Fred Hughes, who remembered authenticating it in the early 1990s – a verdict that Fremont himself, who in those years authenticated Warhol's work in tandem with Hughes, had endorsed. Now, Fremont made the entire process sound like the easiest thing in the world. He seemed to imply that Simon was doing him a personal favour by cooperating.

A few weeks later, Tony Shafrazi, a New York art dealer better known for having used spray paint to deface Picasso's *Guernica* in the Museum of Modern Art, told him the brutal fact: unless the two works had the Board's stamp of approval, no dealer, private collector, or auction house in the world would touch them.

The authenticity of an artwork can be determined in several ways, but one of the most common is to have an expert or experts affirm that it is what the seller purports it to be. The Warhol Foundation went further. If an owner consigned to a gallery or saleroom a picture that the Board had not authenticated, the gallerist or auction house received a lawyer's letter stating that the sale could not proceed until the Board confirmed that the artwork was genuine. No one dared sell a

picture the Board had not approved. Simon decided to get the procedure over and done with.

What Simon could not have guessed was that the Board would declare both works to be fakes. The Board kept a file labelled *Estate Notebook Fake Works: Paintings Authenticated by Fred Hughes*, and Simon's *Red Self-Portrait* was in it. Simon would later learn that Fremont had already viewed the picture in Gagosian's office and was disturbed that the image was printed on canvas (cotton duck) rather than on linen, which Warhol usually used.

In February 2002, Simon was in New York, waiting to collect the painting. That morning, a fax from the Authentication Board arrived at his house in Los Angeles. The person who first read it was his closest friend, British documentary film-maker Maddy Farley. The Board did not consider the picture authentic. As soon as she read these words, her instinct to protect her friend kicked in. Understanding how distressed Simon would be, she took the overnight flight to New York to be with him when he heard the news. Together, they went to the office of the Andy Warhol Art Authentication Board on the Lower West Side to collect the picture.

There, Simon had a second shock. The picture had been stamped on the reverse with the word DENIED in indelible red ink. Not only that, it had been stamped not on the wooden stretcher, but on the canvas itself. A picture he had been about to sell for two million dollars had been 'branded' with such force that the letters came through on the front of the canvas, rendering it worthless.

Still not understanding Fremont's role in what had happened, Simon and Maddy lunched with him the next day at a quiet restaurant, two blocks from the offices of the Authentication Board. Whenever they'd met before, Fremont had been warm

and supportive. Now, Simon said, he seemed cold, detached and emotionless.

With his thick, slicked-back hair, broad face and wide eyes, Fremont exuded self-assurance. From the start, he exerted a gentle but sure control over the conversation. Through two courses, they talked about every subject except the picture. Maddy kept the conversation light, swapping camera tips and news about mutual friends, while Fremont and Simon prodded, each trying to extract information from the other. Simon itched to talk about the portrait, but Fremont sensed this and steered the conversation out of Simon's reach whenever the subject was about to come up. Even when coffee came, he seemed reluctant to discuss the picture.

At that point, Simon couldn't take any more: 'All of my frustrations bubbled over, and I came right out and said how appalled I was by the Board's refusal even to explain their unexpected decision to deny my painting. What I wanted to say – but didn't – was that it was he, more than anyone, who had persuaded me to submit a portrait, that had already been signed by the artist and authenticated by his manager, to a mysterious organisation of which I knew nothing, assuring me that this would be just a formality and would add significantly to its value.'

Fremont said nothing. Finally, he indicated that the conversation was closed by advising Simon to 'discover more of the picture's history'. He even offered to assist by supplying the contact details of conservators and art historians.

'But it's just so unethical!' Simon no longer hid the anger in his voice. 'Surely this sort of behaviour can be challenged legally.'

Fremont replied very slowly, looking straight into Simon's eyes, and stressing every word: 'Don't even think about it.

They'll drag you through the courts until you bleed – they never lose.'[1] With this stark, apparently well-intentioned, but unmistakably threatening statement, he rose from the table and went for his coat. He returned a few minutes later to pick up the tab.

As well as advising Simon to resubmit the picture after gathering more information about it, Fremont also explained that the Authentication Board would require proof that Warhol had been aware of the picture's existence. By 'proof' he meant 'a signature in the artist's own hand or evidence that it had been sold at auction during his lifetime'. The more facts Simon could accumulate, the better chance he would have of getting the work authenticated.

<p style="text-align:center">*</p>

I had never had any dealings with an art authentication board. Simon explained to me that everyone who submits a work to the Warhol Board must sign a waiver agreeing that the owner is not legally entitled to any explanation for the Board's decision. The legal waiver covered a previous authentication of the *Red Self-Portrait* by Fremont and Hughes in the early nineties, and shielded the assistant as a former employee of the Warhol Foundation, from legal action. As one lawyer put it to Simon, 'Five million dollars in legal fees may get you past the waiver; otherwise, the waiver protects Warhol employees from a multitude of sins, including fraud.'

That left Simon helpless. He was not entitled to a refund from Hue-Williams because the time limit within which pictures can be returned had long passed. What upset him most was the dawning knowledge that Fremont had persuaded him to submit the picture knowing it was likely to be denied. Legally, Fremont could not be held responsible for his own

previous authentication of the picture. Simon felt he had been stitched up.

In accordance with its policy, the Board refused to give Simon any indication of why the pictures had been denied. In the days that followed, he worked frantically to find out why it had happened. First, he took a transparency of his picture to the Castelli Gallery. Leo Castelli had been dead for several years, but his widow Barbara told Simon that even her husband, a dealer of legendary stature, had more than once had pictures by Warhol denied by the Board. She encouraged him not to lose hope.

Over that lunch in February, Fremont suggested Simon view his picture alongside a painting from the 1964 series on linen to understand why it had been rejected. Fremont had also informed Simon that Castelli's son, Jean-Christophe, owned one of the 1964 self-portraits – the ones the Board considered authentic. It was in storage in Healey's warehouse in Long Island City, Queens. Simon rang Castelli's curator, who agreed that, for a fee of a few hundred dollars and the cost of opening the warehouse, he could view the 1964 picture and compare it to his own.

Simon also asked Fremont for the name of a picture conservator who specialised in twentieth-century painting. Fremont recommended the American painting conservator Sandra Amann, the Andy Warhol Foundation's chief restorer.[2] When Simon took the picture to her studio, Amann told him at once that it had been made in the 1960s, but she too needed to see it next to a picture from the 1964 series.

Simon liked Sandra Amann and believed she was doing her best to be helpful. But he still wanted a third person to be present to witness the all-important comparison. He found one in John Reinhold, a jewellery dealer and close friend of Warhol's.

Simon hired a car and driver to take all three, together with Simon's painting, to the warehouse. When they arrived, the crate had already been opened and the 1964 picture placed on a table so that it could be examined alongside Simon's 1965 painting.

'Immediately, my heart sank,' Simon recalled. 'It [the 1964 painting] had a thick hand-painted background, and the colours [were] stronger. John looked at me, as if to say sorry. My heart just fell. We laid the pictures down next to each other. Sandra got out her measuring tape and we started to measure the pictures. They were almost the same size. After ten minutes . . . it was obvious that both pictures had been printed using the same acetate, but with different silk screens. The obvious difference was that the 1965 picture was painted on cotton duck, Castelli's on linen, which holds paint much better – it reflects light and just looks richer. This cheered me up . . . I remembered the huge differences among other series – such as the "Studio-type" *Elvis* and the "Ferus-type" *Elvis* – and there were other examples of Warhol switching from linen to cotton within the same series in the early sixties.'

This was true: the series known as the 'Studio-type' *Elvis* has conspicuous hand painting and is not signed, whereas a later series, called the 'Ferus-type' *Elvis* (after the Ferus Gallery in Los Angeles, where they were first exhibited), looks more machine-made, more mechanical in feel, and it is signed. Warhol usually signed at least one picture in every series to signify that the entire series was his work. None of the *Studio-Type Elvis* pictures are signed, and none were exhibited during Andy's lifetime. After a flood in the studio, the entire series became soaking wet and needed extensive restoration. Yet the Authentication Board accepts both series as genuine. What is more, as was true of the *Red Self-Portraits* series, the differences

between the two *Elvis* series are instantly obvious, whether you know anything about Warhol's working methods or not. But this was clutching at straws. The fact remained that, in early 2002, it looked as though the Andy Warhol Art Authentication Board had been justified in deciding against Simon's work.

Most people would have given up then and there. Not Simon.

Chapter 4

Warhol's Silkscreens

BEFORE IT IS ANYTHING ELSE, Simon's *Red Self-Portrait* is a silkscreen, and it is important to know how the silk-screening process works to understand the Board's reasons for denying Simon's picture.

A silkscreen is essentially a stencilled image. Until the middle of the last century, the technology was primarily associated with the manufacture of cheap commercial products like T-shirts and greeting cards. Warhol made his breakthrough when he decided to use it to make works of fine art.

Late in 1962, Warhol stopped hand-painting cartoon characters and Coca-Cola bottles using the loose, drippy brushwork of the abstract expressionists. Instead, he began to transfer images onto flat surfaces using the silkscreen method. Artists before Warhol had made silkscreens, but mostly to make prints on paper. He made the technique his own by printing images he found in newspapers and magazines onto linen or canvas as well as paper. He liked the way silk-screened images tend to print out of register, giving his pictures the ephemeral look of grainy

photos in tabloid newspapers. But Warhol's working method constantly changed.

To emphasise the difference between a painting made by Andy Warhol and the drips, impasto and conspicuous brush-work of so much abstract expressionism, Warhol sought at this stage to diminish – though not to eliminate – evidence of his 'hand'. Warhol's use of the silkscreen technique to make art became a kind of brand that made his pictures instantly recog-nisable, right up until the end of his life.

Warhol used the same process to make a painting as a print, the only distinction being that paintings were printed on fab-ric, prints on paper. His friend, Henry Geldzahler, influential curator of contemporary art at the Metropolitan Museum of Art, and later New York's powerful commissioner of cultural affairs, recognised that the artist's two great innovations were to bring commercial art into fine art and to take printing tech-niques into painting.

This was exactly what flummoxed many of those who first saw Warhol's art. In his memoirs, Colin Clark, son of the art his-torian Kenneth Clark, recounts a story from his time working as a production assistant on the film *The Prince and the Showgirl*. To explain why Marilyn Monroe came across far more vividly on screen than her classically trained co-star Laurence Olivier, Colin Clark observed that, in front of the cameras, she knew how to speak a language an actor trained for the stage simply could not imitate. To Olivier's fury and frustration, the less the Hollywood goddess appeared to act, the more she lit up the screen. Clark continues: 'Some years later, I experienced a similar situation when I took my father to the studio of the Pop artist Andy Warhol in New York. My father was an art historian of the old school, used to the canvases of Rembrandt and Ti-tian. He simply could not conceive that Andy's silk-screened

Brillo boxes were serious art.'[1] Commenting on this parallel in the *New York Review*, I wrote: 'Actress and artist grasped that in the modern world, presentation counts for more than substance. The less you do, the greater may be the impact.'[2] What defeated Kenneth Clark about Warhol's paintings was not only their banal subject matter, but also the means he used to make them: the silkscreen.

A silk-screened image is flat. It has neither depth nor volume. This perfectly suited Warhol because, in painting Marilyn Monroe, he was not painting a woman of flesh, blood and psychological complexity, but a publicity photograph of a commodity created in a Hollywood studio. In a conventional printmaking process like etching, the artist makes a limited number of impressions, then destroys the copper plate. But Warhol's silk-screened images are not finite in this way. The number of finished works Warhol made depended on how many he needed or thought he could sell. Because he could print multiple versions of the same image, Warhol raised new questions about the nature of art. How did the kind of work he was turning out *differ* from any other mass-produced commodity? What value do we place on originality, invention, rarity and the uniqueness of the art object?

The nature of the silk-screening process made Warhol a particularly easy artist to fake. Usually, there would be virtually no difference between the silkscreen he personally printed, and an unauthorised one that an assistant might have run off, after hours. From early on, Warhol signed some works and used a stamped signature on others. Often, he did not sign a work at all, but the absence of a signature alone did not mean it was not his work. His ability to reproduce a single image numerous times on the same canvas was – or could be – an intrinsic element in the picture's meaning. For example, a canvas depicting

a dozen or more Campbell's soup cans might be seen as War-
hol's version of a modern still life. Instead of the fruit or game
an artist like Chardin might paint, Warhol shows food as it really
looks to most Americans when they buy it in a supermarket –
shelf after shelf of nearly identical cans, containing liquefied
beef, tomatoes or beans.

Chapter 5

Joe Simon

THE MAN I MET at Langton Street initially struck me as a card-board cut-out of the sunny, all-American type straight out of a Hollywood film. It was only after I began to take an interest in his *Red Self-Portrait* that I realised how wildly mistaken that impression was.

His name at birth was not Simon. He was born Joseph Whalen in the picture-postcard township of New Hope, Bucks County, Pennsylvania, around 1966. Abuse by a teacher and priest blighted his childhood. In his early teens, Joe Simon ran away from home, an act of self-preservation that later proved justified when, years later, his brother, who had suffered similar abuse, found a different means of escape through suicide. Joe's flight entailed changing his last name to that of his maternal grandmother – the one person in his life who he felt offered him unconditional love and support.

Teen runaways with little formal education and no market-able skills rarely flourish in Manhattan. When I pressed him to explain how he managed to survive living apart from his mother and father at such a young age, he turned the question around:

'Before leaving home, I was a target for every sort of abuse imaginable. As soon as I left, everyone [that is, all his grandmother's friends in New York] protected me, my grandmother being the overall umbrella . . . One would think the opposite would happen.'[1]

As a teenager, through his grandmother's friendship with the former editor-in-chief of American *Vogue*, Diana Vreeland, Simon became an unpaid assistant/gofer/walker to this grandest of *grande dames* during her last years as curator of the Metropolitan Museum of Art's Costume Institute, and was thus launched into the upper echelons of New York society.

According to Joe Simon, on the occasions when Mrs Vreeland did not have lunch at the museum, she took her tow-headed young assistant to lunch with the likes of Nancy Reagan, Anne Bass or Nan Kempner. These early encounters allowed Simon to refine his social skills, giving him an easy manner and a confidence in his ability to amuse. Launched by these influential women, he was soon invited to the best parties – where he met a long list of artists, actors and writers.

His education did not stop there. 'On Mondays, when the Met was closed,' he told me, 'I worked for Jackie Kennedy at her flat opposite the museum. She was working as an editor at Doubleday at the time, so she had me doing research for her at the New York Public Library. I was given a sandwich lunch, and a tie at Christmas.'[2]

Simon had found his milieu. Doing volunteer work for two of the most prominent women in the city by day and partying at night, Simon discovered a sense of safety and self-confidence – in fact, an identity of sorts. In his words, 'They protected me, they propped me up.'

When, over a period of several years, he told me the story of his life, my first instinct was to treat it as an exaggerated version

of the truth, like the chapter 'La Côte Basque 1965', about cafe society, in Truman Capote's unfinished novel, *Answered Prayers*. At the start, it did not matter to me whether Simon's account of his early life was strictly true. But, as I began to take a serious interest in the authentication of Warhol's work, I needed to trust him. Without telling him, I started to check names and dates in the only place I *could* check them – the social pages in back issues of the *New York Times* and *Interview* magazine.

I did not really believe Simon was only a teenager when he hit New York running. But then I came across a *New York Times* feature about fashion designer Carolina Herrera's first collection of haute couture clothing, which took place at the Metropolitan Club in New York on 27 April 1981. In one photo, Vreeland is talking to Herrera; there, just behind them, is Simon, very young-looking, in a preppy jacket and tie. The same article was illustrated with photos of Andy Warhol seated next to Paloma Picasso and her husband Rafael Lopez.[3] Whether Simon knew those celebrities or not, he was certainly moving in the circles Warhol aspired to, at an age when most young men and women were filling out applications to college.

At night, Simon ran around the city with three little rich friends his own age: Cornelia Guest, Maura Moynihan and Gwynne Rivers – daughters, respectively, of the socialite and fashion icon C. Z. Guest, Senator Patrick Moynihan and the artist Larry Rivers. These three danced the night away at nightclubs like Palladium, Area and Xenon. Since the decadent carryings-on in these places were notorious, I wondered how Simon and his pals were admitted as unaccompanied minors. It may be that at that period in New York, beautiful and sensationally well-connected youngsters were welcomed everywhere.

In those years, he was never offered drugs, except marijuana. He thought the reason was fear of retribution from social

arbiters like Mrs Vreeland, Carolina Herrera, British aristocrat John Bowes-Lyon and John Richardson, prominent A-lister, sometime art dealer, friend of Warhol and future biographer of Pablo Picasso – all of whom were concerned for his well-being.

Simon remembered that on weekday mornings, he met Mrs Vreeland at her apartment on Park Avenue and accompanied her by cab to the Metropolitan Museum. In the taxi, Vreeland questioned him about where he had been the night before and who he had seen. At the time, he assumed she was simply interested in the latest gossip. As an adult, he realised her true interest was in his safety.

As well it might have been. 'I spent countless evenings with Fred [Hughes] . . . at [the nightclub] Xenon (which Andy called Studio 27, because it was "half as good as Studio 54"). In the back office, his hideout, Fred socialised with the usual Euro players, or celebrities like Ringo Starr, David Rocksavage and John F. Kennedy Jr. Fred was often hammered on vodkas, snorting coke and telling stories about how he was the nephew of Howard Hughes, even though he wasn't.'

Hughes introduced Simon to Andy, who was obsessed by Diana Vreeland and Jackie Onassis/Kennedy. Warhol would call Simon first thing in the morning to ask for the latest gossip. 'I learned early on not to repeat things, as, whatever I told Andy, he would ring the person straightaway and say, "Joe Simon said you were up to this or that last night . . ." and one day it didn't end too well. Ever since then, I try not to repeat what people say.'

Most of what Simon told me about his life could be verified. There were times when I wondered whether something he'd said could be true, but that may have been because my own background was relatively conventional. In time, I came to believe that Simon was exactly who he said he was, but, in the

early years of our acquaintance, I sometimes worried that I was making friends with the Talented Mr Ripley. For instance, when I questioned a curator who had worked alongside Mrs Vreeland in the Costume Institute, she flatly denied that Simon had been a regular presence in the office. The same curator remembered meeting Simon on Christmas Day in Vreeland's apartment at 550 Park Avenue but scoffed at the idea that a teenage boy could get past the Met's front desk without a security pass. She added, however, that Diana Vreeland was well known for the number of young people to whom she gave work experience in the department – and that accorded with Simon's memory of having painted blue plinths for her exhibition of eighteenth-century French costume.

My best guess is that Simon remembered his time in the museum as lasting a lot longer than it did, and, as young people do, built up in his own mind the importance of the jobs he was given.

Simon knew Warhol on and off for the last seven years of the artist's life, during which he '. . . had a midlife crisis, started lifting weights, became cynical, dressed far too young for his age and began going on ridiculous blind dates. His new crowd just fawned and flattered him. Many artists I know seem to have had dysfunctional relationships, and Andy was no different. The difference is that most artists thrive on these, and their work reflects it – the more dysfunctional the relationship, the better the work. With Andy, it was the opposite. He cared less about the quality of what was being created. After Ronnie Cutrone [left], it was only when Andy took up painting with Jean Michel [Basquiat] and Keith [Haring] that he started to really paint again.'

In his early twenties, Simon moved to London. A European banker, with whom he was then living, invested a bit of inherited

money for him. The pair also had a lucrative business, buying and renovating London properties on soon-to-expire leases. This was when Simon started backing plays and films, collecting art and generally having a good time in a milieu where film, society, fashion and the arts overlapped. The Simon I knew liked nothing more than what he called a 'celeb-a-lula' – his word for an opening, an A-list party, or an awards ceremony. If he disappeared for a couple of months, it was to Bali, not Brighton, and he travelled there in a friend's private jet. Christmas would be spent on a yacht at St Barts, or skiing at Klosters – or both.

But behind Simon's high spirits and pathologically active social life lay a chasm of confusion and self-doubt. He needed people to like him. The obsessive-compulsive behaviour he exhibited in his pursuit of the Warhol case turned up in other aspects of his life. The intensity of his relationships could be frightening. When friends or lovers rejected him, or died, he was crippled with a grief that did not let up. It could last for years.

Simon's background made it almost inevitable that he would be attracted to Warhol and his work. What other twentieth-century artist was as fascinated by celebrity, glamour and glitz as Warhol had been? Simon instinctively grasped the underlying melancholy and loneliness in Warhol's personal life when others missed it completely. As a character, though, Simon was nothing like the self-destructive superstars Warhol put in his films. He was more in the mould of Fred Hughes – a clever and conventional middle-class WASP, who was at home in the higher bohemia, but who in private lived a reasonably stable, albeit unusual, life.

Chapter 6

Warhol's Will

ANDY WARHOL DIED on 22 February 1987 from complications following routine gall-bladder surgery. The *New York Times* reported that he left assets in the region of half a billion dollars, although, for tax purposes, the Foundation he established in his name valued them at $80 million. The inventory of works of art by him included 4,118 paintings, 5,103 drawings, 19,086 prints and 66,512 photographs, plus sculptures such as silver spray-painted Coca-Cola bottles.[1] His real-estate portfolio included his maisonette at 1342 Lexington Avenue; a town house at 57 East 66th Street; a house co-owned with Paul Morrissey in Montauk; land in Colorado; and several properties in downtown Manhattan, including the former Consolidated Edison Building on Union Square, where he had his last Factory, and a house at 57 Great Jones Street, which he leased to the painter Jean-Michel Basquiat.[2] Over ten days in April 1988, Sotheby's sale of his collections of over 3,000 lots of jewellery, watches, cookie jars, Navajo rugs, folk art, and paintings netted £25 million. A single lot, one of Cy Twombly's *Chalkboard* paintings, brought $990,000, while David Hockney's portrait of Warhol sold for

$330,000. The six-volume catalogue alone cost $95.[3] In his will, Warhol directed that these assets be used to establish a foundation dedicated to the advancement of the visual arts.[4] The Andy Warhol Foundation was also bequeathed tens of thousands of artworks, which it was allowed to sell.

For all his wealth, at the time of his death in 1987, Warhol's reputation as an artist had long been in decline in the USA. For two decades, the American public had been reading about his starry social life, but the more his name appeared in the gossip columns, the less important his new work felt. The *Campbell's Soup Cans* and *Brillo Boxes*, the portraits of Marilyn, Elvis and Liz: all were works of the sixties – relics of a moment in American culture that, to younger Americans, felt as distant as the Jazz Age.

The market for Warhol's work spiked just after his death, then plummeted during the financial slump in the early 1990s.[5] A few years after that, as the artist's wobbly reputation began to recover, so did his prices. A full-scale re-evaluation was well under way by 1995, when the Museum of Modern Art paid $15 million for his *32 Campbell's Soup Can* paintings, first exhibited in 1962.

As we learned more about the man and his life through the publication, in 1989, of David Bourdon's biography, followed swiftly by Victor Bockris's *Life and Death of Andy Warhol*, *The Andy Warhol Diaries* and Colacello's biography *Holy Terror*, both the ambition and the consistency of his artistic project began to crystallise. Once the link had been made between his art and his private obsessions and compulsions, Warhol looked very different from the spaced-out painter of movie stars we thought we knew. We came to understand that his achievement was to combine the visual excitement of pop with a depth of thought

that elevated him far above the clichés pinned onto him in the sixties.

Renewed respect for Warhol's achievement quickly trans- lated into a rise in the value of his work. Since the Andy Warhol Foundation owned thousands of his paintings, drawings and prints, its wealth would increase exponentially in the coming years. The Foundation needed to be run by professionals. In 1990, Fred Hughes appointed Archibald Gillies as its first president. A well-connected lawyer, and formerly president of both the World Policy Institute and of the John Hay Whitney Foundation, Gillies created a board of twelve trustees – many of whom were lawyers, including Peter Gates, who worked for the law firm Carter Ledyard, and who was Gillies' personal lawyer. With Gates appointed as its secretary, Gilles' newly formed board moved swiftly to remove anyone connected to Warhol or the former Factory. Hughes, already suffering from the multiple sclerosis that would kill him in 2001, was 'retired' to the position of president emeritus. One employee spared from dismissal was Fremont, who was offered a contract that made him both exclusive sales representative for the Foundation and its licensing agent.

Gillies' turbulent presidency lasted eleven years. Almost from the start, rumours of corruption and scandal swirled around the Foundation. As early as the mid-1990s, the attorney general of New York concluded an investigation into accusations of high salaries, lavish expense claims and general mismanagement by ordering a new audit committee to report quarterly to his office, though no legal wrongdoing had been found. 'There's nothing about the Foundation Andy would have been pleased with,' said Paige Powell, a close friend of Warhol's. And his former superstar Brigid Berlin added, 'All they're doing at the Foundation is spending Andy's money.'[6]

One of the Foundation's priorities in the decade after Warhol's death had been to complete an initiative started by Hughes: the establishment of a museum dedicated to his work. In partnership with two other institutions, the Dia Center for the Arts and the Carnegie Institute, it spent millions to create the Andy Warhol Museum in Pittsburgh, then gifted the institution about 3,000 of Warhol's paintings, drawings, prints and photographs. Included in the donation were most of his archive and all 610 of the *Time Capsules*, containing about 300,000 pieces of ephemera – like playbills, fan magazines, postcards and news clippings – that he had collected between 1974 and his death. Finally, the new museum was granted the copyright to many of Warhol's most iconic images. The largest single-artist institution in America, the Andy Warhol Museum opened in May 1994. Almost at once, it became a place of pilgrimage, offering visitors the overwhelming experience of seeing the power and beauty of works they might only have known in reproduction.[7]

The main work of the Foundation was to support the visual arts. By its twenty-fifth anniversary, it had awarded nearly $250 million in grants to hundreds of museums and non-profit arts groups, large and small, both in the US and (to a limited degree) in Great Britain. In an average year, it made grants totalling about $13 million to projects ranging from the restoration of works of art, churches, historic buildings and monuments, to the publication of books and catalogues, or support for exhibitions and (less often) political organisations like the American Civil Liberties Union. It also awarded research grants and stipends to individual artists. Too frequently, though, its philanthropic activities were overshadowed by a seemingly endless stream of accusations and investigations into its finances and integrity.

Chapter 7

The Andy Warhol Art Authentication Board

THE EVER-INCREASING VALUE of Warhol's art rendered the task of authenticating it urgent. At first, Hughes and Fremont did the work on an informal, ad hoc basis. Fremont has said that they authenticated 'truck-loads' of works to prevent the market from becoming jittery. The volume of paintings and prints that needed immediate authentication meant that their methods were rough and ready. To signify that they considered a painting or print authentic, they rubber-stamped it on the reverse with Warhol's signature. That is what happened to Simon's *Red Self-Portrait*, where the stamped signature on the stretcher looks so convincing that it is hard to believe it was not written by hand.[1]

The two executors dealt with the problem of the sheer number of works requiring validation in two ways. The first was to bring to fulfilment an ambitious publishing project, initiated by the suave Swiss art dealer Thomas Ammann with the approval of Warhol before his death, to compile a multi-volume catalogue raisonné of Warhol's work.

When research for the catalogue began in 1991, the person Ammann chose to write it was George Frei, a dance and art

critic who had become his gallery assistant in 1988. Frei had no obvious qualifications to pass judgement on millions of dollars' worth of Warhols, unless you count youth and a pleasant personality. When Ammann died in 1993, the Foundation stepped in to help fund, edit and jointly publish the catalogue.[2]

A scholarly but necessarily incomplete catalogue raisonné already existed, compiled by young German PhD student Rainer Crone and published in 1970 with Warhol's cooperation. That modest publication had one overall purpose: to include at least one work from each series.[3] Because the entries are reliably accurate, Crone's catalogue became the blueprint from which all later catalogues would be started.

The greatest of these, the Warhol Foundation / Thomas Ammann catalogue, was conceived on an infinitely more ambitious scale. The intention was to include every painting and sculpture Warhol ever made – a gigantic task, given how prolific he was.[4] There was an important difference between the new catalogue and the earlier one. Crone had no commercial stake in the pictures he was cataloguing, but from its inception the Foundation / Ammann catalogue was closely bound up with commercial interests. According to the minutes of a meeting of the Andy Warhol Foundation's board of trustees, held on 7 December 1994, the purpose of the catalogue was to 'contribute to the stabilisation of the market for Warhol works over time, thus having a direct benefit to the Foundation's long-term goal of converting its Warhol works into cash for favourable prices.' Frei initially took the lead in the Foundation's catalogue raisonné. His original co-author was a young American graduate student, Neil Printz. In 1995 Printz was joined by Sally King-Nero, at that point the foundation's curator of drawings and photographs. Kynaston McShine, senior curator at the Museum of Modern Art, and Robert Rosenblum, art historian, critic and

professor of art history at New York University's Institute of Fine Arts, served as editorial advisers.

In April 1995, the Foundation announced a second initiative to assess Warhol's work: the establishment of the Andy Warhol Art Authentication Committee. Printz, Fremont and Frei were members from its inception. The president was Warhol's friend, David Whitney – a curator, art dealer, social figure and partner of the architect Philip Johnson. Warhol's former lover, interior designer Jed Johnson, served as treasurer.[5] In November 1996, however, only a year after his appointment, Johnson died in the explosion aboard TWA Flight 800 from New York to Paris. His place was filled by Robert Rosenblum, with whose arrival the Andy Warhol Art Authentication Committee at last gained a member of recognised academic stature.[6] By 10 February 1999, the committee had evolved into the Andy Warhol Art Authentication Board Inc.[7] In 2002–3, when the Board passed judgement on Simon's *Red Self-Portrait*, its voting members were Printz, Whitney and Rosenblum, as well as Sally King-Nero who we'll hear more about shortly. Fremont attended the meetings but did not vote.

The Andy Warhol Foundation has a board of trustees. The Andy Warhol Art Authentication Board does not. Although funded by the Foundation, the Board is intended to function as an entity entirely separate from the charitable institution. There was a reason for this. The Foundation raised money by selling works Andy Warhol bequeathed to it. Because these paintings, prints, photos and drawings came directly from Warhol, they needed no further authentication. Their provenance alone served as a cast-iron guarantee of authenticity.[8] But any artwork acquired after Andy's death or from any source other than his bequest could not be offered for sale without authentication by the Board. Only with the Board's guarantee of authenticity

could the Foundation sell it. This was crucial. The clear line of demarcation between the Foundation and the Board reassured clients that, when the Foundation sold a Warhol that had not been part of the original bequest, it had first submitted the artwork for authentication to an entirely separate, independent body. No one could then accuse the Foundation of selling artworks with one hand that it authenticated with the other.

The president of the Foundation decides which works are submitted for authentication before being sold. Since Gillies stepped down in 2001, the president has been Los Angeles lawyer Joel Wachs. It was Wachs, therefore, who was in charge when Simon's *Red Self-Portrait* came up for authentication. After Frei left the Board to work full time on the catalogue raisonné, voting members of the Authentication Board consisted of several visiting members, but only two employees of the Foundation: Neil Printz and Sally King-Nero. The pair thus became full-time members of the Authentication Board *and* co-authors of the Andy Warhol catalogue raisonné. In both jobs, the Foundation paid them as employees to examine, research and pass judgement on all works of art submitted for authentication.

The work of the Authentication Board and that of the catalogue raisonné overlapped. Any work Printz and King-Nero authenticated with the approval of other Authentication Board members would in time be included in the catalogue raisonné. Pictures they stamped DENIED would never be considered for inclusion. The Board operated in secret, refusing to let owners or scholars know the evidence or reasoning behind its decisions. Answerable only to the president of the Foundation, its authority was absolute.

Outsiders often found it difficult to understand the criteria Printz, King-Nero and other Board members used to judge authenticity. At the time Simon submitted *Red Self-Portrait*, it

37

felt as though they developed fixed ideas as to how Warhol worked at every stage in his career, and, if an artwork did not conform to those preconceptions, they defaced it with the denied stamp. In general, they would not consult any member of Warhol's entourage – the very people who had witnessed the artist at work. Except under duress, the Board absolutely refused to reveal the reasons for destroying a picture by stamping it DENIED. This policy disturbed some scholars, art dealers, academic art historians and journalists. But they were legally untouchable. The Foundation indemnified the 'Authentication Board, its directors, officers, employees, committee members and volunteers against . . . any claim or liability arising out of any statement, representation, or action made or taken in connection with the authentication process.'[9]

What qualified Printz and King-Nero to do their important job? Some highly regarded experts have no academic qualifications of any sort and yet sit on similar boards because they had some connection with the artist (as a partner, say, or a studio assistant). As a result, they may know more than anyone else alive about his or her work. But why, out of all the many colleagues, assistants and scholars who had either known Warhol or written about him, were Printz and King-Nero chosen to pass judgement on the authenticity and monetary value of his work?

Sally King-Nero graduated from Goucher College, in Towson, Maryland, before receiving her MFA (Master of Fine Arts) from the Maryland Institute College of Art, in Baltimore, in 1981. She then worked at the same institution in a curatorial and administrative position for about seven years before moving to New York. There, she found work in a few commercial art galleries in Manhattan, but she was unemployed when the Warhol Foundation hired her on a part-time basis in 1990. The following year, she became full-time curator of drawings and

photography. By her own account, until she started her job at the Foundation, she had no serious knowledge of any aspect of Warhol's work. Five years later, she joined the Authentication Board, later admitting that, once there, she 'learned as she went along'. Her learning curve went on for years. As late as August 2002, when King-Nero and Printz passed judgement on Simon's *Red Self-Portrait*, they did not know the whereabouts of the *Red Self-Portrait* reproduced on the cover (dust jacket) of Rainer Crone's seminal 1970 catalogue raisonné. Yet both Vincent Fremont and George Frei had seen that picture displayed in Berlin's Hamburger Bahnhof when it was in the Erich Marx collection. Nevertheless, King-Nero's job title expanded to 'research associate' on the publication of the first volume of *The Andy Warhol Catalogue Raisonné, Paintings and Sculpture 1961–63*.

Her colleague, Neil Printz, graduated from the University of Michigan (BA and MA). Early in his career, he had work experience as a 'research curator' at the Menil Foundation in Houston. There, he helped to organise in-house exhibitions of Warhol's *Shadows* (1987) and *Death and Disaster Paintings* (1988). Neither show had a catalogue. Before starting work at the Foundation in 1993, Printz contributed to the catalogue of the Warhol exhibition held at the Museum of Modern Art in 1989. His input consisted of an anthology of Warhol's writings and observations, entitled *Andy Warhol in His Own Words*. In 1995, he became a founding member of the Authentication Committee. Seven years after that, he would receive a doctorate from the Graduate Center, CUNY, with a dissertation on Andy Warhol and Truman Capote. Much like King-Nero, Printz readily confessed that, when the Foundation hired him – initially to work on the catalogue raisonné and later to serve on the Authentication Committee / Board – he learned most of what he knew about Warhol's work in the 1960s on the job. By 2010, he felt confident

enough to declare that he knew about Andy's art in the sixties, but that his knowledge of the artist's working methods in the 1970s and 1980s was still limited.[10]

To me, the most puzzling thing about Printz was his apparent unwillingness to accept information or advice from scholars who offered it. In the volumes of the catalogue raisonné published so far, the entries seem to be detailed, accurate and exhaustive. All such publications contain errors, so it would be unreasonable to expect the Warhol catalogue to be perfect. But, with a catalogue raisonné, often it is not what is included that is problematic – all errors are unfortunate, but those that are published can at least be seen, debated, and sometimes corrected. That doesn't happen when a work is omitted.

Another employee of the Foundation whose name I kept coming across was Claudia Defendi. She acted as the Authentication Board's spokesperson and secretary and was also co-editor of the catalogue raisonné of Warhol's prints. She, too, acknowledged that, when she started in this position, she knew absolutely nothing about either Andy Warhol or printmaking. In deciding the status of a print, she followed the advice of her co-editor, well-known print dealer Frayda Feldman.[11]

Neither of the visiting members, Rosenblum and Whitney, worked for the Foundation. They were paid a modest stipend plus travel expenses to attend Board meetings three times a year. The use of the term 'meeting', here, may be somewhat misleading; such meetings might take place over several days, with any unfinished business held over till the next time the Board met, four months later.

Board meetings followed a regular pattern. After a good lunch, Printz and King-Nero presented their decisions on the status of the works of art they had examined since the last meeting. They might give updates on the progress of their

research, show supporting evidence such as X-rays, or consider the report of a conservation scientist. They answered questions and, if asked, would provide more factual detail, particularly when the issue under discussion was contentious.

No conservator served on the Board. All four of the original members voted on the status of the pictures they reviewed. The board evolved over time to include more visiting experts, but in this book I focus only on the original members who passed judgements on Simon's and d'Offay's pictures in 2003. Judging only by minutes of the Board I have seen, the decisions Printz and King-Nero had made were presented to the visiting members as a fait accompli.

Chapter 8

Selling Andy

GIVEN THAT FOUNDATION and Board were meant to be entirely separate, it struck me as curious that there were two other people present at Board meetings. Both were employed by the Foundation, both attended meetings in a non-voting capacity, and both could, and did, influence the Board's decisions. One, whose attendance was intermittent, was Joel Wachs, who, as well as being president of the Foundation, served as chair of the Andy Warhol Art Authentication Board. The other was Vincent Fremont, who, in his capacity as exclusive sales representative, needed the Board's approval to sell a picture, although this seems to have been a mere formality if it came from the original bequest.[1]

During Warhol's lifetime, Fremont doesn't seem to have had much to do with Warhol's art. The two met when the eighteen-year-old Fremont visited the Factory during the summer of 1969. In 1971, he began to work there full time, with responsibility for opening the studio in the morning, sweeping the floors, answering the phones and locking up at night. As smart as he was efficient, Fremont soon made himself indispensable.

In 1973, he became vice-president of Andy Warhol Enter-prises, developing ideas for TV shows and helping with the distribution of Warhol's films. When Warhol wrote his will, he named Fremont an alternate executor – that is, the person who becomes executor if the primary executor, in this case Fred Hughes, either declines to serve or is unable to fulfil his duties. For three years after Warhol's death, Fremont authenticated and sold works jointly with Hughes, then did so on his own until 1995. That year, he became the Foundation's exclusive agent for sales of paintings, sculpture and drawings – a job for which he was paid a percentage commission of the gross cash proceeds on each sale, plus expenses. He claimed never to have missed a meeting of the Authentication Board, but always stepped out of the room while the members voted.

His job title, 'sales agent', may need some explanation. His extraordinary contract stipulated that the Foundation was obliged to indemnify him and to hold him and his company, Vincent Fremont Inc., 'harmless of any claim or liability asserted against either.' The Foundation was further contracted to defend the man and his company at its own expense against 'any action or proceeding' brought against them. This made him legally untouchable. Why? If all Fremont did was sell the art left to the Foundation in Warhol's bequest, why did he need this kind of legal armour? The more I learned, the more I wanted to know about Fremont – and particularly about how he ran his business.

In a draft press release written by Claudia Defendi, intended as a general response to queries from the media about the Foundation's sales process, she makes Fremont's job sound straightforward: 'People will call up Fremont or Hunt [Tim Hunt, former Christie's expert in Tribal art, who from 1996 became exclusive agent for sales of prints and photography] and they will ask if a specific work of art is available; if not, they

might say is there anything [else] they might be interest[ed] in. The sales agents then consult with the Foundation to establish a price. The Foundation then determines the price and then the sales agent goes back to the owner and at that point the individual determines whether he/she wants to purchase the work. Again, the sales agent must consult with the Foundation to set a price. The Foundation will not discuss how prices are set'.[2] In this official version, Fremont's sales method sounds intimate, personal.

But, in practice, Fremont worked in another way. On behalf of the Foundation, he consigned paintings to certain favoured dealers – offering them a 40 per cent to 60 per cent discount and taking a generous percentage of each sale himself. Whenever Fremont made 'bulk sales', the Foundation raised his commission from the normal 6 per cent to 10 per cent. The chosen dealers – Gagosian, Acquavella, d'Offay and the rest – then sold the pictures to their clients, acting, in effect, as middlemen, taking a group of pictures from Fremont to sell 'on spec'. That made sense. Given the enormous prices achieved by Warhol's works, few dealers had the resources to purchase many canvases outright. Fremont's way of working made the process relatively risk-free.

There was a practical reason for the way Fremont chose to do business. Let us say that he sold a picture to a client who bought it with the assurance that it came straight from Andy Warhol's bequest to the Foundation. As far as the buyer knew, that guaranteed its authenticity. But what if the client later learned that the picture for which they had paid millions had once been deemed a fake by the Andy Warhol Art Authentication Board and then declared to be authentic by the same Board? The client would raise the matter with the dealer who sold it to him or her, not the Foundation. If the dealer quietly returned the client's

money, the small unpleasantness could be handled without any awkward public questions about the authenticity of the pictures the Foundation was selling. If the client also signed a non-disclosure agreement, no one outside a small circle of insiders was any the wiser.

There is nothing illegal or even questionable about this way of working, unless the sales agent for the Foundation knowingly gave dealers fake pictures. Even if that had happened, we do not know how much information Fremont gave the dealer about the picture's history. If he said nothing, then he might stand accused of dishonesty, but the dealer would be able to sell the pictures in good faith. On the other hand, Fremont might have given the dealer a full and accurate account of the picture's history, in which case he would be blameless. But an unscrupulous dealer could sell the picture to a client without providing the same information. In that case, it would be the dealer who was the criminal.

From the moment he took on the role of chief salesman, Fremont was able to make colossal sums of money. The New York attorney general became so worried about the amounts Fremont was taking from a non-profit charitable institution that, in 1996, he capped the amount Fremont could make in any given year at $950,000. His contract was changed so that he became sales agent for paintings and sculpture only, with Tim Hunt taking the reins for prints, photographs and drawings. Fremont also stepped down from the lucrative position of licensing agent.

But the lawyers who ran the Warhol Foundation were not about to let the city's district attorney prevent them from operating in any way they chose. The Foundation circumvented the attorney general's cap on the amount Fremont was allowed to make by 'rolling over' any amount exceeding $950,000 in a single

year to the following year. If, for example, Fremont earned a commission of two million dollars in one year, he was legally allowed to take home only $950,000 of that. The remaining $1,050,000 would be rolled over and added to whatever amount he made in commissions the following year. Even if he sold nothing the next year, he would still be paid $950,000, and any amount exceeding that would again be rolled over.

By the time he left the Foundation in 2010, Fremont had taken home approximately $15 million in commissions ($950,000 for every year he worked there). But, during the same period, Fremont's yearly commission routinely exceeded the $950,000, so millions of dollars of 'rollover' had accumulated. The Foundation continued to pay this in yearly instalments of $950,000. In 2010, the chief financial officer of the Foundation estimated the total amount Fremont would eventually receive to be in the region of $25 million.

Chapter 9

The 'Dollar Bill' Piece

SIMON WOULD SOMETIMES JOIN me on Saturdays when I drove around the art galleries scattered haphazardly through London's East End. He often came back for supper, with his partner, the Brazilian actor Anthero Montenegro. My wife and I took it for granted that Simon's apparent attachment to us would be temporary. As soon as his problems with the Board were resolved, he would be off to pursue one of his many other projects. But, until then, Hatty had enjoyed spending time with him. Likeable, energetic and a font of Hollywood gossip, he could be the best possible company – at least, when he was not obsessing about the 'Dollar Bill' piece and the *Red Self-Portrait*. In our house we called this 'Joe's Woes'. Unfortunately, that was happening more and more. Over the winter of 2002 to 2003, he was preparing to send both pictures back to the Authentication Board.

Warhol took on several assistants as dogsbodies, to mix paint, stretch canvases or act as art handlers. When the Board denied the authenticity of *Red Self-Portrait*, Simon made renewed efforts to gather information he might somehow have overlooked.

Long before we met, he had taught himself everything there was to know about the silk-screening process, canvas weave, pigments, Warhol's working methods and his use of studio assistants. Now, he hared off after new facts, new clues – spending tens of thousands of dollars on flights to and from New York, on hotels and on research assistants – ever more obsessed with finding the key that would prove the work's authenticity. When he thought he had collected the necessary information, he submitted the piece for authentication a second time. Again, it was rejected. Again, he was bewildered by the verdict. Again, Defendi suggested he do more research.

That was what Simon had been doing during our meeting at Langton Street. The 'Dollar Bill' piece was due to come before the Board again, and he entertained a forlorn hope that I would notice some detail no one else had spotted and tell him why it was or was not real. But I had nothing useful to say.

There was, though, one thing I could do that might help. Robert Rosenblum was the first person whose lectures on art history I had attended in college. In later life, we became friends. On his frequent visits to London, either he came to supper or we met at the house of our mutual friends, art critic David Sylvester and his partner, art historian Sarah Whitfield. In my eyes, Bob was everything an art historian should be – a great scholar, and also a critic who wrote with unparalleled insight into the art of his own time. Besides, he was a delightful person.

Art historians tend to talk shop – and so did he – but he wore his knowledge so lightly and expressed ideas with such wit that, even after a short conversation with him, I always came away feeling I had learned something. I thought that, if I simply asked him to tell Simon why the collage had been denied, he would oblige. I did not know then that, because Bob was the one universally esteemed member of the Board, he frequently took flak

from furious curators and collectors demanding to know why their pictures had been rejected.

At this early stage, I was trying to help resolve what I believed was an ordinary disagreement about an attribution – the kind scholars thrashed out in the pages of the *Burlington Magazine* all the time. It was natural that I should put the question to Rosenblum. With characteristic good humour, he explained that, as a member of the Andy Warhol Art Authentication Board, he was bound to abide by its rules, but our exchanges always remained friendly and easy-going.

In my email, I asked him to be sure to examine the supporting material provided by Simon. This was because no less a figure than John Richardson had warned Simon that Whitney and Rosenblum only rubber-stamped decisions presented to them by Printz and King-Nero. The source of Richardson's information lent it credibility: it was Bob Rosenblum himself. Simon simply wanted Rosenblum to be aware of all the evidence he sent along with his picture, worried that Printz and King-Nero might not show it to the visiting Board members.

In one of our email exchanges about the 'Dollar Bill' piece, Rosenblum casually mentioned something about the 'detective work' the Board had done to determine whether the notes in the collage were suspicious. Without first checking with Rosenblum, I interpreted his casual comment as an off-the-record hint that the bills were counterfeit. That would make the case against their authenticity open and shut. When I mentioned the word 'counterfeit' to Simon, it rang a bell. After the Board rejected the piece the first time, Richardson told him a story doing the rounds in New York: Tim Hunt, the British-born agent for the sale of photographs at the Andy Warhol Foundation, was telling friends that the dollar bills used to make it were forged.

A short time later, Board Chairman Joel Wachs spoke to Los

Angeles art dealer Ilene Kurtz. This is what he said, in his own words: 'She [Kurtz] kept saying how good he [Simon] is, and I said, "Well, listen, let me tell you something," and I . . . told her, "Did you know that your friend Mr Simon submitted a fake dollar bill collage to the Board?" . . . She basically said no, and I said, "Well, he did and we know it's not good, we know it's no good because of the dollar bills that he [Simon] used, and we have proof of that." ' Kurtz told Simon that she came away from the conversation with the impression that Simon had forged both the notes and the collage.

When Simon heard about Wachs's accusations, he was appalled and immediately took the 'Dollar Bill' piece to the US Secret Service on 9th Avenue. Its agents tested the bills and assured Simon they were real. He asked one of the Secret Service agents to write a letter to the Board affirming that the bills were not counterfeit. The agent refused, explaining that government policy is not to provide information regarding counterfeit currency by letter or email.

At Simon's request, Agent McColl then telephoned the Authentication Board. Research assistant Bibi Khan took the call. McColl confirmed that the bills had not been forged. Ten minutes later, Simon's telephone rang. It was Claudia Defendi. Enraged, she shouted that the Board did not accept *any* information over the telephone. In reply, Simon reminded her that the Board had already kept the collage for ten months. They had Agent McColl's telephone number, but, if they did not want to use a telephone, any Board member could easily nip down the street to speak to McColl in person. At this, Defendi became incandescent.

Simon went back to implore Agent McColl and his colleagues to override US government policy by sending an email to the Board confirming that the notes were genuine. And that,

finally, is what he did. At that point, Simon wrote to Defendi. His email of 13 March 2003 gives some sense of his earnestness, his despair, his sheer bewilderment:

> . . . You know how thorough I am, what could I possibly [have] missed? When it was first denied I was told that it was because the board were not sure how I acquired the picture. I showed the picture to the owner . . . he wrote a letter/invoice for me and I resubmitted the picture with his letter and Warhol's diary entry. I telephoned Vincent Fremont who told me very clearly that he denied it because Paige Powell [editor of *Interview*] hadn't seen it. Of course, she has. I was told that 'Andy made a lot of these'. Well, isn't he famous for making a lot of things? I was then told that the dollar bills were counterfeit, the numbers were rubbed out. I really thought he [Fremont] was joking. Why would anyone fake a painting with forged dollar bills? What's the point? When I started receiving emails from people, even a curator of a museum, telling me that members of the foundation were saying that I had a painting that was fake with counterfeit notes, this was very hurtful and untrue. As you know I took it to the proper authorities [The American Secret Service in New York] and cleared up this matter.

<p style="text-align:center">*</p>

About six months after our meeting at Langton Street, Simon was waiting to hear the Board's verdict after they had 'reviewed' the collage for the second time. On 20 June 2003, he received an email from Claudia Defendi: 'If you can provide a copy of the serial number confirmation from the embassy or secret service, the Board would be more than happy to review the information.'

Worried that the Board might require a second opinion on the status of the bills, Simon had already submitted the collage to officials of the American Secret Service at the US embassy in London. When the agency made contact to say that they had examined the bills and would like to meet to discuss their conclusions, Simon telephoned me and asked me to go along with him as a witness.

On 23 June 2003, I met Simon in front of the grandiose building that sprawled over the entire west side of Grosvenor Square. I had been in the vast waiting area many times over the years – and always found it to be soul destroying. I hoped the agents would not park us in this waiting room for hours – but brought a book just in case.

It was not necessary. After a few minutes, we were shown into a windowless office in the basement. Waiting there were two nondescript gentlemen in rumpled grey suits and ties, who introduced themselves as Agent Alfie Quinn of the US embassy and Doug Albright of the United States Treasury office in Washington DC. They were *exactly* my idea of what Secret Service agents should look like. But they could not have been less like tough guys. The status of works of art is probably low down on the agency's list of problems, but questions of counterfeit currency they took very seriously indeed. The collage was lying there on the table.

Both men spoke to Simon with courtesy. They had already examined and tested the bills. In the manner of a kindly GP reviewing the results of recent medical tests, Agent Quinn confirmed what his colleagues in New York had already told Simon: the Federal Reserve notes used to make the collage were real. They had checked the serial numbers. It was as simple as that. Agent Quinn told Simon that he would have Doug Albright, his colleague at the Secret Service in Washington DC, write to the

Board directly. There was no more to be said, so Simon thanked them, and we left.

But Simon was unable to stop fretting. As the date grew closer to the Board's decision, he telephoned me again. He had a favour to ask. Would I email Bob Rosenblum to tell him that I had been present at the meeting and could confirm what the agents said? I did not mind doing so, but I reminded Simon that I could not say the collage was authentic, only that the bills were not counterfeit.

In the meantime, Simon anxiously telephoned the Board to ask whether they had received written confirmation that the bills were genuine. He also asked whether the dollar bills would be re-examined in the light of this new evidence. Defendi merely confirmed that the letter from Agent Quinn had arrived. Simon was driving everyone he knew crazy. On his behalf, Ilene Kurtz also rang Sally King-Nero, who told her Simon would hear the verdict within the month. Simon telephoned the Foundation's lawyer, Ronald Spencer, who repeated the same formula, but added that, just because Simon had done his own research and answered some of their questions, it did not mean the work would be authenticated.

On 14 July, Simon telephoned the Board again. A decision had been made, but they could only fax it to him, not tell him on the telephone. The fax said that the Board had not requested the new information he had sent and had not changed its opinion. The Board members had done their own research, 'including but not limited to information from the US Treasury'. And then came the ritual words indicating that the discussion was closed – but not completely closed. If Simon would like to resubmit the work of art with additional information, 'the Board would be happy to look at it', though it must be sent by post, not fax or email.

Simon still believed that Defendi was trying to be helpful. Taking her words to imply that the verdict was not definitive, he believed that, if he found additional information, the Board might change its mind. He had already spent years of his life trying to understand the reason for the Board's decision and had always ended up hitting his head against the same wall. Why? Then it dawned on him: *there must have been some mistake.* Perhaps the letter from Agent Quinn had not, after all, reached the Board. Or perhaps Printz and King-Nero *had* received it, but then withheld the information in it from the visiting experts, like Rosenblum. If that was what had happened, at least the lawyer for the Board, Ron Spencer, should be made aware of what the agents had said.

Simon asked me to write to Spencer. I felt sorry for Simon. I understood his frustration. In fact, having now seen the way the Board treated him, I was coming to share it. On 16 July 2003, I wrote to Spencer. I began by introducing myself, listing my publications and my job as an art critic for the *Daily Telegraph*. I also offered to send him my CV, referring him to Bob Rosenblum, 'who will certainly vouch for my credibility'. The rest of the letter simply affirmed that the Secret Service agents in London had pronounced the bank notes to be genuine. Though I offered to submit sworn testimony, I sincerely hoped the Board would accept 'this simple statement of fact'.

And now, as had happened the year before when Simon had asked Agent McColl to contact Defendi by telephone, my letter sent the Foundation into an uproar. The Board's lawyer had received a letter from an outsider. Apparently, this was a mortal transgression, or at least a billable one. The lawyer reprimanded Rosenblum for speaking to a journalist. But, this time, Bob had had enough. His email to me was dated 17 July and, in it, he said that he was leaving for Greece that afternoon:

. . . and may fall out of the loop, although I left my strong recommendation with the board and the lawyer that a full disclosure of our data be sent to Joe Simon. Meanwhile, however, I must tell you – and the lawyer has given me permission to do so – that your letter to him concerning whether the bills are counterfeit or not is completely off the mark. No one ever raised this question (although, to my discomfort, I seem to remember saying something informal to you quite a long time ago about the board's detective work, which included the dating of canvases, inks, determining whether bills were counterfeit, etc. and perhaps this is what you picked up) . . . I can tell you, as a friend, that the evidence we have is irrefutable, and that, if disclosed, even in part . . . no sane person would continue to sustain faith in the work's authenticity . . . I wanted to get this off my chest before leaving, and I only hope that, in a matter of days, the board and the lawyer will see fit to disclose enough factual information to make you realise that our decision is . . . unquestionably true.

I regretted having caused Rosenblum irritation by writing to the lawyer – but, at that point, I did not understand, as I do now, how alarmed employees of the Foundation became when people like me wrote or called offering assistance.

My letter did, apparently, have some effect. At Rosenblum's insistence, the Board at last let Simon know what was wrong: the bills used to make it were genuine, but they had been printed after Warhol's death. That meant the collage was fake. The bills bore the signature of Nicholas F. Brady, Secretary of the Treasury, who took office on 15 September 1988. That was more than two years after the date inscribed on the work (21 April 1986), and over a year after Warhol's death. I had picked up on Bob's use of the phrase 'detective work' to see if the

notes were 'suspicious', and in doing so had thrown Simon off the track. The bills were real; it was the collage that was fake.

The Board had known this from the outset. In a memo to members of the Authentication Board dated 16 July 2003, King-Nero discusses the forgery of the 'Dollar Bill' piece: 'It has been documented [that a Warhol assistant tried to sell] black and white 8 x 9 photographs with Andy's signature on the front, so I began to think that maybe there could be more than one dollar-bill collage. Indeed, there is.'[1] What she found was that, in 1989, a work somewhat resembling Simon's collage had been submitted for review to the estate. Simon had purchased a forgery. He, of course, had no idea that the Board already possessed King-Nero's email of 16 July 2003 which gave the Board good grounds for suspecting that an assistant – someone closely connected – had forged the collage. When Simon asked why the forger had not been prosecuted, he learned that, as a former employee of Warhol's, the assistant was indemnified by a legal waiver. Simon therefore had no legal recourse.

Knowing the truth, the Board still refused to give Simon the explanation he had begged for the first time the collage had been denied. Each time they rejected the work, they threw him a lifeline, deliberately sending him on a very expensive, three-year wild goose chase. When he learned the truth, he accepted their explanation as valid. That was the end of the matter. He never again tried to contact them about the picture, nor attempted to have it authenticated, nor tried to sell it. When, sometime later, I asked Bob Rosenblum why the Board refused to explain its decisions, he replied that, by revealing the reasons for denying a picture, the Board would only enlighten potential forgers as to Warhol's working methods.

But other authentication boards *do* explain to owners their reasons for saying that a work is not by the artist in question.

They distinguish between an outright fake, made with the intention to deceive, and a copy – perhaps by a student whose intentions were innocent. By contrast, Simon had heard a rumour was being spread in the art world that he had forged the collage. Why? Even if they believed what they were saying, why had Fremont not told them that it was not Simon who was passing off fakes?

I wanted to believe that it was entirely because of Bob Rosenblum's intervention that the Board relaxed their otherwise inflexible policy and told Joe Simon the truth. But I do not think it was. For months, the Foundation had been apprehensive over the looming publication of Michael Shnayerson's scathing indictment of the Andy Warhol Art Authentication Board in *Vanity Fair*. His article, 'Judging Andy', accused the Board of incompetence, duplicity and of making a succession of egregious misattributions. In what was clearly a last-minute attempt to raise questions about the accuracy of Shnayerson's article, the Board told both Simon and Shnayerson at the same time why the 'Dollar Bill' piece had been denied – an hour or so before the article went to press. Simon and Shnayerson used the limited time they had to write responses, but neither had the space to reply in detail. The Board came clean not to accommodate Simon, but to neutralise the impact of his media campaign. From that point onwards, their spokespersons could and did claim, in a tone of injured innocence, that *of course* they had told Mr Simon why his picture was a fake.

The number of times Simon telephoned the Foundation before hearing the verdict meant that Defendi and her colleagues knew they were dealing with an anxious, obsessive personality. Yet, in an email dated as late as 1 July 2003 (a few days before the Board told Simon the truth), Defendi wrote to her fellow Board

members. Fully aware that their opinion would never change, she ends: 'Please let me know if you would like me to issue this letter [telling Simon the truth] or *if you would like me to indicate that he is free to submit the work again if additional information is provided.'* (My italics.)

Chapter 10

Celeb-a-lula

As EXOTIC A BIRD as ever alighted in our little corner of North London, Joe Simon and his partner, Anthero Montenegro, brought with them high spirits and a touching wish to make friends with my children and my wife's large and close-knit family. They were like no one else we knew. Simon did not gossip about his friends, but the ones he was plainly closest to were Mick Jagger and his partner L'Wren Scott. He saw a lot of them, spending many birthdays, Christmases and summer holidays together at home in London or in Jagger's chateau in France or his house on Mustique. L'Wren seemed always to be fussing about Simon's health or state of mind, or both. Wherever they were, the two talked on the telephone daily. When she died in 2014, Simon helped with the funeral arrangements, overwhelmed with grief.

Like a renaissance courtier, Simon instinctively knew how to make himself indispensable, and always with a light touch. What do you give a couple like Jagger and Scott for an anniversary present? Simon's answer was a splendidly emblazoned Vatican document with Pope Benedict XVI's personal blessing on their union. Since the couple were neither Catholic nor married, and

since one of Jagger's biggest hits was 'Sympathy for the Devil', we asked Simon how he'd wangled a benediction from the supreme pontiff, intended for devout couples who'd been married (to each other) for fifty years. As so often before, his answer was vague. He 'had this friend who worked in the Vatican . . .' We did not press for further details.

Simon did his best to interest us in his weird and sort-of wonderful world, but with only limited success. One day, he rang to say that Nick Rhodes, who plays the keyboard for Duran Duran, had reserved a box for the band's concert in Earl's Court – would we like to come? Rhodes's guests were the opposite of the teenagers I imagined screaming themselves hoarse at these events. Social figure Tara Palmer-Tomkinson was there, along with a fair number of middle-aged bankers, stockbrokers and landowners. Everyone knew the music by heart and all roared with joy as they recognised each familiar song.

At dinners in Langton Street, Simon and Montenegro were surrounded by their inner circle. As well as Nick Rhodes, this included Simon's closest friend Maddy, milliner Philip Treacy, John Bowes-Lyon and the wonderfully eccentric fashion maven Issy Blow. Simon's name-dropping could be annoying, although I came to recognise it as a sign of his chronic insecurity. It did not normally happen when he came to dinner on his own, but on one occasion I had to leave our kitchen table in desperation when he and an American curator spent the entire evening talking about their mutual friend, the King of Morocco. On the other hand, his work ethic was inspiring and his powers of concentration phenomenal. He read voraciously and had an insatiable appetite for theatre and film. As a producer, Simon was a member of the British Academy of Film and Television Arts, and therefore was able to vote in the BAFTAs, receiving DVDs of new films long before they went on general release.

When he became fixated on a subject, he set out to learn everything he could about it. For now, his obsession with the Warhol case stopped just short of unhinged. The time would come when I could see how near to lunacy it really was.

At that first meeting in his flat, I had no measure by which to gauge how profoundly the Warhol issue had already blighted his life. After a start as a high-flying impresario, his career had stalled in mid-air. It looked as though its downward spiral could not be reversed. He had channelled his phenomenal creative energies into his compulsive need to find out why the Board had denied the *Red Self-Portrait*. A few months after we met, in May 2002, Simon quietly sold his house in Malibu to pay his legal bills and to cover the costs of new research. The million or so dollars he got for that house was not nearly enough. On a visit to Langton Street that spring, I noticed that the two Warhol *Cow* prints were no longer there. He had sold them to Jeffrey Archer. A few months later, Simon sold a much more valuable print – Warhol's portrait of Mick Jagger – to the Tetra Pak heiress Eva Rausing.

From then on, the sitting room walls were bare. It was like watching a man possessed throw everything he owned onto a bonfire. Then, towards the end of 2003, he left Langton Street and moved into the basement flat in Nick Rhodes' house. The contrast shocked me. Simon's changed fortunes reminded me of the scene in Hogarth's *Rake's Progress*, where the rake is incarcerated in Bedlam, a helpless lunatic. Except that Simon was not insane, only manic, and, far from being in an insane asylum, there seemed to be no let-up in his jet-setting social life. In public, he was never less than optimistic, certain that his research would in the end prove him right. The Warhol fixation served a useful purpose: it kept his mind focused on a struggle he believed he could control, rather

than facing the regiment of demons that forever threatened to engulf him.

If only Simon had not submitted his picture to the Authentication Board, none of this would have happened. He'd have kept his home, his possessions, his career and his comfortable life. To what end was he destroying it all? It wasn't money. At the beginning, at least, Simon had plenty, and the longer I knew him the clearer it became that it did not impress him. He seemed indifferent to the mere passion of wealth, whether his or anyone else's.

No, it was something else, something deeper. It seemed to come down to the Board's refusal to tell him why it had rejected his picture. Their behaviour – inexplicable to him – triggered the feelings of humiliation and helplessness he'd experienced during a difficult childhood. All he wanted from the Board was an explanation. They would not even return his calls. Their continued silence he rightly saw as arrogance – and it fed his rage.

Chapter 11

Eyewitnesses

IN THE SPRING OF 1964, Andy Warhol made a series of eleven identical self-portraits, using a head-and-shoulders shot taken in a Times Square photo booth, silk-screened on linen. As Simon discovered in that warehouse in Queens, the 1964 series is instantly recognisable because the background colour of each painting is different, and all are painted, in places, by hand, with visible brushwork and areas of thick impasto. These, the Board considers genuine.

But, during the summer of 1965, Andy Warhol made a second series of eleven self-portraits, using the same acetate as he had used the year before, but printed on canvas by a commercial printing company. The uniform background colour gave the series its name: *The Red Self-Portraits*. These pictures have virtually no evidence of Warhol's hand in the form of brushwork or impasto. It is a painting from this series that Simon owned, and which the Authentication Board denies is the work of Andy Warhol.

Those who disagree with the Board's verdict maintain that the context in which the *Red Self-Portraits* were made is crucial

to assessing them. They point out that, at this stage in his career, Andy Warhol was constantly experimenting with new ways to make art. The summer of 1965 was a moment when Warhol was cutting back on painting to concentrate on making films and videos. For them, the second series epitomises this creative gear change and is perfectly in keeping with his increasing interest in creating fine art by mechanical means.

During the summer of 1965, Warhol was turning out about a film per week and getting into serious debt as a result. At the same time, Bruce Torbet and his partner Juan Drago were making a film about Warhol, trailing after him to record how he worked. In a tape recording now in the Andy Warhol Museum, Drago tells Andy that, to improve the sound, he should shoot less. Warhol replies, 'I don't cut; I shoot a 1200-foot reel and I don't cut . . . I don't believe in cutting. We want to do a twenty-four-hour movie, following someone around.'[1]

With running times of five and a half hours and eight hours respectively, *Sleep* and *Empire* are hard to watch, especially if you are employed or have something more interesting to do. On the other hand, the shorter films featuring actors and with notional storylines, such as *Haircut (No. 1)* or *Kitchen*, are at least watchable. Seeing them today, we may be struck by how far in advance of his time Warhol was when he made them. Now, they look like prototypes for reality TV shows like *Big Brother* and *Love Island*.

Just like Warhol's early films, these trashy but enjoyable programmes offer audiences voyeuristic experiences in exchange for their willingness to tolerate inane dialogue and long stretches of inaction, quickened by glimpses of insipid sex. Until *Chelsea Girls*, few Americans had seen a Warhol film. For the vast majority, Warhol was the pop artist who made the *Campbell's Soup Cans*, nothing more.

Pete Palazzo was the art director who gave Warhol his start in New York, commissioning the young artist to make the pretty line drawings used in advertisements for I Miller shoes, which used to appear weekly in the *New York Times* from 1955 to 1960. In 1964, Palazzo introduced Warhol to Richard Ekstract, a publisher of magazines about consumer electronics. Andy was fascinated by tape-recordings of the human voice, and so would call Ekstract regularly to acquire taping equipment and blank tapes at little or no cost. With his numerous contacts within the electronics industry, Ekstract could do this easily.

One of Ekstract's contacts was with Philips Electronics, which owned a company called Norelco. During that momentous summer of 1965, a new machine appeared on the market – one that used tape to capture not just sounds but moving images. Manufactured by Norelco, it functioned like a movie camera, except the 'film' could be played back instantly, just like playing back sounds on a tape recorder. It was called a 'video recording machine'. Richard Ekstract became Warhol's conduit to Philips and other electronics firms. In a letter to the Board dated 12 November 2002, Ekstract writes that Warhol 'began soliciting me regularly to obtain recording tape and tape equipment at a discount or for free. I always obliged.'[2]

Ekstract arranged for Norelco to loan Warhol a prototype for one of the first consumer videotape recorders, together with recording tape – but only for a period of one week, in mid-July 1965. Warhol described the machine in his book, *Popism: The Warhol Sixties*: 'It wasn't portable, it just stood there. It was on a long stalk and it had a head like a bug and you sat at the control panel and the camera rejointed itself like a snake and sort of angled around like a light for a drawing board. It was great looking.'[3] An audio tape supplied by the Warhol Museum documents his infatuation with the new technology.

In it, Andy Warhol and Ondine discuss the video camera. Warhol says that Norelco has given him the use of the camera for a month. Asked how much it cost, he answers, 'about fifteen thousand dollars.'[4] On side B of the same tape, Warhol is heard discussing the camera with a new friend, eighteen-year-old photographer Stephen Shore. The moment captured on tape has historic interest, since the then-unknown Shore would become one of the most influential American photographers of his generation.

Stephen Shore says, 'What kind of camera is this?'

'It's a videotape,' Warhol replies.

'Did they rent it to you . . . ?'

'No, no. They've just, um, it's not mine . . . but we'll see. But we'll see.'

With this bulky machine, Warhol would make his first masterpiece of video art, *Outer and Inner Space*, starring his troubled friend and muse, Edie Sedgwick. In exchange for the week's loan, Warhol agreed to appear on the cover of Ekstract's magazine and to be interviewed about the new machine.

Warhol was quick to realise the video recorder's potential for making art. He is heard on a tape recording saying, 'maybe they'll let us keep it,' and complaining about how expensive the tapes are.[5] Desperate to have the loan of the expensive equipment extended, he came to an arrangement with Ekstract. The publisher would persuade Philips to let Warhol keep the equipment for longer and would obtain for him more video cartridges and other electronic goods, either at cost or for nothing. In exchange, Warhol offered Ekstract a new series of self-portraits, printed from the original acetates he had used for the series he made the previous year, which the publisher could use as barter.

Ekstract bought the canvases and took them, with the small

acetates, to Norgus Silk Screen Company in Madison, New Jersey. In a letter to the Board dated 12 November 2002, Ekstract wrote, 'During the screening of the prints, Andy was on the phone giving specific instructions on paints, colors, order, etc.'

Jennifer Sordini, a former archives intern at the Warhol Museum, transcribed tape recordings made in the Factory that summer, now owned by the museum. She says, 'While there is no hard evidence of this transaction between Warhol and Ekstract, it is obvious from the tapes that Warhol wanted very badly to keep the video camera and was trying to come up with a way to keep it. Also evident in the tapes is Warhol's concern for money; throughout the tapes, he schemes to get discounts and to get people to work for him for free.'

Warhol kept the equipment for at least four months, long enough to shoot his first video of Edie Sedgwick, and (with Paul Morrissey, his business manager at the time) to film a party under the Waldorf Astoria Hotel, which Ekstract gave to celebrate the first issue of the new magazine. In 1965, we must remember, an original Andy Warhol painting was worth almost nothing. He often bartered pictures for services or goods, settling his dentist's bills, his restaurant tab at Max's Kansas City, or the cost of a recording session for the Velvet Underground with a piece of artwork. Morrissey was the manager of the Factory, which meant he looked after financial matters. He has said that he was not involved in those deals, because they were relatively small. This suggests that Morrissey saw the barter of pictures for equipment as significant in terms of the financial worth of the goods Warhol obtained, in return, through Ekstract.

At that point, there was no second series of the self-portraits to exchange for the equipment. Andy would have to make a new one. Preoccupied as he was with film and video that summer, he had neither the time nor the inclination to undertake

the arduous silk-screening process himself. Another drawback
to using the traditional silkscreen process was the expense. At
the time, a single screen cost fifty dollars. Warhol needed five
screens for the *Red Self-Portraits*, at a total of $250. At the time,
rent on the Factory was $100 per month. The series would cost
Warhol two and a half months' rent if he did the screen-printing
himself.[6]

Morrissey is clear that it was *his* idea that Warhol should turn
the acetates over to Ekstract and let the printer do the whole
job, thereby ensuring that the publisher, not Andy, would have
to pay for the expensive silkscreens, and saving Warhol time,
and the trouble of cleaning the mess.[7]

Prompted by Morrissey, Andy simply told Ekstract to send
the acetate to a commercial printer for silk-screening, and
Ekstract therefore bought the canvases and took them, with
the small acetates, to Norgus Silk Screen Company in Madison,
New Jersey, where the series was printed with Warhol's written
and telephoned instructions. Ekstract is adamant that, 'The . . .
self-portraits I had made were produced in complete accordance
with Andy Warhol's wishes and under his direction.'

In a handwritten letter to the Board written on 1 Novem-
ber 2002 (later typed) recounting the events of that summer,
Morrissey also testifies that Warhol spoke to the printer over
the telephone to give him specific, detailed instructions regard-
ing the colours he wanted the printer to use.[8] Both Warhol
and Morrissey communicated with the printer, but Morrissey
makes it clear that neither was present during the silk-screening
process.[9]

In almost every way, the commercially screened series differs
from the one Warhol screened by hand. The red background,
the blue eyes, silver hair and pink face were all screen-printed
as opposed to painted by hand. Instead of acrylic paint, the

background colours were probably screened using a product called plastisol. As the name implies, this plastic-based screen ink gives the picture a shiny, 'sealed' look. The colours of images printed over the plastisol background will not 'sink' into the primer layer or fabric in the way they do when the underpaint is acrylic. Paul Stephenson, the London-based artist who has made a study of Warhol's screen prints, believes this is an important reason why Simon's *Red Self-Portrait* looks so unlike other works of the sixties.

Another reason is the entire absence of halftones in the head, shoulders, and upper torso. Halftones are in fact tiny islands of hardened photo emulsion. The anonymous technician at Norgus must have underexposed the enlarged acetate. This means that the halftone dots were not under ultraviolet light long enough to 'harden', and therefore stick to the screen. They were literally washed away.

The printer can intensify the strength of the halftones by laying in more than one layer of ink. The more often the printer pulls the squeegee, the more ink is layered, so the stronger the contrasts of the halftone print. To compensate for this loss of contrast, the printer at Norgus may have 'hit' the halftones several times. But this only intensified the black. Look at the upper shoulder and torso in the *Red Self-Portrait*. Either an area is black, or else there is nothing – no gradations, no tonal transitions, no shading.

Another factor that affected the appearance of the picture surface in the 1965 series was the canvas weave of the screens. The linen screens used for the 1964 series probably had a mesh count of about seventy-seven threads per inch. By contrast, the canvas screens used for the second series had a mesh count of around half that – thirty-five threads per inch. The low thread

count also contributed to the loss of halftones in the 1965 series; they simply fell through the gaps in the weave.

Why did Ekstract not buy canvas with the higher mesh count, as Warhol usually used? The reason, as he explained to the Board in a letter of 2 November 2002, was that 'at that time, the recommended supplier had only cotton canvas in stock for the portraits – so we used that – the stretcher on the other hand was readily available from the supplier Andy recommended.'

This only raises another issue. Why would Warhol hand the small acetates to Ekstract and then give him only minimal guidance on the printing process used to make his work? It is a legitimate question, and I believe Stephenson has come up with the correct answer: at this point in his career, Warhol was fascinated by Marcel Duchamp and his work. Because of Duchamp, Andy became intrigued by the role of chance and accident in making art. Many printers who worked for him will tell you that he loved it when they made a mistake. When printers botched a job, Warhol would tell them to leave the work as it was – and he even asked them to do it again, though it isn't usually possible to make accidents happen on purpose. In short, he gave the acetates to Ekstract because he was curious to see what Ekstract would come up with. It was like taking his hands off the wheel to see where the car would end up.

There may, however, be an even simpler explanation. Whenever anyone asks why Warhol did something, the answer – what you might call his default setting – is that he wished to expend as little time, effort and money as possible. In the words of a printer who worked closely with Warhol, but wishes to remain anonymous, 'he was cheap and lazy'.

No one – least of all Simon – underplays the real and instantly observable distinctions between the two series. But these differences do not in themselves prove that the 1965 series

is not Warhol's. His working method was like photographer's: often, he allowed other people to do the technical work of priming the canvas, painting the background colours and screening the pictures – but it was he, and he alone, who controlled the acetates. In the same way that a photo by Diane Arbus is considered authentic even if printed by someone else on different paper stock and with different levels of contrast, so the crucial factors in determining the authenticity of a Warhol are, first, that it was printed from the original acetate, and, second, that it was printed with the approval (though not necessarily the supervision) of the artist.

The word 'approval' is essential. To what degree did Warhol acknowledge these unusual works as his own? Once again, the answer is found in events that took place during the summer and early autumn of 1965. After the series was printed, Ekstract returned the acetate to Warhol, who exhibited the finished paintings at the premiere of his new videos – including *Outer and Inner Space*. Ekstract takes up the story from here:

I agreed to sponsor the world premiere of these videos in an underground location. The party was held [on 29 September 1965] on an unused rail platform underneath the Waldorf Astoria Hotel in New York, adjacent to the tracks of the New York Central Railroad. Guests had to enter through a fire door on East 49th Street and descend two long staircases to reach the tracks, which then had to be crossed to reach the platform. The hotel ran an electric line down the platform so that Warhol's videos could be shown using the bulky equipment needed to project the sound and video. Food could not be served because there were rats around.[10]

The *New York Herald Tribune* sent a photographer to document what sounds like the opening night from hell, which included a staged 'happening' in which two costumed 'Elizabethan' swordsmen suddenly began duelling on the platforms. The photo feature appeared in the Sunday edition of the newspaper. Ekstract threw the party for the publicity it gave his magazine. Almost in passing, he mentions, 'The *Red Self-Portraits* were on display for all to see and a new chapter of art history was written in the bowels of Manhattan.'

Morrissey, on the other hand, considered the event at the Waldorf to be of little importance.[11] His focus was always on business. In his statement to the Board, he makes this clear: '[When] the party was over, I asked if the images [the *Red Self-Portraits*] were going to Leo Castelli. No, [Warhol] said that they would be useful to trade for things [presumably electronic equipment].' There might have been several reasons for this. Castelli was then paying Warhol a monthly stipend in exchange for receiving all of Andy's work. One way Warhol got around his obligation to the dealer was to barter his work for goods and services.

Except for a single self-portrait, which he kept for himself, Warhol gave the whole series to Ekstract to use as barter for future access to electronic equipment. Most of the original owners of the 1965 series of *Red Self-Portraits*, therefore, had connections with the world of consumer electronics or publishing. Not only do we know the exact circumstances under which the 1965 series of self-portraits was created, but also the names of most of the first owners.

The full list comprises Ekstract himself, Jay Schwab and Ennis Azzinaro (both employed by Philips-Norelco), Walter Goodman of Harmon Electric, and Bernard Nieman of *Audio Times*. Ekstract says that he also gave one portrait to the printer at Norgus, Norman Locker, for doing the silk-screening, and

another to Gus Hunkele, Locker's partner. Ekstract may also have gifted a *Red Self-Portrait* to his accountant. In a letter to the Warhol Board in 1995, painter Alan Fenton wrote that his friend, Richard Ekstract, 'had given Warhol a Betamax which he used in his early film-making activity. Warhol was so appreciative on receiving this Betamax that he gave both Richard and myself one of the self-portraits'.[12] That accounts for nine out of the eleven printed.

What is so extraordinary about these events is how fully documented they are, which is by no means always true of Warhol's work. The accounts from Morrissey and Ekstract differ in emphasis, since both men were remembering events that took place decades earlier, but neither contradicts the other, and each supplements the other's account. Scholars tend to place great weight on the testimony of eyewitnesses who, as here, testify without payment and without expectation of reward.[13]

Learning how the series was made and that some or all of the pictures were shown at the party beneath the Waldorf did not mean that Warhol approved them or claimed them as his own work. One reason why Morrissey's 2002 letter rang true for me is that it describes only what he saw at first hand. He has nothing to say about whether Warhol considered the pictures works of art. The stark fact remains that they look utterly different from everything he had done until that summer. Our knowledge of how they were made does not prove their authenticity. In his own mind, Warhol may have consigned them to the status of leftover party decorations, gifted to Ekstract precisely because he did not consider them worthy of exhibition at the Castelli Gallery.[14] That is what makes the testimony of the next eyewitness so decisive.

Samuel Adams Green inherited his blue blood and patrician manner from a distinguished family of Boston Brahmins. An

art dealer, curator and occasional actor in Warhol films, Green became director of the Institute of Contemporary Art in Philadelphia at the age of twenty-five. But he was not around over the summer of 1965. He first saw one of the *Red Self-Portraits* in October 1965, when he helped to hang Warhol's first retrospective at the ICA.[15]

Green met Simon a few times in the 1980s, but they had not become friends. When they met again in February 2002, Simon asked him to put his account of what happened at the ICA in writing for the Authentication Board. Green agreed, and wrote that Andy Warhol liked the flat, machine-made look of the new series. Green emphatically did not. He felt so strongly about it that he did not wish to include one in the exhibition, 'because it seemed too "manufactured" to go with the other paintings.' But Warhol was insistent that the new *Red Self-Portrait* should hang in the show: 'Andy was pushing for it . . . because he said it exemplified his new technique of having works produced without his personal touch: he wanted to get away from that.' So, the very qualities I found jarring in Simon's *Red Self-Portrait* were the ones that had most pleased Warhol, who was trying to eliminate all evidence of his hand in the making of it. At the time of the exhibition, it is understandable that Green could not grasp what Warhol was doing.

Fifty years later, it isn't difficult to understand at all. Hang a self-portrait from the 1964 series side by side with one from the series made in 1965, and it is the 1965 picture that looks strange. But hang portraits from both the 1964 and the 1965 series next to almost any Warhol portrait from the 1970s, and the one that looks out of place is the 1964 portrait. The 1965 picture now looks prescient, a harbinger of the work to come. As usual, Warhol was way ahead of everyone else.

Chapter 12

'I should have died. It would have been better', 1968

IN THE 1960s, visitors to the Factory were assaulted by chaos and cacophony from the moment they stepped out of the elevator. The voice of Maria Callas boomed out of one speaker, heavy metal from another, both at top volume. Artist Alan Fenton, a frequent visitor at that time, remembered that Andy Warhol had a telescope at the front windows trained on the weightlifters in the YMCA across the street. Street people, hippies, clean-cut college kids, art dealers and aspiring artists wandered in, hung out, drifted away. In the late 1960s, Manhattan was a dirty and dangerous place. Heroin addicts, in-your-face squeegee guys, beggars and the homeless crowded the streets. Every day, you read about another mugging, robbery or senseless murder.

The city's toxicity seeped into the Factory. Towards the end of the decade, a rougher and more aggressive crowd began to turn up, driving the arty types and party people away. Warhol's early supporter, the art dealer Ivan Karp, kept his distance, as did his first superstar, socialite Jane Holzer, who said, 'there were too many crazy people around. The whole thing freaked

me out . . . I couldn't take it. Edie [Sedgwick] had arrived, but she was very happy to put up with that sort of ambience.'[1]

One of the new hangers-on was Valerie Solanas, a failed writer who'd had a small role in one of Warhol's least watchable films, *I, a Man*. Mentally unstable and a loud-mouthed exhibitionist, she was not all that different from others in Warhol's entourage. Styling herself as a 'radical feminist', she had founded a one-woman movement called SCUM – the 'Society for Cutting Up Men'. For months, she'd been pestering Andy to read a terrible play she'd written, called *Up Your Ass* – but it was so filthy, it could never have been performed legally in the United States. By refusing to accept her calls, Andy became the target of her homicidal rage.

On the afternoon of 3 June 1968, a few months after Warhol moved the Factory to a new location at 33 Union Square, Solanas stepped out of the elevator, pulled a gun from her coat pocket and opened fire. Her first two shots missed Warhol, but one bullet grazed the back of a visiting art dealer, Mario Amaya, who barricaded himself in a back room.[2] Andy fell over, pretending to have been hit, then instinctively crawled under a desk to hide, or at least to shield himself. As he crouched there, helpless and terrified, Solanas knelt, pushed the muzzle of the gun into his torso, just below the ribs, and fired at point-blank range. The bullet ripped through his stomach, liver, spleen, oesophagus and both lungs.[3] Solanas then turned on Fred Hughes, who was sitting frozen with fear at his desk, near the elevator. Screaming that she was going to shoot him, Solanas held the pistol to his head. He begged for his life; she hesitated for a few seconds and, in that moment, heard the clang of the elevator stopping at the second floor. Seeing her chance, she forgot about Hughes and made her escape. Morrissey, who had witnessed the mayhem, called an ambulance and the police.

On arrival at the hospital, Warhol was pronounced dead. But, over the next four hours, the doctors worked to restart his heart and stitch him together. They saved his life. Two months later, he was able to come home from hospital, but for the rest of his life he wore a surgical corset to support his sagging abdomen. Years later, when the film-maker Emile de Antonio asked him about the shooting, Andy said, 'I wish I had died . . . I wouldn't have had to live through it all. I should have died. It would have been better.'[4]

A paranoid schizophrenic, Solanas belonged in a hospital for the criminally insane. Instead, she was judged to be rational enough to stand trial for attempted murder; she was found guilty and sentenced to three years in jail. On her release, she stalked Warhol by telephone, making outlandish demands for money and for an appearance on a TV talk show. That got her rearrested, but, once again, she was not detained for long. From the day of the shooting until the day of his death, Warhol lived in constant fear, always aware that she might be out there, and armed.

While he was in the hospital, two of his closest associates, both witnesses to the events of 3 June, kept the studio running. Paul Morrissey oversaw business matters relating to the Factory. He would soon make successful commercial films like Trash, Flesh and Dracula – all released under Warhol's name. Practical, politically conservative and teetotal, Morrissey changed the locks at the Factory, installed security cameras and drove the crazies away. He also kept methodical accounts and placed the sales records under lock and key. Thanks to him, some semblance of order was now imposed on Warhol's archive.

The events of that afternoon changed Warhol's personality, and the direction in which his work subsequently moved. June 1968 became the demarcation date between the first and second

halves of his career. The damage Solanas did to his body and mind inevitably impacted on the quality of his art. For all the occasional brilliance of individual paintings or projects in the 1970s and 1980s, he never fully recovered the energy, wit or originality of the work he produced in the years between 1962 and 1968.

In the aftermath of traumatic events, survivors often experience emotional numbness, mentally distancing themselves from reality and becoming hyper-aware of potential dangers. In the months following the shooting, Warhol exhibited all these symptoms. He needed to get back to making art, but had lost the will to do so. This was when Hughes became indispensable. Suave, smart and well-connected, the handsome young Texan had a quick wit and a good head for business. After meeting Andy in 1967, he dedicated himself, body and soul, to the artist's career. A former art dealer with a sure sense of what would sell, he was largely responsible for the meteoric rise in Warhol's prices and reputation. At this crucial juncture, he knew exactly what he needed to do to get the artist back to work.

Hughes's idea was as simple as it was inspired. He turned Warhol's attention to the one area of his practice that required neither innovation nor imagination: portraiture. Andy had always made portraits and had always accepted commissions. But, before he was shot, commissioned portraiture as a genre had played only a small part in his creative project. With the cool competence that characterised everything he did, Hughes hustled rich friends, like the Houston-based art patrons John and Dominique de Menil and Governor Nelson Rockefeller, into commissioning works, thereby initiating one of the most lucrative – and, to some critics, problematic – parts of Warhol's studio practice. In the 1970s, he received thousands of portrait commissions, not only from movie stars and socialites, but from

wealthy American and European businessmen and their wives. The visual interest of these purely commercial paintings varied greatly, depending on whether he felt some connection with the sitter. But, whatever their overall quality, these commissioned portraits paid for the conspicuous extravagance that character- ised Warhol's later way of living.

Chapter 13

Andy Warhol Enterprises Inc.

IN 1973, the Factory moved for a third time, to the second floor of 860 Broadway, on Union Square. Hughes had helped to open a new chapter in Warhol's career, one reflected in the appearance of the last Factory and the activities that took place there. By now, its transformation from artist's studio into large-scale art-making business was complete. The walls were now white, not silver. Modern desks and glass-topped coffee tables replaced the filthy sofas and broken chairs of 47th Street. The space now looked like what it was: the corporate headquarters of Andy Warhol Enterprises, Inc.

The first thing a visitor saw on stepping out of the lift was an ugly artwork by Keith Sonnier consisting of two black speakers sticking out of the wall, with a cable connecting them. Warhol joked that he hoped visitors would think it was a security device. Behind the reception desk sat a relic from the original Factory, Brigid Berlin, erstwhile speed freak and shrill superstar. Now, she spent her days greeting visitors, signing for packages, transcribing the audio tapes Warhol was turning out non-stop, and knitting. To the right of the elevator were the offices of Bob

Colacello, editor of *Interview*, the combination gossip and fan magazine Warhol had started in 1969. In a screened-off space on the left, Hughes had his desk. Straight ahead, beyond a large, light-filled room with high windows overlooking Union Square, was the office of Vincent Fremont.

In that last Factory, Warhol's painting studio was next door to the freight elevator, looking out onto 18th Street. It was so small that Warhol tended to work at weekends, when the Factory was empty. He would spread a roll of blank canvas over the wooden floor of the large reception area, the only space in the Factory where he had the room to paint freely. Warhol and his Factory assistants would pre-paint raw canvases with a mop, to give them what Warhol called a '3D' texture, before sending them to the off-site printers to be screened.

By the mid 1970s, Warhol no longer treated the Factory as a traditional artist's workshop. By then, he was delegating the mechanical task of silk-screening prints and paintings to more and more off-site printers. In a documentary film called *Painters Painting*, made between 1969 and 1972 by the director Emile de Antonio, Warhol was interviewed in tandem with his friend and assistant Brigid Berlin. Warhol tells the interviewer, 'Brigid does all my paintings, but she doesn't know anything about them . . . Brigid has been doing my paintings for the last three years.' When the interviewer asks how, it is Brigid who answers. Referring specifically to the series of *Flower* paintings Warhol began in 1964, she says, 'I just call Mr Goldin [an off-site screen-maker and printer] and I just tell him the colours . . . I take Polaroids of the four flowers and I switch the colours around and superimpose four cut-out ones on top of it, take a picture, and just have Mr Goldin do it.'[1] To some of these paintings, Warhol later added hand painting, but not all. Eventually, he simply sent the prepared acetates to the printer so that the entire job was

done off site. With his eye always on the market, Fred Hughes began to complain that European clients were becoming upset because Andy was telling everyone that he did not paint his own work any more. Andy responded by finger-painting the backgrounds of some portraits of the early seventies, such as the *Mao* series, and the portraits of Julia Warhola.

In the seventies and eighties, Warhol worked on a monumental scale, and on commission. This later period kicked off with his *Mao* series (1972), followed by *Shadows* (1978–9) and *Gems* (1978). It ended with the *Last Supper* and the *Camouflage* paintings (both 1986). American critics mostly ignored these late series. At the time, they felt tacked on to a career that would always be judged by the *Campbell's Soup Cans*, the *Brillo Boxes*, the *Liz*, *Marilyn* and *Elvis* portraits, *Electric Chairs* and *Car Crashes*. That is inevitable, since the early work is *about* America. During the last decades of his life, the universality of Warhol's subject matter made it far more popular and more widely exhibited in Europe than it was in the US.

The period saw other changes at the Factory. The old guard of devoted friends and colleagues surrounding Andy Warhol fell away. Paul Morrissey parted company with Warhol in 1975. In 1982, Warhol's chief assistant, Ronnie Cutrone, left the Factory to do his own work, and Bob Colacello stepped down after twelve years as editor of *Interview*. New cronies fawned on Warhol, Eurotrash accumulated. Out-of-state visitors passed through the Factory in the same spirit that tourists see the Eiffel Tower on a package tour of Europe. Except for the portraits, the work of the seventies and eighties did not sell for anywhere near the prices his early work was beginning to achieve.

The studio assistants who witnessed Warhol at work daily in the 1960s – Gerard Malanga, Billy Name and Paul Morrissey – all say the same thing: that, just as you might expect from a

mind as restless, inventive and original as Warhol's, the degree of his intervention in the creation of a painting varied – not only from series to series, but also from painting to painting within the same series. In the words of the authors of the catalogue raisonné published by the Warhol Foundation, around the years 1964–5, when he began working in film and video, 'Warhol's approach to composition was becoming increasingly improvisatory and aleatory, open to invention and change. This is manifested in the major series of these years – the *Flower* paintings, the *Box* sculptures, and the *Jackies*.'

To this list, I would add the 1965 series of *Red Self-Portraits*. The sole reason it is crucial to include them in any summation of Warhol's achievement is the experimental technique Warhol used to create them. That hands-off technique led directly to the working method that became habitual from the 1970s. When Rupert Jasen Smith became Warhol's primary silkscreen printer in 1977, when Warhol no longer had any sustained involvement in the production of his paintings, apart from making alterations to the acetate and signing them when they were sold. Commercial success became another factor in the mass production of paintings and prints. In his book *Holy Terror*, Bob Colacello quotes Rupert Jasen Smith: 'He had so much work that even Agusto [the security man] was doing the painting. We were so busy. Andy and I did everything over the phone. We called it "Art by Telephone".'[2]

One person they were calling was Horst Weber von Beeren, a German printer who worked with Rupert Smith. In 2006, von Beeren told the *New York Post* that he had produced thousands of works over a period of eight years – including images of Liza Minnelli, Michael Jackson and Madonna – and had then sold them. In von Beeren's words, quoted in the *New York Post* in 2006, 'We had so much work, we used to farm it out

to neighbouring shops, and none of their employees had any contact with Warhol whatsoever.'³ When a portrait of Dolly Parton that von Beeren claimed was his own work failed to sell at Sotheby's for $1.5 million in November 2006, a representative of the auction house defended its authenticity: 'The work is stamped on the overlap by the Andy Warhol Authentication Board and in fact was once owned by the Warhol Foundation.'⁴ Art dealers, collectors, curators and academics all accept that a painting can be an original Andy Warhol even if he never touched it. This is possible only because silk-screening is essentially a mechanical process. What did it matter whether it was Warhol or his assistant who pressed the silkscreen ink or paint through the mesh?

In the last ten years of his life, Warhol would simply give the acetate to off-site printers with instructions as to the colours to be used and how he wanted the image printed. Sometimes, he spoke to printers like Rupert Jasen Smith over the telephone, but his directions were often vague. 'He wanted the prints to be more-something or less-something,' remembered Bob Colacello, 'but he couldn't say what that "something" was.'

Working in this way, the team of Smith, and his studio assistant von Beeren, were responsible for creating tens of thousands of prints and more than 3,000 paintings – all considered to be authentic Warhols. But that is not all. When Smith had too much work or a looming deadline, he sometimes subcontracted jobs to other off-site printers, such as Norman Lassiter at Editions Lassiter-Meisel.

In a notarised affidavit written to the Authentication Board in support of the 1965 series of *Red Self-Portraits*, Lassiter explained that, when he was subcontracted in this way, Rupert Smith or one of his assistants continued to make all creative decisions regarding colours and images, and 'would visit our studio to

check the work when we finished'. He emphasised that 'at no time did the staff at Editions Lassiter-Meisel ever have any contact with Andy Warhol', and said, 'All reimbursement for our work was received from Rupert Jasen Smith Inc. and not from Andy Warhol or any employees of his factory'. Not only that, but payment 'was monetary – never proofs or art.'

When Smith's factory and others like it invoiced Warhol Enterprises for their work, they were paid for each authorised piece they created. But Warhol never visited their studios. These printers worked without supervision. Warhol therefore had no way of knowing whether they were knocking off unauthorised paintings in addition to the ones for which they had been paid, or how many. It is hard to label these pirated works fakes, since they are exactly the same as the 'real' works Warhol had ordered, but made without his authorisation.

What is more, it was generally known among dealers and collectors that Smith continued to generate 'Warhols' after the artist's death. He traded them with other artists for their work and sold them to collectors; many have ended up in museums or large private collections. Smith's large-scale manufacture of Warhol's work ended only when the printer died in 1989.

Art-world insiders were aware of what was happening, whereas the public and the punters assumed that Warhol himself silk-screened the paintings and prints at the Factory. As Joe Simon recalls:

> . . . a client would be waiting in the reception room, so when a painting was late, usually while Vincent [Fremont] made sure the check had cleared, Rupert [Smith] would assign someone to create the painting, usually Norman Lassiter or another outside printing firm, using [hair] dryers to dry the paint faster. Rupert or one of his assistants usually screened a few extras

85

for themselves. An assistant of Rupert's would roll it up and carry it under his arm on the subway to 14th Street, take the elevator up to the second floor, go left into the offices of *Interview* magazine, and hand it over to Andy. Andy would walk in [to greet] the client in the reception room, either hold it out unfolded or roll it out in front for the client. It was all about presentation. Real showbiz! At other times, the off-site factory would ship the work directly to the gallery before Warhol saw it. Once, seeing a new painting at an opening, he exclaimed, "Oh wow, they printed it in glossy!"[4]

Warhol cared little about how his art was made because that was the way he had worked long before he became a successful artist. Those who worked with him when he first came to New York as a commercial illustrator recall that, even then, he employed an 'arm's length' working method. In his days as a successful fashion illustrator, his job was simply to make the drawing and hand it over to the art director. He never became involved in the layout. Tina Fredericks, the art director at *Glamour* who gave Warhol his first New York job, said, 'he didn't care about that stuff – "Will my drawing be displayed big enough? Are you going to shrink it down?" You could say to him, "We want this," and he'd just do it, he'd understand.'[5]

In his early fashion drawings, Warhol developed a technique of blotting his initial design onto high-quality paper in such a way that his pen nib never touched the final drawing. As Scherman and Dalton explain:

. . . the original mattered so little to Warhol that he didn't even draw it – his long-time assistant Nathan Gluck made the first sketch, rubbed it down to make a tracing, and hinged the tracing to the Strathmore [a brand of high-quality drawing paper].

Andy entered only for the *coup de grace*, the inking and blot-
ting ... What remained constant throughout Warhol's career,
whether he drew, painted, or silk-screened photographs, was
his fascination with the simulacrum, the copy, the second-
generation image. In commercial art, the division of labour is
the norm. When Andy began using it in fine art in the sixties,
he undermined the myth of the auteur, the sole, and solitary,
fount of art.[6]

In this approach to making art, Warhol inherited the legacy of
Duchamp, an artist he knew, admired, painted and filmed. Like
Duchamp's readymades, the essence of a work by Warhol is not
by whom or even how each object is created, but the artist's
decision to show it in an art gallery and the ideas generated by
that decision. In 1964, almost fifty years after he first exhibited
his readymade urinal under the title *Fountain*, Duchamp author-
ised Italian dealer Arturo Schwarz to create an edition of twelve
replicas, comprised of eight signed pieces and four proofs. In
fact, the 1964 sculptures are not actual urinals, but ceramic
sculptures copied from photos Alfred Stieglitz took of the 1917
original. Yet they are accepted as genuine Duchamp ready-
mades. One sold in 1999 for $1.8 million.[7] Years later, five more
urinals appeared on the market, one of which Warhol bought
from the Ronald Feldman Gallery.[8] So obsessed was he with
the French artist's life and work that, in 1965, he and Morrissey
followed Duchamp around New York with a camera, recording
his every move and utterance.

All this helps us to understand Warhol's detachment from the
execution of his later work. That detachment, in turn, had pro-
found consequences for how his work looked. This is easier to
appreciate if you look again at the mechanical process of creat-
ing a silkscreen and how Warhol mastered it. Although a single

negative is used to make the silkscreen from which the image is printed, separate screens are used for each colour and each additional colour. In some paintings, the colours are painted by hand; in others, they are wholly silk-screened.

If you hung half a dozen of the early silkscreens along a wall in the order in which Warhol made them, you would be able to see the artist's confidence in his use of colour increase from series to series. Starting with the black-and-white newspaper photo he used for *Race Riot in Alabama* (1964), he then introduced a limited range of red, black, white and yellow in the *Campbell's Soup Cans* (1969), and in time grew bolder with the delicate palette of lilac, rose, light green and mauve that he used in the series *Flowers* (1964–70).

But, in later work printed off site, the colours were often mixed by professionals. Warhol always refused Rupert Smith's invitations to supervise the work in progress at the printer's studio in Tribeca. Unlike Warhol, Smith wasn't bored by the screen-printing process. His long experience gave him confidence to experiment with much more complex colourways and contrasts than Warhol ever attempted on his own. Indeed, colour is used in Warhol's later prints with a sophistication unmatched in American art, and Smith should be recognised as Warhol's collaborator. After printing the image in several different colour combinations, Smith showed the results to Warhol, who then chose the combinations he preferred. In the still-life print series *Space Fruit*, for example, the saturated red, velvety purple, lush orange and sensational washes of lilac create a far more sensuous and infinitely more complex visual experience than anything Warhol ever achieved on his own.

As Fremont told *Vanity Fair*: 'Andy would have 15 versions, say, made of one image, to see which colors he wanted to use. The 14 he didn't choose aren't any less good; so Ronald Feldman

[an important art dealer] made portfolios of those'.[9] Fremont does not add the words 'to sell', but that is what he meant. Rightly, the authenticity of these prints is not in question. But, according to Donald Sheridan, a former employee of Smith's, other publishers would ask Smith to run off illicit extra copies. After Andy's death, those publishers approached Fremont with the 'extra' prints for authentication. Fremont acquiesced, but, for every group of prints he authenticated, the Warhol estate received a print in return.[10] Warhol's hands-off way of making and thinking about art might be called the opposite of what happened in the studios of his twentieth-century predecessors, such as Picasso. Neil Printz, the longest-serving Authentication Board member, told one journalist, 'I wanted to catalogue Warhol like they catalogued Picasso.'[11] Yet to treat Warhol's work in this way turns him into an artist he was not.

Printz was not alone. Some of Warhol's dealers desperately wanted him to work more like a traditional artist. According to Bob Colacello, the art dealers Castelli, Bruno Bischofberger and Ammann all begged him to cut back on the number of works he was making. Their fear was that the market would be flooded with so many Warhols that they would be forced to lower the price they asked for them. That was simple economics – the price of a work of art had always been linked to rarity, which in turn depended on a finite number of works available. They lobbied Fred Hughes to persuade him to stop treating paintings as though they were prints – when, of course, the whole point of Warhol's project was to demonstrate that they were exactly like prints, except that one was printed on paper and the other on linen or canvas. 'They would chant in chorus,' Colacello reports, ' "Tell Andy there's a limit to what the market will bear. Enough is enough, enough is enough." '[12]

John Paul Russell worked with Rupert Smith in their Tribeca

studio to print Warhol's later work. The creative process War-
hol used, he says, was:

> . . . very similar to the way that Warhol's printer Rupert
> Smith and I printed the last series of self-portraits that Andy
> Warhol ever made . . . Most were (pre-)printed on solid color
> backgrounds, which were painted by his assistants with no
> artistic brushwork before they came to Rupert's, others on
> a pre-printed [solid colour] canvas from New York Central
> Art Supply.
>
> *There really is no difference whatsoever in the way that the*
> *paintings were made by Richard Ekstract from Andy Warhol's*
> *transparencies in 1965 or the last series of self- portraits that Rupert*
> *Smith and I made.*
>
> Andy Warhol worked this way, with either Rupert Smith,
> myself, Richard Ekstract or many other people that I know
> of such as Alex Heinrici [Austrian master printer]. I don't see
> any difference at all. Warhol gave directions but always left an
> opening for input from others. He was very open to experi-
> mentation.'[13] [Italics and paragraphing are mine.]

Gerard Malanga, who was particularly close to Warhol at this
time, said:

> In 1965 Warhol stepped up his film-making and as Andy
> advanced with his work he came more and more to rely on
> a less hands-on approach. At least he made an attempt. He
> gradually moved away from the physicality of painting . . . to
> erase all vestiges of the human touch. In doing this Warhol
> deliberately detached himself from the art-making process by
> removing all traces of his hand.[14]

Chapter 14

The Red Self-Portrait *Comes Up for Authentication*

As the time grew near when Simon's *Red Self-Portrait* was to come before the Andy Warhol Art Authentication Board for the second time, his chief worry was that Rosenblum and Whitney would not be shown the results of new research he had sent to the Board, but would rely instead on what he now felt was the flawed investigation conducted by Printz and King-Nero. He thought the two researchers' academic qualifications were negligible and their work slipshod, a view which Warhol's close friend, the art historian John Richardson, loudly seconded. Even if the documents Simon sent them proved that they had been in error when they denied the *Red Self-Portrait*, would the pair show them to the other Board members? Or would they protect themselves by claiming they had never received the new evidence? Once again, Simon asked me to write a letter of support.

On 7 May 2003, I wrote to explain that, although I would not pretend to be an expert, nor presume to comment on the authenticity of the picture in question, given the nature of Warhol's work, it would be a mistake to say that *only* a portrait painted by Warhol's own hand and in his own studio would

qualify as authentic. My naivety at this early stage in my involvement with the Board now strikes me as almost comical. I no more knew who I was dealing with than had Richardson. I did not expect a reply and I did not get one.

In January 2006, the picture was returned to Simon, for the second time, stamped DENIED. Nick Rhodes, who happened to be in New York, collected it and brought it back to London on a BA flight, as hand luggage. There was now no realistic possibility that the Board would either change its mind or tell Simon why his picture was wrong. But Simon did not give up. Michael Shnayerson's *Vanity Fair* article had done real damage to the Board's reputation. Its publication showed Simon how publicity could be weaponised. With his usual chutzpah, Simon somehow persuaded the creative director at BBC Television to make a programme about the Andy Warhol Art Authentication Board. Alan Yentob was the producer and presenter of the BBC's prestigious *Imagine* series. His show, *Andy Warhol: Denied*, aired on 24 January 2006. It was not specifically about the *Red Self-Portraits*, but took a broader look at the Board's many controversial decisions, and was enlivened by interviews with owners who railed at the Board's methods and conclusions.

I participated in the programme as a talking head, but the stand-out contributor was the American dealer Ivan Karp, one of the grand old men on the American art scene, who had mentored Warhol at the start of his career. Karp, owner of the OK Harris Gallery, spoke of his outrage that the Board had deemed works he had bought, which Andy Warhol had signed, to be fakes. A spokesperson for the Andy Warhol Foundation also appeared on the programme. Ronald Spencer was the chairman of New York law firm Carter Ledyard, and a specialist in art law, as well as the in-house lawyer for the Andy Warhol Authentication Board. From the moment he appeared on camera, Spencer

sneered at those who challenged the Foundation's methods or decisions. He curled his lip at Yentob's suggestion that the Board could be in error. When Karp said that a work he owned was authentic because it was signed in Warhol's own handwriting, Spencer brushed aside the idea that an artist's signature could have the slightest significance. What if Warhol had signed a baseball or a *real* Campbell's soup can? Did that make them works of art? Spencer's scornful dismissal of reasonable questions could not have created a worse impression. To British viewers, he came across as a bully.

The programme made no difference. Nothing did. The Board was never going to change its mind. All of Simon's efforts were getting him nowhere. I was now certain that no resolution of any kind would be found. Still, Simon persisted.

In 2007, Simon started myandywarhol.eu, a website dedicated to publishing research he believed proved the authenticity of the *Red Self-Portrait*. I was unaware of its existence for some time, but, when I finally saw it, I thought it was well done – serious and respectful, entertaining and well designed. True, it only gave one side of the argument – Joe Simon's side – but, thanks to the Board's silence, there was no other side he was able to give.

And yet, despite the compelling testimony of Paul Morrissey and Samuel Adams Green, my reservations about Simon's *Red Self-Portrait* had not been put to rest. It still troubled me that the surface of the picture looked nothing like anything else Warhol was doing, at a time when he was still personally supervising most of his own work. And Simon had produced no real proof. All he had was the testimony of Warhol's friends and associates that Warhol accepted the work as his own. That was not enough. Who was to say that those associates had not misinterpreted the artist's intentions or misremembered what happened? Whichever view of the issue you took, the second

series was an anomaly – but was it an anomaly for which Warhol took responsibility? If that were the case, its art historical importance would be hard to overstate. Otherwise, it was a fluke that meant nothing. The second explanation seemed to me marginally more likely.

My doubts about Simon's *Red Self-Portrait* would not go away. Sam Green testified that Warhol insisted on including one painting from the series in his retrospective at the ICA. That certainly suggested that Warhol acknowledged the work as genuine, but it was not conclusive proof. It was still possible that Warhol simply wanted to see how a picture that he had made using the new 'hands-off' method measured up when hung alongside the hand-painted pictures in the rest of the exhibition. In the absence of any further information, how could anyone be sure that, after the close of the Philadelphia exhibition, he continued to value them as significant works of art? Might there be some evidence we had not yet seen – a letter, a comment in a diary – in which he dissociated himself from the series?

For, despite his increasing reliance on assistants and off-site printers, Warhol had by no means abandoned hand painting. A few years later, for purely commercial reasons, Andy's two main European dealers, Bruno Bischofberger and Thomas Ammann, both pressed him to return to painting by hand. They were concerned that the number of paintings his studio was turning out would depress the prices that dealers could ask for them.[1] To encourage Warhol in this direction, Bischofberger commissioned the *Mao* series (1972), in which the hand-painted brushwork and finger painting is conspicuous. A decade later, Bischofberger commissioned Andy and Jean-Michel Basquiat to work together on the joyful *Collaboration Paintings*, which are among the best-loved and most critically acclaimed of Warhol's late works.[2] Largely because of Basquiat's high-spirited

participation, the handling of paint has a spontaneity unusual in any work made by Warhol on his own in the years leading up to his death.

Warhol went back and forth between techniques, so generalisations need to be made with care. Towards the end of his life, he made hundreds of paintings on the theme of the Last Supper and over a hundred self-portraits, many screened by Rupert Smith. Only a few of the Last Supper artworks are painted by hand. Warhol and his assistants would tack a blank canvas on the wall, project the image onto the canvas, trace it and then paint inside the outlines. For someone who comes to these paintings for the first time, it would be very hard to determine the degree of Warhol's participation in them. Back in 1965, the opposite was true. Then, hand painting was more the norm than the exception.

There were so many factors and possibilities at play at this stage of Simon's struggle with the Authentication Board that I would never have argued in print for the authenticity of the 1965 series of Red Self-Portraits. To make things even more complicated, on one occasion Warhol told his diary that he had signed a fake – when the work he signed was authentic. In the entry for 8 May 1984, he says that he had come across a print of Four Jackies at Christie's and was surprised to see he'd signed them for the owner, Peter Gidal, adding, 'I don't know why I ever did', because he only made single Jackies.³ But the Four Jackies is now accepted as genuine and is listed as such in the Foundation's catalogue raisonné of prints, co-edited by Claudia Defendi.

Back and forth I went, weighing the evidence in my mind, unable to settle the issue of the Red Self-Portrait's authenticity. Unless I could see some indication of Warhol's direct contact with a picture, it would be impossible to determine the degree to which he participated in its creation.

Chapter 15

Bruno B.

AND THEN, OVERNIGHT, my entire understanding of the work was transformed. On 13 October 2008, Simon received an email from the London art dealer and collector Anthony d'Offay, asking him to get in touch. He had something to tell Simon.

Until his retirement in 2000, d'Offay was the pre-eminent British dealer in international contemporary art of his generation. In the 1990s, he had staged early exhibitions in Britain of Anselm Kiefer, Jeff Koons, Joseph Beuys, Agnes Martin, Gerhard Richter, Vija Celmins and the Chapman brothers, among many others. The reason those shows were so important is that, until the opening of Tate Modern in 2000, there was no museum or gallery of contemporary art in London. State-funded institutions like the Tate Gallery on Millbank did not have the money to buy most of the artists in the d'Offay stable, and among British collectors only Charles Saatchi was acquiring new art in any quantity.

The 'something' d'Offay wanted to tell Simon was that he owned another canvas from the 1965 series of *Red Self-Portraits*. His picture was identical to Simon's in every respect, except for

one: it was signed and dated by Andy Warhol. What is more, it was dedicated in Warhol's own handwriting to Bruno Bischofberger: *To Bruno B Andy Warhol 1969.*[1]

Bischofberger was one of Warhol's earliest and most important dealers. In 1965, he became the first European gallerist to show Warhol's work and, three years later, he signed a 'first right of refusal' contract that lasted until the artist's death. In addition to this, artist and dealer were unusually close. He was a financial backer of *Interview*, co-financed Warhol's 1970 film *L'Amour*, starring Karl Lagerfeld, and was responsible for the collaborations between Warhol and both Jean-Michel Basquiat and Francesco Clemente. For all these reasons, it was impossible that the d'Offay canvas could be a fake. Even if, as the Authentication Board maintained, a signature alone was not a guarantee of authenticity, then a handwritten dedication and date made authenticity very likely.

And, to cap it all, there was inarguable proof that the Bischofberger *Red Self-Portrait* was Warhol's: it was published in the first catalogue raisonné of Andy's work, compiled by the Rainer Crone in 1970. There, it is reproduced and fully catalogued, with a note referring the reader to the colour reproduction of the same picture on the book's dust jacket.

This was the clincher. In January 1970, as a young graduate student from Germany, Crone's recently completed Warhol catalogue raisonné was about to go to press. A punctilious scholar, he was careful to consult Warhol, not just about the accuracy of the catalogue, but about the appearance of the book. He stopped by the Factory one day because, he said, 'I wanted to discuss with him the cover image. That was not solved. That was not really discussed yet, what we put on the cover.' He told Warhol that the publisher's preference was for a self-portrait.

Crone takes up the story from here, in his slightly broken English:

> Warhol said, 'Well, yeah, okay,' and then he walked away somewhere in the back and came back with two 20 x 16 paintings . . . One was the 'Bruno B.' self-portrait and the other a self-portrait from the 1964 series. [Warhol] said to me, 'Which one of these two . . . would you prefer?' . . . and I said, 'Andy, if . . . I see correctly, the one is produced more with [a] silkscreen technique and the other is produced more with hand paint or [a] hand-painted surface' . . . and so I said to him . . . that I always like your hand paintings, [but] I mumbled that because I didn't want to determine which painting [should be used on the dust jacket], this was much too important for me [to decide], and so he said, 'Yeah, well, I like this silk-screen version better . . .'

Warhol then showed Crone the back of the picture, with the inscription to Bruno B. He asked Crone whether he would mind that the back of the canvas had been inscribed. Crone said he did not mind. 'Why would I mind that? Whatever you think, Andy, you know, this is fine, it's good, let's take that.'[2]

In 1975, Bruno Bischofberger sold the *Red Self-Portrait* to Los Angeles gallerist Margo Leavin.[3] She then sold it to curator and dealer Heiner Bastian, who in turn placed it in the prestigious Erich Marx collection in Germany. Warhol had plenty of opportunities to speak out if he thought the picture was not his. When the Marx collection was displayed at the inaugural exhibition of Berlin's Hamburger Bahnhof Museum, in 1996, the picture was reproduced in the catalogue and sold as a postcard in the museum shop.[4]

Crone worked closely with Warhol over a two-year period

to compile the catalogue raisonné, which was revised and republished twice during Warhol's lifetime. If the artist had any reservations or doubts about its authenticity, he could have asked Crone to omit it from the second and third editions of the book. In both expanded editions the 'Bruno B.' self-portrait was again used on the dust jacket. In fact, Crone and Warhol worked together up until shortly before the artist's death, in 1987. A few weeks before Andy went into hospital, they met to discuss Crone's latest book, *Andy Warhol: A Picture Show by the Artist – the Early Work 1942–1962*, which was published on 15 December 1987.

Bischofberger, Leavin and Bastian all believed the picture to be genuine, as did d'Offay, who, in a written statement presented to the Andy Warhol Art Authentication Board, said:

When Andy Warhol came to London for his show [of the *Fright Wig* self-portraits, which were commissioned by d'Offay] in 1986, he signed in my presence our copy of Crone's book in two places: one signature was across the dust wrapper [dust jacket] which reproduces our 'Bruno B.' self-portrait eight times. The other was on the book's half-title.

. . . Andy's signature across the Bruno B. image on the dust jacket is further unequivocal evidence that Warhol not only was authenticating the work but remained extremely proud of it.

On page 294, the catalogue entry (no. 169) for the 'Bruno B.' self-portrait makes it clear that the picture also appears on the front cover of the book and that it was owned at the time by Bruno Bischofberger. It is unthinkable that Warhol would have signed the book and the image if there was the smallest doubt in his mind that the work was not authentic. The combination of the dedication on the back of the painting with

the choice of that image for the cover of the catalogue rai-
sonné, together with his further endorsement of the image
by signing across it, leave no room whatsoever for any doubt
as to the authenticity of the work and the artist's intention.

Anthony d'Offay asked to see Simon because he too had a beef
with the Authentication Board. When his clients, California-
based philanthropists Charles and Helen Schwab, submitted
the 'Bruno B.' portrait for authentication in 2003, it was denied.
On 21 May, Neil Printz wrote one of the strangest sentences
ever used in connection with a work of art: 'It is the opinion of
the Authentication Board that the said work is NOT the work
of Andy Warhol, but the said work was signed, dedicated, and
dated by him.'[5] Fremont repeatedly told collectors that, before
he could authenticate a picture, he needed proof that Warhol
had been aware of it, and that, by 'proof', he meant a signature,
over-painting, or an exhibition held during the artist's lifetime.
To deny that the 1965 series was Warhol's was absurd, but there
was more to come.

In 2004, when the Warhol Foundation published the first
volume of its catalogue raisonné with the Ammann Gallery,
the authors – Frei, Printz and King-Nero – silently omitted all
mention of the Bischofberger self-portrait, even in a footnote
or an appendix. This may well be the first time in history that
a picture with so much proof of its authenticity has been
removed from an artist's oeuvre by those he did not appoint or
know personally. Although Rainer Crone had worked closely
with Warhol and possessed an important archive of the work
they did together, at no time was he consulted by the compilers
of the 2004 catalogue. In a statement of 14 August 2009, Crone
writes, 'I am aware of no other instance in which a revised

catalogue raisonné omits a hitherto accepted work without explanation.'

When an owner of one of the *Red Self-Portraits* challenged the Board to explain why it continued to deny the authenticity of the works in this series, Neil Printz replied in a letter dated October 2004 that the Board knew 'of no independent verifiable documentation from the period in question, 1964 through to 1965, to suggest that Warhol sanctioned or authorised anyone to make the work.'

<center>*</center>

One day, in 2008, Simon telephoned me to tell me that he'd seen the 'Bruno B.' portrait. The new information rekindled my interest in Simon's search for answers. Having been a detached observer trying to figure out what was wrong with the picture, I was beginning to wonder not about the Board's competence, but about its integrity. Why had the only member of the Board I respected, Robert Rosenblum, not spoken out? Had he really been told all the facts about the picture? I would discover the answer to both questions – but not until several years later. At the time, his silence mystified me.

Once I knew about d'Offay's painting, I could no longer put the behaviour of Printz and King-Nero down to inexperience. The existence of the canvas suggested instead a deliberate policy to reshape Warhol's achievement, to rewrite art history by denying the authenticity of a pivotal work, for which they had the strongest evidence of Warhol's authorship. As far as I could see, they did this for no other reason than because the date of its creation did not accord with their predetermined belief that Warhol did not start making 'hands-off' works until the 1970s. I needed to know exactly when Printz and King-Nero first

learned about 'Bruno B.' Back then, I did not know where to look, but in time I would find out.

Because I was so focused in these years on the question of whether Simon's picture was genuine, I was completely taken aback when Simon revealed, in passing, that, in July 2007, his lawyers had filed a complaint against the Andy Warhol Foundation, the Andy Warhol Art Authentication Board, Vincent Fremont and Vincent Fremont Enterprises, in the Federal District Court in the Southern District of Manhattan. In mid-September of the same year, the Foundation asked that the case be dismissed as frivolous. It would take two years before the court ruled in Simon's favour and allowed his suit to go forward. Only then did a disagreement I once thought could be settled easily in an academic symposium turn into a full-scale, high-profile lawsuit.

I had already written an article about the authenticity of the *Red Self-Portraits* in a review of the *Imagine* programme for the *Daily Telegraph*, back in January 2006. Now that I knew about the 'Bruno B.' self-portrait, I wanted to write another piece. But such an article was not suitable for publication in a broadsheet daily. I would have to explain the silk-screening process and go into detail about what authenticity means in the work of an artist who specialised in the mass production of images. I thought of the *Burlington Magazine* as a possibility, but it did not accept articles about works of art that were – or could be – for sale. Then, the right moment, the right place and the perfect opportunity fell into my lap.

Chapter 16

Dinner on Park Avenue, March 2009

I HAD KNOWN BOB SILVERS, co-editor of the *New York Review of Books*, since 1990, when he contacted me after reading a book review I had written in the *Times Literary Supplement*. Without preliminaries, he sent me two books to review, and that was that: I would be a regular contributor to the paper for the next twenty-eight years, writing about books and exhibitions that ranged from old-master paintings to works of twentieth-century art.

Then, as now, book reviewing was the worst paid and least prestigious job in journalism. The *NYRB* was an exception. Bob once told me he believed a book review had the potential to be more interesting and of more long-term value than the book under review. At the *New York Review of Books*, writers were given as much time and space as they needed to say what they wanted to say. Copy-editing and fact-checking were meticulous. The editors would not change a comma without first consulting the author. That may not sound like a particularly ground-breaking way to work, but only a handful of publications did it.[1]

As for readers, the editors took for granted that they were

educated and intellectually curious. No subject was deemed too esoteric or too technical to write about if the writing itself was clear and if the author held the reader's attention from start to finish. On the title page, the words NEW YORK REVIEW appeared in large letters, with *of Books* in smaller type below. That was because, in a single issue, you might find essays on international politics, science, psychology, poetry, theatre, film, travel, sport and the visual arts – there was a lot more to it than books.

Part of the mystique of the *New York Review of Books* was the letters pages, the arena where literary disputes, vicious and otherwise, might unfold over the course of several months, like lobs and returns in a tennis match filmed in slow motion. To play on the centre court, you had to know what you were talking about, because it felt as though the whole world was watching.[2]

Because significant revelations in the story I am telling first appeared in those notorious letters pages, I should mention that I first experienced this form of bare-knuckle literary brawling in 1993, after I'd written a scorching review of a three-volume biography of the painter William Hogarth by an American academic. I thought the book twaddle and said so. The author replied. My original review was about 4,000 words long, but our correspondence was longer, and I imagine, for most readers, more entertaining. So vitriolic did our exchange become that it attracted the amused attention of the *New York Times*:

> Does it mean anything to call William Hogarth a 'critical deist'? Richard Dorment, the art critic for the London *Daily Telegraph* would really like to know. And Ronald Paulson, who used the phrase and whose three-volume biography of Hogarth was scathingly reviewed in the *New York Review of*

Books, would like to know how Mr Dorment can fail to see that Hogarth's art created a counter discourse to Shafsburyian civic humanism. The debate rages on, six months after the review originally appeared, with no end in sight. Eventually, Robert B. Silvers, the co-editor of the *New York Review of Books* will call a halt to it and make space for a slanging match over Bosnia or the Federal deficit. But for the moment Hogarth boils furiously on the front burner.[3]

Bob believed (as did I) that a writer had an obligation to defend his or her views against inevitable objections from disgruntled authors – and anyone else who had something to say that he thought worth considering.

Whenever I was in New York, Bob invited me to lunch or dinner. In March 2009, I was in the city to review an exhibition for the *Daily Telegraph* when I received an invitation to have dinner with Bob and his companion of forty years, Grace Dudley, in the flat they shared off Park Avenue, on the Upper East Side. Grace sometimes came to lunch or dinner with Bob when they were in London, so I knew her slightly. Fluent in several languages and as cosmopolitan as anyone I'd ever met, she was formidably well-informed about the arts, as well as everything else. She also spoke English with a thrillingly unplaceable accent (Serbian).

At 7.30 p.m., I stepped into a flat of discrete elegance – all silver and silk, soft greys, polished wood and deep, comfortable chairs and sofas. A uniformed maid served dinner in the candle-lit formal dining room. The other guests were John Richardson and Jayne Wrightsman, the collector and donor of the sensational Wrightsman collection of eighteenth-century French furniture and painting to the Metropolitan Museum of Art, where she had long been a trustee. What happened over

the next few hours could only have occurred in that place, at that time, with those people.

Richardson had been a guest at my first wedding in 1970, and it was he who introduced my wife and me to Andy Warhol, when we were in Paris, a few years later. I had not seen him recently, but I had written a rapturous review of the first volume of his *Life of Picasso* for the *Times Literary Supplement*. Wit, raconteur, and the best possible company, Richardson seemed to know everybody. So close was his friendship with Warhol that he delivered the eulogy at the artist's memorial service in St Patrick's Cathedral. Unlike others in Warhol's entourage, he commanded respect in the art world and beyond, as historian, essayist and frequent contributor to the *New York Review of Books*. His contempt for the Authentication Board was hardly a secret, since he took every opportunity to denounce its incompetence.

Over coffee in the drawing room, John told me of his resentment at the way the Board had treated Joe Simon and others like him. He mentioned, too, that Andy Warhol had given him numerous drawings and paintings as Christmas and birthday presents. All were signed and dedicated, but he said he would never dream of submitting these works to a Board that was perfectly capable of declaring that they were not by Andy Warhol. We talked of our mutual disgust at the way the Board was distorting Warhol's legacy. Bob Silvers listened but said nothing. When at last he did speak, it was to ask me to write about the Andy Warhol Foundation for the *NYRB*. John leapt in with encouragement, and there and then we discussed the form the article would take, its length, and when I might be able to get it to Bob. By the time I returned to London, I had a commission – 4,000 words, to be filed as soon as possible.

Chapter 17

A Cruel Joke

IN OCTOBER 1990, Richard Ekstract asked Vincent Fremont why the authenticity of his *Red Self-Portrait* had been questioned. Fremont replied that, although the silkscreen was made from an acetate transparency created by Warhol, it was not signed by Warhol and was 'without any hand painting or other indication of direct contact by Andy Warhol with the work.'[1] Ekstract's picture is unsigned, undated and it is not inscribed. At that date, Fremont did not know about the 'Bruno B.' portrait from the same series. His explanation for denying Ekstract's picture in 1990 is reasonable. I would have said the same. But once solid evidence of 'direct contact' came to light in the form of the 'Bruno B.' *Red Self-Portrait*, it was no longer possible to dismiss the 1965 series in this way. Fourteen years later, on 29 October 2004, Printz and King-Nero wrote to Ekstract about the same picture: 'The Board knows of no independent verifiable documentation from the period in question, in 1964 through to 1965, to indicate or suggest that Warhol sanctioned, or authorised anyone to make the work.'

This was a strange thing to tell Ekstract, of all people – since

he had been the very person whom Warhol had verbally author-ised to oversee the printing of the series. By now, Printz and King-Nero knew about 'Bruno B.', and, if that was not 'tangible evidence' of Warhol's contact with the series, nothing was. The same letter of October 2004 goes on to state that, 'no employee of the silk-screen printers ever spoke to Warhol regarding the 1965 series'.

When I first started writing about the *Red Self-Portraits*, I thought of the Board as a single unit consisting of full-time Foundation employees and visiting experts, like Whitney and Rosenblum. I quickly came to realise that I was wrong to think of it in that way. In essence, the 'Board' consisted of two peo-ple: Printz and King-Nero. Whitney and Rosenblum were on the Board to oversee their work, but for the most part accepted whatever the pair chose to tell them. If the pair withheld infor-mation from them, there was no way they could know about it.

And information withheld from the Board would also be withheld in the catalogue raisonné. In such a publication, the inclusion of a wrongly attributed work can, in theory, be recti-fied in later volumes. But omissions – particularly the omission of a pivotal series like the 1965 *Red Self-Portraits* – are harder to pick up and rectify. However informative the catalogue entries may be, collectors and dealers never know how many genuine works have been omitted.

From what I could see, the Authentication Board operated under a fundamental misconception: that authentication can be done in isolation. Its policy of secrecy corroded the board from within. Their lawyers constructed a fortress to keep out-siders from knowing how they came to their decisions, but the same defences cut them off from a whole world of people who had known Warhol and where, when and how many of his pictures were made. Out in the real world, scholars, curators,

students and dealers never stop talking to and listening to each other. Conferences, symposia and one-off lectures are the places where art historians may first choose to tell colleagues about recent discoveries or new research. Questions and observations from the audience after the lecture may open new paths of further enquiry.

Curators constantly question, revise, reattribute and re-date the works in their care. If they make a mistake or revise their opinion in the light of recent scholarship, they acknowledge it. If a respected scholar reattributes a painting or questions its authenticity, the picture is relabelled or taken off view. There is nothing to be achieved by inflating an attribution. For me, the Authentication Board's refusal to engage with other scholars was incomprehensible. Why would a scholar researching a problematic painting *not* draw on the knowledge and experience of others?

When writing about the art of the past, scholars try to draw on eyewitness testimony. What could be more valuable than evidence from those in the artist's circle, the men and women who watched him or her at work, who understood how the artist thought and – for all the scholar knows – may have been present when the painting or sculpture was created? With Warhol so recently dead, I could think of no reason why the Board would *not* consult the people who had been close to him – who had watched him at work and who may have assisted him in the silk-screening process. Sure, individual members of Warhol's entourage took drugs; others had mental-health issues or could hardly remember what had happened last week, let alone in 1965. I am sure there was more than one of these characters among Warhol's hangers-on. But there were others, including Sam Green and Paul Morrissey, who remembered a lot and had no reason to dissemble. When dealing with eyewitnesses,

researchers need to be sceptical. But to refuse to consider what old Factory hands had to say was bad practice.

The atmosphere in Warhol's Factory must have felt like the bohemian milieu Picasso cultivated in the Bateau-Lavoir, the Montmartre studio complex to which he moved in 1904 and where he painted the pictures of the 'Blue' and 'Rose' periods. Warhol drew inspiration from his entourage of beauties, eccentrics, art dealers, drug dealers and conmen as surely as Picasso. In the first volume of his great biography of Picasso, John Richardson mined the memoirs, letters and poems of the artist's friends and lovers, like Max Jacob, Fernande Olivier, André Salmon and Guillaume Apollinaire, for information about Picasso's creative processes and personal life. It looked to me as though Printz and King-Nero did not consider it worth their trouble to consult Paul Morrissey, Gerard Malanga, Brigid Berlin, Billy Name, Sam Green and others.

The Board's self-imposed isolation would not have been so contentious had their work been above criticism. But too many instances had come to light in which the Board made errors because Printz and King-Nero ignored information offered, in good faith and with no financial motive, by those who had witnessed certain events. In the words of Billy Name, 'the people who make these decisions were not there at the time and so are rewriting actual history to their own satisfaction. I think it is a cruel joke.'[2] That's why, at different times, the published volumes of the catalogue raisonné had come under fire. Avoidable errors and omissions, coupled with the unwillingness of King-Nero and Printz to admit mistakes, eroded their credibility.

This was what happened when the pair came to catalogue an oversized portrait entitled 315 Johns, consisting of a grid of 315 silk-screened red and black photos of the sculptor John Chamberlain, famous for assemblages of dented, twisted metal

scavenged from crashed cars. Chamberlain owned the picture and maintained that Warhol made it. In 2000, Printz and King-Nero authenticated it, enabling the sculptor to sell it as a Warhol in the same year for around $3.8 million. A few years later, Malanga got wind of the sale and vociferously claimed authorship of the picture, which he had made in 1970. Even in colour photographs, the picture does not look much like Warhol's work, even to a layman like me. It is not signed, and it is not in Crone's catalogue raisonné. What's more, Chamberlain was unable to produce a single document connecting it to Andy Warhol. Yet Printz and King-Nero chose to believe the sculptor. They listed the picture as a genuine Warhol in the second volume of their catalogue, published in 2004. They date it to 1967, without offering any evidence to support their conclusion.[3] Late in 2005, Malanga sued Chamberlain for profiting from the sale of a picture that he was passing off as an Andy Warhol, when he knew that Malanga had made it. Six years and hundreds of thousands of dollars later, the case was settled out of court. The terms have not been made public, but, in 2011, Malanga's lawyer, Peter Stern, told reporters that his client was 'very pleased' with the settlement.[4]

In the case of the *Red Self-Portraits*, the Board failed to initiate contact with Paul Morrissey, Sam Green or Richard Ekstract – all eyewitnesses. Ironically, the Board's policy of ignoring the testimony of Warhol's associates and contemporaries only made their work harder. By treating him as though he were an old master, they missed dozens of opportunities to hear eye witness testimony – which is exactly what art historians who study Raphael or Rubens search for in archives and libraries. Every time they made another slip-up, they called attention to their relatively flimsy academic credentials.

Chapter 18

First Article for the New York Review of Books, *2009*

SIX YEARS EARLIER, when Simon first called me about authenticating Warhol, I knew nothing. Here I was in 2009 ready to challenge the Authentication Board of the Andy Warhol Foundation. That was because I'd examined the material Simon had been collecting and I believed he knew more about Warhol's materials and methods than did Sally King-Nero or Neil Printz. I had written about the importance of Warhol's art, his contribution to the history of art, the breadth and originality of his genius. Simon didn't care about any of that. He looked at Warhol closely, scrutinising the properties of canvas and linen, water-soluble ink and ordinary ink, how Warhol prepared his silkscreens and how he created his acetates. Simon spoke to those who worked in the Factory at the time, and it was his business to meet and interrogate scholars and dealers just as he'd done with me. When, during her cross-examination, a lawyer asked Sally King-Nero who she thought were the greatest experts on Warhol, she named Rainer Crone, but she also named Joe Simon.

A week or so after our dinner in New York, Bob Silvers sent several recently published books about Warhol to London

with a note asking me to review them in the same article in which I was to write about the *Red Self-Portrait*. These publications turned out to be a godsend. They allowed me to introduce the reader to Warhol's work before focusing on the issue I was writing about. From the top of the pile, I picked up a breezy, gossipy and surprisingly informative memoir about the ins and outs of the art market, by Richard Polsky, a private dealer in contemporary art. Its title, *I Sold Andy Warhol (Too Soon)* gives a flavour of Polksy's down-to-earth style. Published in 2009, his account of wheeling and dealing in relatively high-value pictures explained some of the issues Simon was having with the Andy Warhol Art Authentication Board. In the chapter 'Not So Simple Simon', Polsky adamantly defended the authenticity of Simon's *Red Self-Portrait*. In his words, it was 'right as rain'.

More prescient than anyone I'd heard from so far, Polsky outlined what would happen if Simon's case ever came to court. He began by noting the ramifications for the art market:

> As an unregulated field, with little transparency, collectors and the public alike would be privy to some of the inner workings of the market. Though the board members are secretive about their criteria for approving paintings . . . it's likely they would have to disclose more than they would like. Through depositions, light would also be shed on individuals who had works validated, and, equally revealing, those who hadn't. Finally, if Simon won, the management of significant artists' estates would come under heavy scrutiny, possibly affecting current and future prices.[1]

Shortly after this paragraph, Polsky describes a telephone conversation with Joe Simon (whom he had never met) about the lawsuit. Polksy did not beat about the bush:

'What would you really like to see happen?' Simon paused before answering. He was obviously exhausted by the ordeal . . . I could feel the gravity of Simon's frustration as he was about to speak. Since 2002, getting his Warhol authenticated had become a full-time job. While millions were at stake, so was his reputation among friends and art-world colleagues. Not to sound melodramatic, but the fight had come to define Simon's life. It was not only a matter of money, but also an obsession he could not control. With all this weighing on his mind, Simon said, in a voice filled with sadness, 'I just want my painting approved and I'll go away. That's all I want.'[2]

The second book was by the philosopher and art critic Arthur C. Danto, whose insights into Warhol's genius had been a significant factor in the posthumous re-evaluation of his art. In his short study, *Andy Warhol*, Danto points out that the question Warhol asked was not, 'What is art?' but, 'What is the difference between two things, exactly alike, one of which is art and one of which is not?' Using as an example a real Brillo box and Warhol's facsimile, Danto concludes that the difference lies in the questions we ask about each object. Just as with the work of Duchamp, when we look at Warhol's *Brillo Box*, we ask not *what* the artist made or *how* he made it, but *why* he made it, and how its meaning changes when it is placed in an art gallery. That process of interrogation introduces ideas about the nature of the creative act that lead us to approach the act of looking at art differently from any earlier generation. Danto concludes that Andy Warhol was as close to a philosophical genius as art has produced.

Next up for review was *Pop: The Genius of Andy Warhol*, by Tony Scherman and David Dalton. This was the most profound look yet at the range and originality of Warhol's work, and the

authors were particularly good on Warhol's working method, from his years in advertising to the silkscreen process. My review was too short. I regret not doing the book justice, but space was limited, and the article was essentially about the *Red Self-Portraits*, so I had to move on.

The warm-up over, I introduced the subject by listing the differences between the 1964 series and the 1965 series: although Warhol used the same acetate for both, he employed two different printing techniques to make them. Then, I enumerated the other ways in which the second series differed from the first: cotton duck versus linen; uniform red background versus different colours; and the absence, in the second series, of the artist's hand in the form of drawing or paint texture. When it came to the mechanical process used to make the series, I was careful to say that the circumstances under which they had been printed was indeed a departure from his usual working method at this date.

An article of this length and complexity takes months to write. When I finished, in the autumn of 2009, Bob telephoned to thank me for the piece, and said he would send the first set of galleys to me in a few days. When they arrived, I was appalled. For the first and only time in the many years I had been writing for the *New York Review of Books*, something had been changed without the change first being discussed with me. Omitted were a few sentences in which I said that John Richardson considered the Authentication Board incompetent. That shocked me. After all, Richardson had been responsible for my writing about the Andy Warhol Foundation and the Board in the first place.

I called Bob to ask what had happened. He apologised for not telling me, but explained that the deletion had been made at the last minute, at Richardson's request. Since the dinner party, back in March, Richardson had taken a job with Larry Gagosian, the

bluest of blue-chip art dealers, and one who had close commercial ties to the Warhol Foundation. Richardson was worried that to be seen to criticise the Authentication Board might cost him his new job, so he had asked that his comments be removed.

I had no wish to injure Richardson, and Bob Silvers was taking a risk by publishing what was bound to be a highly controversial article. So, with reluctance, I accepted the change. But the loss weakened the article. To attribute Richardson's words to 'a well-known figure in the art world' did not cut it; the power of the criticism lay in its source. Richardson was no mere acolyte at Warhol's court; he was its prince-cardinal. As the ultimate *eminence rouge*, his influence in shaping opinion in the highest echelons of the art world could not be overestimated. And yet, in print, he could say nothing. I was beginning to understand the Foundation's power to silence even a person of his stature.

In the rest of the article, I went on the offensive – but I also offered the Foundation an easy way out: if the chairman of the Foundation or members of the Board would put forward a cogent reason for denying the authenticity of the *Red Self-Portraits*, I'd apologise without reserve. My hope was that this would at last engage Printz or King-Nero in a debate – one that I was perfectly prepared to lose. I limited my criticisms of the Board to their handling of the *Red Self-Portraits* and was careful not to write anything I couldn't prove. Simon's lawsuit, for example, alleged that the Board routinely denied genuine works to restrict the number of Warhols on the market, thereby increasing the value of its own holdings in violation of anti-competition law. I had no evidence that this was true – and if applied to the valuation and sale of works of art it would be very difficult to prove – so I did not repeat the accusation.

Chapter 19

Wachs

PUBLICATION DATE WAS 22 OCTOBER 2009. The Andy Warhol Foundation could have reacted in several possible ways. Their best course would have been to announce an academic symposium, perhaps held at the Institute of Fine Arts at New York University or at the Museum of Modern Art, where some of the issues surrounding the authentication of Warhol's work could be discussed. Alternatively, it could do nothing. This, too, would have been smart. To the average reader, I had written about an esoteric dispute on a rarefied subject, published in a highbrow paper with a tiny circulation. The piece had caused a lot of talk among a handful of artists, students, curators and dealers, certainly, but that died down after a few weeks.

There was, however, a third possible course of action – and it was the very last thing the Foundation should have done if it wished to kill the controversy and bury it forever: it could reply. Any response would have been ill-advised, but, if the Foundation felt one was necessary, it needed to be a dignified letter vaguely affirming its faith in the Board and offering assurance that, with the publication of the entire catalogue in ten years' time, all

questions would be answered. Everyone would have yawned and then forgotten the whole thing. That is not the response the Foundation gave. Instead, with its reply, it dropped a match onto a few smouldering twigs, then fanned them into a conflagration.

The letter from the Foundation was exactly the kind journalists pray for and rarely receive – a gloriously over-the-top tirade, signed by its president. Joel Wachs was a former tax attorney from Los Angeles, who had worked for the LA City Council for almost thirty years. The Foundation groaned with lawyers, and Wachs was the lawyer-in-chief. He was a short man on a short fuse, with a style to match. In warm weather, he favoured jazzy Hawaiian shirts, accessorised with sandals, socks and Bermuda shorts. You would not have noticed him in LA, but, surrounded by the men in suits who then ran things in New York, his sartorial choices made him unmistakable.

And he was excitable. His every communication opened by calling the object of his rage a liar. In his first letter to the *New York Review of Books*, Wachs set the tone for what was to come. He began by saying that 'any impartial reader' of my piece would conclude that I had a particular point of view – or, rather, that I had written a 'thinly veiled effort to further [my] unstated agenda'. I was sorry that Wachs thought my agenda was either unstated or in any way veiled, but knew that he was only limbering up before the main bout began.

Wachs was, of course, writing to complain about my account of the reasons why the Board had denied Simon's painting:

Mr Dorment twice misstates the Andy Warhol Art Authentication Board's reasons for its opinion that Joe Simon's 1965 *Self-Portrait* painting was not a work by Andy Warhol (because Warhol was not present when they were painted) and then goes on to quote a single sentence from the last paragraph of

a letter the Authentication Board wrote to Mr Simon. As Mr Dorment knows, the preceding seven paragraphs of the letter set forth in detail the board's reasons for its opinion, none of which have anything to do with Warhol's presence during the creation of the painting.

In truth, my article specifically mentioned all but one of the differences described in the seven paragraphs he referred to in the letter the Board only grudgingly wrote to Simon *after* the publication of Shnayerson's article in *Vanity Fair*, but the usual limitations on space meant I had not listed every single one.

So, now I did: '. . . Of course, I was summarising, but for Mr Wachs's benefit, I can go into more detail here. Observing that the halftones in the second series are less dense than those in the first, the letter to which Wachs refers concludes that the pictures in the second series were *not made from the same silk screen Warhol used to make the first.*' [My italics] That was true, and it gave me a chance to expand on the point:

> But of course they weren't; as I explained, the second series was made not from the same *silk screen* but from the original *acetates* – transparencies – that Warhol gave to Richard Ekstract, who in turn took them to a factory (commercial printers) where they were used to make the (new) silk screens from which the pictures in the second series were printed . . . That the Authentication Board has failed to grasp these basic facts merely reveals how little it has understood – or tried to understand – the sequence of events that led to the creation of the second series.

I knew, as I think most people interested enough to read this exchange did, that Printz or King-Nero had written the letter, or

at least provided the information Wachs used in it. Until I read that letter, I had no idea how little they appeared to know either about Warhol or about the mechanics of the silk-screening process. In my article, I had questioned the competency of Printz and King-Nero. In responding to my strictures, Wachs professed indignation at my 'petty attack on the professional credentials and scholarly independence of members of the Authentication Board.' It was an attack, for sure, but, far from being petty, I thought it went right to the heart of the issue under discussion. These two had made serious misattributions for which they had not been held responsible, and here was a good example of why they got things wrong. When I asked Wachs how the Board could maintain that the signature, date, dedication and publication during the artist's lifetime of a picture in a catalogue raisonné were all genuine, and yet still declare that the picture was not, I was pretty sure he could not answer. But he could do something else.

Chapter 20

Big Noise on Hudson Street

SOON AFTER THE PUBLICATION of my reply to Wachs's letter, the man himself bustled into the offices of the *New York Review of Books*, then located on Hudson Street in Greenwich Village. Strikingly attired in Tommy Bahama-type leisurewear, the purpose of his call was not to dispute a single fact concerning the authenticity of the paintings, but to personally deliver material to the editors that he believed would serve to discredit me. Specifically, he said that, in my article, I had not written about my attempt, in 2003, to help Simon determine why the 'Dollar Bill' piece had been deemed to be a fake. That was perfectly true. I was writing about Simon's lawsuit, in which the 'Dollar Bill' piece played no part. Given the limited number of words I had been given to explain the complicated story of the *Red Self-Portraits*, I omitted anything that had no direct relevance to the topic of the essay.

What bothered me was what Wachs said next: he claimed I had 'put pressure on' the Board to authenticate the 'Dollar Bill' piece. Wachs knew as well as I did that my intervention amounted to no more than asking Bob Rosenblum to tell me

the reason why Simon's picture had been rejected. As 'proof' that I had put pressure on the Board, Wachs told Silvers that the Foundation had on file two letters that I had written on behalf of Simon. But he did not show Bob the letters.

I knew why. The letters – written on 7 May and 3 October 2003 – proved the exact opposite of what Wachs claimed. Both were entirely innocuous, and in both I had been completely transparent about who I was and why I was writing. In the first letter, I stated that I had been present when the Secret Service agents in London declared the bank notes to be genuine, concluding that I hoped the Board would accept this as 'a simple statement of fact'. I said nothing about whether the collage was authentic or not. In the second letter, I emphasised that I was not an expert on Warhol and was not writing to comment on the authenticity of Simon's *Red Self-Portrait*. I had kept copies of both letters and sent them to Bob as soon as he told me of Wachs's visit. After reading them he understood at once what Wachs had been up to.

But Wachs was dealing with a person rare in his experience, a man of absolute integrity. If he thought Bob could be intimidated, he could not have been more wrong. Wachs put his accusations against me in a letter to the *New York Review of Books*, this time including supporting 'evidence' in the form of the letters. Bob refused to publish it. Writing to Wachs on 9 December 2009, he refuted each allegation, line by line, concluding with the words, 'we did not find that what you say [in your letter] is borne out by the documents you gave us.'

Chapter 21

Lies and Libel, 2009

AFTER BOB TOLD Wachs his accusations against me were baseless and then firmly refused to publish his letter, I imagined the president of the Andy Warhol Foundation might feel some shame. But, in the full knowledge that his slurs were untrue, he repeated them to David Leigh, a journalist who worked for the *Guardian* newspaper in London.

On the morning of Friday, 4 December 2009, my wife and I were at breakfast. We take two morning papers: she starts with the *Guardian*, I with the *Daily Telegraph*. At lunchtime, we switch. On this day, she suddenly reached across the breakfast table and, in a voice in which I detected a note of concern, she said, 'I think you'd better read this.'

Within a few moments, I was aghast. Under the headline, 'Is this a $2m Warhol, or a fake? Art world sees red over self-portraits', Wachs accused me of 'pressing the board . . . to authenticate an "obviously forged" piece' – the 'Dollar Bill' piece. 'Mr Dorment sent emails to board members advocating that the work should be deemed an authentic Warhol, despite the fact that the collage contained dollar bills that were signed

by the US treasury after Andy Warhol had died.' In fact, the letter Wachs referred to affirmed that the Secret Service agents in London had pronounced the *bank notes* to be genuine; I had said nothing about the authenticity of the collage. Not only that, but, without at any point speaking to me, David Leigh added, 'Dorment called this "an attempted smear".'[1]

What Dorment called it was libel, a defamatory statement intended to damage my reputation for integrity both as a critic and as an art historian. I put down the *Guardian*, picked up the telephone and called my boss, Sarah Crompton, the arts editor at the *Daily Telegraph*, to tell her what had happened. She, in turn, contacted the paper's lawyer, Arthur Wynn-Davies. Both grasped the serious nature of the libel, and both advised me to act quickly and forcefully.

Here is what they told me to do:

1. Write a strong letter to the *Guardian's* editor saying that the libel is completely unfounded.
2. Demand that the paper publish a retraction, a correction, or an apology.
3. Insist on setting a time limit for the response, making it clear that, unless a correction was forthcoming, I would be consulting solicitors.
4. Lodge a complaint with the Press Complaints Commission on the grounds that the libel was 'a clear breach of the editors' code of conduct'.[2]
5. Demand to be shown a draft of the wording of the apology and insist they confirm it would only be printed with my approval. If I was not happy with the wording, I should say that I would consult Carter, Ruck – the biggest libel lawyers in London.

The situation was utterly new to me. Was I really prepared to sue the *Guardian* for libel? If so, I would have to do it out of my own pocket, since I'd written about Warhol on a freelance basis for the *New York Review of Books*, not as an employee of the *Daily Telegraph*. Arthur Wynn-Davies could advise me on how to handle my response, but he could not help me professionally. That meant I would have to take out ATE [after the event] insurance to cover my costs if I lost the case. A tough-guy stance did not come naturally to me. I hesitated. Leigh's reporting, while inaccurate, was not malicious in intent. I was then a *Guardian* reader and considered the editor, Alan Rusbridger, the best on Fleet Street.

On the other hand, Wachs had told the paper's reporter a version of facts, which could easily have been checked. Unless it was refuted quickly, it could be picked up by other publications. I therefore followed Wynn-Davies's advice to the letter. On Monday, 7 December, I wrote to Rusbridger explaining that his reporter had made no attempt to contact me or anyone with knowledge of the facts before publishing an accusation that 'appears to implicate me in what could be construed as a criminal act.' I attached copies of my letters to the Andy Warhol Foundation.

At that time, the *New York Review of Books* and the *Guardian* had formed a sort of partnership. Every month, the London paper would reprint a long article from the *NYRB*, usually having to do with US affairs. Bob Silvers was therefore in regular touch with Alan Rusbridger. In my letter to Rusbridger, I mentioned that Silvers would be contacting him with more documents that directly contradicted Wachs's assertions. Rusbridger did not argue, but it did take time for the *Guardian* to print the correction I'd written and Wynn-Davies had checked. On Wednesday, 23 December, two and a half weeks after Leigh's

article was published, the correction appeared next to the main editorial leader for that day. It followed my denial of the allegations word for word, and, crucially, made it clear that the editors had seen the documents disproving them. Alan Rusbridger (or perhaps one of his staff) then did something that I had not asked for, but for which I will always be grateful: he placed the same correction in bold letters and large print at the top of the online version of Leigh's article, where it remains to this day. I was satisfied.

Since Wachs had been rebuffed by quality papers like the *New York Review of Books* and the *Guardian*, he now turned to the one platform guaranteed to give him as much space as he needed to denounce me in any terms he wished: the website of the Andy Warhol Foundation. Only a dunce would read what Wachs said there without further enquiry – and further enquiry would, in short order, lead the reader first to the *Guardian* website and, from there, to my original article. In fact, the Warhol Foundation website served as a billboard referring anyone who had not read the piece and the subsequent correspondence it generated to the *NYRB*'s website. By giving publicity to my accusations, the Foundation showed how seriously it took them – without lifting a finger to change or modify the behaviour of the Board.

*

Beginning with that first article in 2009, and for about four years thereafter, I lived with low-level anxiety, the background hum of permanent unease. The Foundation clearly regarded the *NYRB* as a stone in its shoe. My deepest worry was that, if it could show that I had written something that was factually incorrect, or inadvertently libelled one of its employees, its lawyers would sue. Worse, whether it won or lost, the cost of a lawsuit might shut the paper down.

At home in London one day, I received a telephone call from a person who said he worked for an independent arts radio station in New York. The caller told me he was interested in my articles about Warhol and asked whether I would be willing to give a telephone interview to the station. The person on the line was friendly and well-spoken, but, as we talked, I began to wonder who he really was.

There was another consideration. The editors and staff of the *New York Review of Books* scrutinised the accuracy of every statement, quotation and date in every article I wrote. Then their lawyer (or a member of the staff with legal training – I never knew who did the work) checked the piece again and sometimes asked me to rewrite or rephrase comments that could be considered libellous. That would not be possible in a live interview. I worried that I might inadvertently make a remark that lawyers for the Foundation could twist to mean something I had not intended.

I decided to play it safe, thanked the person for his interest, and declined. There was no argument from him, and no attempt at persuasion – as there certainly would have been had the caller worked for the BBC. I told a friend who lived in New York about the call. A few days later, she telephoned to say that the radio station in question was indeed devoted to the arts, and that it was funded with a grant from Creative Capital, a charity created and supported by the Andy Warhol Foundation for the Visual Arts. The offices of Creative Capital were in the same building as the Foundation. Maybe the call had been legitimate. But, since Joel Wachs was a board member of Creative Capital as well as of the Foundation, I could not take any chances.

I was becoming paranoid. One day, Bob Silvers forwarded a letter addressed to me care of the *NYRB*. It was dated 8 November 2009, had been sent from an address in Florida, and

the wavering handwriting was that of a very old person. In it, the writer explained that he was the owner of one of the *Red Self-Portraits*. It had been given to him by Richard Ekstract forty years earlier, because he had worked as Ekstract's accountant for 'an extended time'. That was potentially interesting, but I became suspicious when he went on to say that, at eighty-eight years of age, he was interested in selling the Warhol and was willing to offer me a substantial commission to help him do so. He provided an address so that I could easily get in touch. What worried me was the writer's offer of a fee to help him sell the painting. No one does that. If they want to sell, they go to dealers or auction houses. Perhaps he was who he said he was, but it was also possible that the letter had been written by someone in the pay of the Foundation's lawyers to expose me as someone motivated by financial gain.

As an art critic, I never accepted gifts from artists, however well intentioned. The occasional work of art sent in the post or offered to me in gratitude for a profile or a review I always returned, each time with a letter of thanks in which I explained that acceptance would leave me open to allegations of corruption. It would not matter that the allegation was not true; the charge alone was enough to cast doubt on the sincerity of my review. Now, I wrote to the Florida address supplied, saying that I was not a dealer and had nothing to do with the art market. If he wished to sell, he should contact Sotheby's or Christie's and ask for their advice.

My ever-increasing paranoia turned out to be entirely justified. Way back in 2004, Simon had written to the London publishing house, Pan Macmillan, asking whether they would be interested in a fictionalised book about his struggle with the Andy Warhol Foundation. The publisher, Jeremy Trevathan, met with Simon, who handed him six pages describing his

dealings with Vincent Fremont before and after his pictures were denied. Trevathan read what Simon had written, then politely advised him that Pan Macmillan was not the right publisher for his project. That was all. Trevathan kept the pages, but did not hear from Simon again regarding his notional book.

In 2010, British law firm McGrigors contacted editors at Pan Macmillan. After declaring that they were employed by the Andy Warhol Foundation, they demanded the publisher hand over Simon's manuscript, together with the contract they believed he'd signed. Trevathan replied that neither the book nor the contract existed. But McGrigors insisted, then threatened. Either the publishers gave whatever papers they had to McGrigors, or they must allow the Foundation's lawyers to search the Pan Macmillan offices. Like any honourable publisher, Trevathan's instinct was to tell the lawyers to go jump in a lake. But he knew that, if the Foundation persisted, an exchange of legal letters alone might cost the publishers thousands of pounds. He therefore gave the lawyers the few pages he had, so they could see for themselves that there was nothing to see. Trevathan was certainly right not to engage in a dispute with the Foundation. According to its 2010 tax return, McGrigors was paid $29,460 for their work.

Over the winter of 2010, I was following newspaper reports about a lawsuit for libel which Richard Desmond, the proprietor of Express Newspapers, had brought against investigative journalist Tom Bower. Desmond objected to a few passages in the biography Bower had written about him, and, although Bower won the case, it had been a close-run thing. I read about the lawsuit with intense interest, not only because I feared I might face similar legal difficulties, but also because Bower's wife, Veronica Wadley, was then deputy editor at the *Daily Telegraph*.

With each article I wrote for the *New York Review of Books*, I

ran the risk that the Foundation would find some pretext to sue me personally. I had seen for myself how unscrupulous Wachs could be. Simply by making an accusation of defamation, the Foundation's lawyers could tie me up in a legal tangle that would take years of my life to deal with. I lay awake at night wondering whether, knowing the risks, I should continue to write about the Warhol case. At last, I could stand it no longer. I telephoned Tom Bower (whom I did not know) to ask him two questions: at the risk of losing everything, should I go on? And, if I did go on, should I transfer ownership of our house to my wife, so that she at least would have a roof over her head if the worst happened? His response was brusque. That I even asked the first question meant I didn't have the stomach for this kind of journalism. I should get out now. As for transferring the deeds to our house, it was pointless. Lawyers would see through the ruse and take the house anyway.

Chapter 22

The Warhol Foundation on Trial, 2010

ALERT BY NOW TO WACHS and his ways, Bob Silvers published more letters to the editor in the 25 February 2010 issue of the *New York Review of Books*, this time under the far-from-neutral title, 'The Warhol Foundation on Trial', with the headline emblazoned on the cover of that issue. The letter for which I was most grateful came from the journalist Paul Alexander, a person whom I did not know and had never spoken to. Alexander began by ridiculing the idiocy of the Board's refusal to accept as authentic a picture Warhol had signed, dated and inscribed, describing its behaviour as 'Orwellian in its absurdity'. He then recounted how, for years after Warhol's death, he had written about the activities of the Warhol estate and Foundation for various publications as a prelude to publishing his book, *Death and Disaster: The Rise of the Warhol Empire and the Race for Andy's Millions* (1994).

When Alexander read the exchange of letters between Wachs and me in the 17 December 2009 issue, he was particularly struck by one detail – that the president of the Warhol Foundation had shown up at the office of the *New York Review of Books*

to deliver, in person, material that he claimed would serve to discredit me in the eyes of the editor. That triggered a memory of Alexander's own. In March 1994, he had published an article in *ARTnews* documenting in some detail a lawsuit between the Foundation and its lawyer, Ed Hayes, concerning the true value of Warhol's estate. The Warhol Foundation responded with a tactic I recognised: Archibald Gillies demanded a meeting in the office of the magazine's editor. Alexander was present. When Gillies arrived, he spent the entire meeting attempting to discredit Alexander's journalism: 'He had brought with him a list of some one hundred "factual errors" in my article, as if I could have slipped that many errors past the magazine's excellent fact-checking department – but when we looked at the so-called errors none seemed to be actual errors. None. The whole episode was merely an attempt by the Warhol Foundation to intimidate me.'

Alexander's letter helped me to weather the coming months and years. I now knew the mud Wachs had just thrown at me was routine procedure, the Foundation's way of discouraging journalists from poking around in its affairs. Soon after Wachs's dramatic appearance on Hudson Street, someone who identified himself only as the director of a well-known New York art gallery wrote to the editor of the *New York Review of Books* in support of the Authentication Board. The writer was Michael Findlay, who worked for the Acquavella Gallery.[1]

One of Simon's allegations in the forthcoming lawsuit was that a few powerful dealers enjoyed a special relationship with the Andy Warhol Foundation. One was Acquavella. His antennae now attuned to a side of the art world to which he had not previously been exposed, Bob Silvers wrote to Mr Findlay to ask whether his gallery had 'ever purchased a work by Andy Warhol

directly from the Foundation'. Without answering the question, Findlay immediately withdrew his letter.[2]

I had never met or corresponded with Rainer Crone and did not know he intended to write, so I was thrilled when I heard that a letter from him had arrived at Hudson Street. More than support for me, it contained his own first-hand, eyewitness account of how Warhol had personally approved the publication of the 'Bruno B.' *Red Self-Portrait* as his own work, and how Warhol had personally chosen the picture for the image on the dust jacket of the catalogue raisonné. It is an important document. Crone was an academic heavyweight. He had taught at Yale, the University of California at Berkeley, Columbia and New York University. At the time of writing to the *New York Review of Books*, he was Professor of Art History at Ludwig Maximilian University in Munich. What is more, he knew two of the visiting scholars on the Board, Robert Rosenblum and David Whitney.

Crone met Warhol as a young German PhD candidate, funded by a two-year doctoral grant from the German government. Between June 1968 and July 1970, he wrote the first catalogue raisonné of Warhol's paintings, films and works on paper. His catalogue was published in Stuttgart, New York and London in 1970. Crone went out of his way to declare that, in writing this work, he had received no commercial backing or financial support from any gallery or individuals, including collectors and art advisers.

The resulting work is a milestone, not because it is definitive, but because it was written so early in Warhol's career and with the artist's full cooperation. To grasp the importance of Crone's emphatic support for Simon's case, it helps to know that he wrote the primary published source of information about Warhol's art in the 1960s. That status lasted from 1970 to

2002, when his catalogue was supplanted by the publication of the first volume of the Foundation's catalogue raisonné.

The 1970 catalogue was republished in revised editions twice – in 1972 and again in 1976. The later editions included an additional 406 works approved by Warhol. In all editions, the *Red Self-Portrait* is listed as entry #169. The existence of two revised editions strengthened the argument for the picture's authenticity. It meant that, if Warhol had any reservations about including the 1965 series of *Red Self-Portraits* in the first edition, he had ample time to remove the picture before the publication of the second and the third editions. He did not. As Fremont stated when the authenticity of the 'Studio-type' *Elvis* series was questioned, 'If Warhol had wanted to destroy them, he would have. He had twenty-plus years to do that.'[3]

Crone made no attempt to list every known painting Warhol had ever made. Instead, he catalogued and illustrated at least one painting from every series.[4] Whenever Crone did not include a work in his catalogue, he has been proved right. No one, including Crone himself, considers his catalogue flawless, but he was a formidable eyewitness. No one was better qualified to tell us whether Warhol himself believed the 1965 *Red Self-Portraits* to be his own work.

Crone explained to readers of the *New York Review of Books* that the 'Bruno B.' *Red Self-Portrait* was 'a perfect example of Warhol's technique of making multiple silk screens of the same image' (in different colours etc.) and was produced using the more 'hands-off' approach he continued with in the 1970s and 1980s. 'Ever since I published the 1970 catalogue in close cooperation with Warhol,' he concluded, 'I have been guided by the idea that a catalogue raisonné should be produced in close consultation with the artist.'

Crone's fascinating letter was far too long to appear in the

print edition of the *New York Review of Books*. It was, how-
ever, published in its entirety on the paper's website.[5] In it,
he gives a unique insight into how Warhol worked and – just
as interesting – how careful he was to protect his legacy by
supervising the young German scholar closely, and by person-
ally choosing the image that would be reproduced on the dust
jacket. Crone's testimony was unimpeachable. It was important
for me that he confirmed the authenticity of the portrait in a
publication read by so many artists, curators, academics and
dealers, even if it was in the online edition.

There were two artists who I felt sure would help once
they read what Crone had to say. Cindy Sherman and Barbara
Kruger both sat on the board of the Andy Warhol Foundation.
I was convinced that, after reading Crone's letter, one or both
would defend a fellow artist's absolute right to determine what
he did and did not paint. Unlike curators and scholars, they
had nothing to lose. Or perhaps, I speculated, the two trustees
would use their influence to compel Printz and King-Nero to
engage in public debate, in a place that enabled scholars like
Crone to challenge their conclusions. But neither artist said
a word – or, if they did, it was in private. Corruption in the
art world takes many forms, and silence is among the most
corroding.

I was getting a crash course in how self-interest in the art
world works. At a dinner at Tate Modern, on the night of 12
April 2012, to celebrate the opening of an Agnes Martin show, I
found myself seated next to Arne Glimcher, founder and owner
of Pace Gallery and one of the most powerful art dealers in the
world. This was by design. Before we sat down, Glimcher told
me he'd asked Tate director Nicholas Serota to engineer our
meeting because he wanted to congratulate me on the articles
I'd been writing in the *NYRB*. Like so many other characters in

this story, Glimcher looks like he's been sent by central casting to play the role of a suave international art dealer. In his case, this was literally possible. According to his entry in Wikipedia, he'd produced several Hollywood films including *Gorillas in the Mist*, and directed Antonio Banderas in *Mambo Kings*. He'd also had a small on-screen role in *Still of the Night* with Meryl Streep. During the long dinner, Glimcher stated that he would never buy a painting not signed by Warhol himself.

In 2008, d'Offay had sold his collection of contemporary art to the British nation, accepting £28 million for a collection that was then conservatively estimated at £125 million and today would perhaps be valued at ten times that. The 'sale' was, therefore, more of a donation – one that Prime Minister Gordon Brown called 'the greatest gift this country ever received from a private individual'.

Anthony d'Offay gave the collection jointly to Tate and the National Gallery of Scotland, but stipulated that the pictures should be circulated in provincial galleries and museums throughout the country. The former dealer even provided a generous endowment so that exhibitions of artworks drawn from the collection could be staged in venues outside the great hubs of Edinburgh and London. The importance of d'Offay's collection for the popularisation of contemporary art in the United Kingdom cannot be overstated. His imaginative scheme enabled people in all walks of life to see, perhaps for the first time, the work of Robert Mapplethorpe, Jeff Koons, Agnes Martin, Diane Arbus, Bruce Nauman, Alex Katz, Roy Lichtenstein, Gilbert and George, and Jenny Holzer.

Among the many works included in the d'Offay collection was Warhol's 'Bruno B.' *Red Self-Portrait*. The Board's rejection of the picture necessarily called into question its monetary

value. Until its status was resolved, d'Offay was forced to withdraw the painting from the gift.

Nicholas Serota was the most powerful person in British art. When he wanted something to happen, it usually did – whether it was his choice of artist to represent Britain at the Venice Biennale, the creation of a new gallery in St Ives, Cornwall, or indeed the conversion of a former power station into the building in which I'd met Glimcher, Tate Modern. But, as a person, he was modest, softly spoken and never anything but circumspect in voicing an opinion. Above all, he was wily. As the director of one of Britain's national museums, which happened to be one of the galleries that had received the gift from d'Offay, Nicholas Serota could make no public statement challenging the exclusion of the *Red Self-Portrait*, nor could he be seen to be taking sides in the dispute over its authenticity. What he could do, using the simple expedient of a carefully thought-out seating plan, was to put a journalist – me – in touch with one of the few people who had the stature, the authority and the ability to blow the whistle on what the Foundation was doing.

Chapter 23

A Cold-Blooded Murder – A Brazen Swindle

IT WAS TYPICAL OF Simon that he took the decision to go to court at a party. In April 2007, he met a hip young New York lawyer named Seth Redniss over drinks in the garden of Nick Rhodes's house in London. When Simon told him about his beef with the Andy Warhol Art Authentication Board, Redniss offered to represent him in court. He would act as a sole practitioner, assisted by two young attorneys, Brian Kerr and Lee Weiss, both of whom worked for the respected New York law firm of Dreier, LLP.

Founded in 2006 by Marc Dreier, this was one of the biggest law firms in America. With hundreds of employees, it occupied twenty-eight floors of a building at 499 Park Avenue. From April to July 2007, Redniss worked with Weiss and Kerr to prepare Simon's complaint. They drew up a list of 157 allegations, which included a worldwide conspiracy to monopolise trade in Warhol's work in violation of the Sherman antitrust laws, and conspiracy to persuade Warhol owners to submit their works for authentication when denial was a foregone conclusion. The complaint accused both the Foundation and the Board of unjust

enrichment, fraud, and violation of the federal Lanham Act, which prohibits false or misleading statements that can confuse commerce.

Redniss and his colleagues from Dreier agreed to represent Simon on a 40 per cent no-win, no-fee basis. To anyone who has never been to court, this kind of arrangement sounds irresistible – and it would have been, had Simon been suing a double-glazing company for a botched job on the back porch. But he was taking on an organisation with unlimited resources, and Simon would still have to cover his own expenses – in a case like this, those costs could and did run into millions.

Initially, the Foundation asked the court to dismiss the suit as frivolous. It took two years before Judge Laura Swain ruled in Simon's favour and allowed his suit to go forward. Immediately after that ruling, on 19 June 2009, the Foundation filed a counter-suit against Simon for 'frivolous litigation'. It got nowhere, but the decks were now cleared for an epic battle that would become a milestone in the history of a new branch of the legal profession: art law.

Simon had already spent a fortune researching the history of the *Red Self-Portrait*. A lawsuit would require even more capital, so he hesitated. At that point, a friend from Los Angeles stepped in with an offer to cover all expenses incurred during the lawsuit. Leonid Rozhetskin was a forty-year-old Russian multi-billionaire, and a larger-than-life character. Born in St Petersburg, but raised in the US, he had been a scholarship student at Columbia University before graduating cum laude from Harvard Law School and starting work for a New York law firm. Rozhetskin made his billions in post-Soviet Russia by helping to set up the newly privatised Russian mobile-phone industry in the 1990s and later investing in Russian mining and venture-capital projects.

By the time Simon met him, Rozhetskin was living it up in

Los Angeles and London, a jet-setting financier, film producer and newspaper publisher, whose glitzy style and louche personal life fed the gossip columns. Rozhetskin came to know Simon when he asked him to become co-producer of a film comedy entitled *Hamlet 2*, which would star Steve Coogan. Simon had already produced a superb film version of *Richard III* starring Ian McKellen, Robert Downey Jr and Maggie Smith, so he was interested. But, although he was paid for rewrites to the *Hamlet 2* script, he was so bogged down with his pending lawsuit that he had to tell the Russian he had no time to produce a new film. This was when Rozhetskin offered to help Simon with expenses. Without his backing, Simon would never have proceeded to the next stage in his suit against the Foundation.

Rozhetskin was married to a glamorous Russian fashion model with whom he had a three-year-old son. Early in 2008, he moved his family to a three-million-pound flat in a high-security building in London's Mayfair, which he intended to use as his base in Europe. On a Monday evening in March 2008, Joe Simon had a birthday dinner at the Ivy restaurant in Covent Garden. Leonid Rozhetskin was there, together with a few close friends. Over dinner, Rozhetskin invited Simon to spend the coming weekend at his villa in Latvia, travelling there in his private jet.

Simon had been invited on many occasions before to join his friend in Latvia, but had always been too busy with work. This time, he accepted. He intended to leave on Friday. But, on Thursday, Simon came down with flu and so had to bow out. The next day, Leonid flew out on his own to his villa in the Baltic resort of Jūrmala, near Riga. Late on Saturday evening, he disappeared. When the police arrived, they found the house turned upside down. Desks and drawers had been ransacked, tables and chairs overturned. Three litres of blood stained the

floor and smeared the walls, but there was no sign of Rozhet-skin. A few days later, the police found his Porsche, but no body.

For several years afterwards, it was rumoured that the oligarch had arranged his own disappearance – perhaps into an American witness protection programme – but, in 2013, a decomposed body was discovered in a Latvian forest. DNA tests confirmed the body belonged to Rozhetskin. It is believed that, before his death, he had been in a dispute with a partner of Vladimir Putin's, who demanded he make a deposit of $400 million into Putin's account in Cyprus. Leonid made a deal with the extortionist to reduce the shakedown to $40 million, and so believed it was safe for him to go back to Russian territory without his bodyguards. The investigating police told Simon that had he been with Leonid, he would, without doubt, have been killed as well.

When Simon's lawyers first filed his lawsuit in July 2007, Rozhetskin was still alive and helping with the expenses. Two years later, when Judge Swain ruled that the lawsuit could proceed, the oligarch's corpse was rotting in a northern forest. During the same two-year period, Simon's legal team had gone through an upheaval which, like the murder of his friend, left Simon reeling. Marc Dreier, the founder and sole equity partner in the law firm representing Simon, was arrested.

A stupendously wealthy celebrity lawyer, whose art collection alone was estimated to be worth $40 million, Dreier's downfall was as spectacular as it was sudden. In December 2008, police detained him in Toronto. A few days later, Simon was contacted by the journalist Kelly Crow of the *Wall Street Journal* for a comment. Simon, who had heard nothing, checked the internet and found photos of police leading the fifty-eight-year-old lawyer in handcuffs; he had been charged with securities fraud, wire fraud, money laundering and what the *New York Times* called the 'brazen swindle of some of New York's savviest

investors out of 700 million dollars.'[1] The crimes of this mini-Madoff received more than the usual levels of press coverage because among his named victims were celebrity singer Justin Timberlake, comedian Bill Cosby and film director Tim Burton, as well as Manchester United Football Club and the New York Mets baseball team.

Dreier would be sentenced to twenty years in prison in July 2009. But what concerned Simon now was the announcement of the immediate dissolution of his law firm. At once, he rang Redniss, who told him that Dreier's Park Avenue offices had been sealed, and that the lawyers who worked there had not been paid. Redniss was talking to Simon from Starbucks, where he was sitting alongside Kerr and Weiss. The three lawyers were working on their laptops because all the documents relating to the Warhol case were sealed inside the building. At that very moment, they were trying to find a new law firm to take Simon's case.

They succeeded. Weiss and Kerr found positions at the New York office of Browne Woods George; Redniss stayed with his practice Redniss and Associates. Simon was the first client of BWG's New York office and, since the firm had no premises in the city, Redniss and Kerr found an office from which to work – a run-down building on West 37th Street, where they would have to manage without the backup team of researchers and paralegals they had been used to at Dreier's. Simon helped to 'build' the office they worked in, creating dry walls and carrying second-hand furniture. Theirs was obviously a hand-to-mouth enterprise, but Redniss negotiated a new retainer agreement on Simon's behalf, assuring him that the contract was fair. The case could now move forward.

By the start of 2009, Simon had built a strong case based on what he believed to be irrefutable evidence that the *Red Self-Portraits* were authentic. If the dispute came to trial over the issue of authenticity, there was a good chance he could prevail.

Evidently, the legal team representing the Andy Warhol Foundation thought so too. Or, at least, Wachs did. In December 2008, Dreier's arrest had forced Simon to change law firms. Now, the Foundation would do the same, though for a very different reason.

On 22 October 2009, the *New York Review of Books* had published the article in which I revealed that Warhol had chosen the 'Bruno B.' *Red Self-Portrait* for inclusion in Crone's 1970 catalogue raisonné, as described in Chapter 17. Coincidentally, the following day, the Andy Warhol Foundation announced that it had filed a Motion for Substitution of Counsel with the court; they wanted to change their lawyers.[2] At the time, I paid no attention to these dates. But they are significant. Simon hired Browne Woods George in January 2009. Their brief was to fight a lawsuit against a Foundation represented by Carter Ledyard & Milburn – a blue-chip law firm with a centuries-old history and a reputation for fair play. Ten months later, Simon's three-man legal team found themselves up against Boies Schiller Flexner – the most aggressive, ruthless and expensive law firm in the United States.[3]

Lawyers for Carter Ledyard & Milburn had already spent months looking at evidence that seemed to prove that Warhol acknowledged the 1965 series as his own work. It is hard to understand why they were replaced – unless, as they were ethically obliged to do, they told Wachs the truth: that, if the case were fought over the issue of authenticity, the Foundation might not win. Did lawyers for Carter Ledyard & Milburn get the sack because they advised the Foundation to settle? What is certain is that Wachs omitted to tell the Foundation's insurers, Philadelphia Indemnity, that he had changed lawyers. Nor did he mention the astronomical fees charged by the new law firm. Since he was required by the terms of the insurance policy to do both, his failure to notify them of the change would, in time, land the Foundation in yet another lawsuit.

Chapter 24

'A premeditated and underhand ploy'

THERE WAS ANOTHER LETTER in the 19 November 2009 issue of the *New York Review of Books*. At the time, I had been so preoccupied with disproving Wachs's efforts to cast doubt on my integrity that it didn't seem important. Back then, I still considered Printz and King-Nero answerable only to the charge of a having a hit-and-miss approach to research. But, when I read the overlooked letter again, I began to see them in a different light. It was written by someone called David Mearns. The name meant nothing to me, but Google filled me in. He was a famous underwater archaeologist who filmed his discoveries of wrecked ships and, if the vessels were modern, lifted them from the seabed to sell for the considerable value of their metal. In front of a camera, Mr Mearns came across as a mild-mannered geek. But, in his letter to the *New York Review of Books*, he was tough, to the point, and lethally eloquent.

His family owned one of the eleven 1965 *Red Self-Portraits*. In the spring of 2004, Mearns explained, they had been surprised to receive a letter from the Board inviting them to submit their picture for authentication. They did not understand why. The

family had never tried to sell the painting and they'd had no contact with the Authentication Board. But David Mearns is an innately cautious person. He persistently questioned the Board's intentions – and, by doing so, saved the family's picture from being defaced with a DENIED stamp. In words that still burn with indignation, he wrote that the Board's 'seemingly straightforward letter was ultimately exposed to be a premeditated and underhand ploy to deauthenticate our picture.' How David Mearns realised what they were up to, I do not know. I suppose what made him suspicious was the Board's insistence that his family submit the picture. The important thing is that he smelled a rat and refused.

David Mearns's account perfectly accorded with Joe Simon's story. But, unlike Simon, Mearns quickly understood that the Authentication Board was 'more interested in protecting its skin than in honouring the artist's last wishes and advancing the scholarship of his work.' Like other correspondents, he pointed out that the Foundation was spending a fortune defending 'self-inflicted lawsuits' when the money could be used for charitable ends, as Warhol had intended. The first time I read his letter, I was grateful to David Mearns for taking the trouble to write, but that was all. I might easily have overlooked it had Joel Wachs not written a reply, which was duly published in the *New York Review of Books* on 25 February 2010.

Wachs had a sort of genius for calling attention to the very things he most wanted to hide. As usual, his tone was shrill, his accusations vile. He began by calling Mearns a liar: 'Mr Mearns's allegation that the Andy Warhol Art Authentication Board somehow "conspired" with the Andy Warhol Foundation to deauthenticate his work is an utterly false, reckless claim, and completely unsupported by the facts.' I read on, expecting him to tell us what the true facts were. But, in the rest of the letter,

Wachs did not offer a single 'fact' to counter what Mearns had said. Instead, he changed the subject, telling us that the Board was comprised of 'experts in the field, noted for their integrity and scholarly excellence', and that these paragons conducted 'thoughtful, reasoned analysis of each work to reach decisions that are completely independent, by design, from the Foundation'. He then went on to bluster about the good works supported by the Foundation (which no one had questioned), ending with a flourish: 'Mr Mearns's views are a damaging distortion of the truth and are motivated by his own economic self-interests that don't stand up to the facts.'

Two things leapt out from Wachs's tirade. The first was that he wrote it at all. Why single out David Mearns? His straightforward account of his family's brush with the Board struck me as far less trenchant than other letters published in the same issue. That led me to wonder whether there was something in Mearns's letter to which I should have paid more attention – something that worried Wachs so much, he needed to denounce the writer with a violence far in excess of anything he had written in objection to my article. I reread Mearns's letter and found nothing. So, I went back and read Wachs's letter again. Then I saw it. As far as the Foundation was concerned, David Mearns represented a far deadlier threat than I did. He was their worst nightmare.

Simon's pending lawsuit against the Foundation was not only about whether the 1965 series was authentic. It was also about whether the Foundation was attempting to control the market in Warhol's work. The case hinged on whether, knowing that the 1965 'Bruno B.' *Red Self-Portrait* was in fact authentic, the Board suppressed this primary evidence of Warhol's working methods in the mid-1960s. If so, their cover-up worked in three ways. First, they defaced the picture by stamping it with the

word DENIED; then, they silently deleted the picture from the catalogue raisonné, as if it had never existed; finally, they contacted owners of other paintings in the series, inviting them to submit their pictures to the Board with the deliberate intention of mutilating them. It was for the last reason that Mearns's letter was so dangerous.

In truth, Mearns was a successful businessman who had not tried to sell his family's painting, nor indicated any intention of doing so. He had written to the *New York Review of Books* to describe his personal experience of how the Board operated. Wachs needed to smear him because what Mearns had to say undermined the credibility of both the Board *and* the Foundation. More than that, his letter raised new and potentially devastating questions about the Board's conduct.

To understand what caused Wachs to react with such fury, I looked again at the dates mentioned in the Mearns letter. On 21 May 2002, the Board denied the 'Bruno B.' painting. That much we knew. What we had not known was that, after that date, the Board continued to solicit owners of other pictures in the same series. As had happened with Simon, they targeted people with invitations to submit pictures for authentication in the full knowledge that they would be denied.

In his denunciation of David Mearns, Wachs made a dangerous mistake. He said that the Mearns *Red Self-Portrait* was 'one in a series of works that the Board determined were not the work of Andy Warhol'. But the Board had never actually seen Mearns family's painting. If Printz and King-Nero already knew that it wasn't a Warhol, why had they invited the family to submit it for authentication? Their only possible purpose could have been to gain physical possession of the Mearns family's private property with the express purpose of rendering it worthless. Conspiring to defraud in this way could be considered a crime.

There were other things in Wachs's letter that I found odd enough to investigate further. After denouncing Mearns, he went out of his way to stress that the Board and the Foundation were separate and independent charitable organisations. Until then, it had not crossed my mind that there might be something irregular about the way in which the Foundation and the Authentication Board had been set up. Now, I began to look with more attention at the relationship between them.

For the second time, a letter from Wachs electrified me. It raised so many new questions that I knew I could not stop writing about the case now. By this time, museum directors and curators, collectors, auction houses, gallerists and serious academics were paying attention to the drama unfolding in the letters pages of the *New York Review of Books*. The more Wachs wrote, the more it looked to me as though the Foundation had a lot to hide.

Wachs's denunciation of David Mearns had one immediate result: Mearns's sister, Susan Shaer, joined Simon's antitrust action against the Andy Warhol Foundation, Vincent Fremont and 'all past and present members of the Authentication Board who knowingly participated in, or wilfully ignored an alleged thirty-year scheme of fraud, collusion and manipulation of the market in works of art by the late Andy Warhol.' The decision to file this suit had not been made when David Mearns wrote to the *New York Review of Books* in November. It was filed on 15 January 2010, after Shaer had read Wachs's letter.[1]

Chapter 25

The Defence

WHEN TOLD BY SETH REDNISS that the Foundation hired David Boies, Simon asked his lawyer what the firm was like. 'This won't be about the authenticity of your painting. Are you prepared to be pummelled on a daily basis?' As Gillian B. White explains in her coruscating examination of David Boies' career in the *Atlantic*, where most big law firms try to settle expensive or high-profile cases out of court, BSF [Boies Schiller Flexner] boasts that they regularly take cases to trial. The company website informs potential clients and job applicants that they like to hire 'attorneys who are eager to get into a courtroom or deposition as soon as possible, rather than someone who would be more comfortable behind a desk'. The chairman, David Boies, is probably the most famous lawyer in the United States. His hourly rate in 2017 was $1,850. Stories of his vicious tactics make entertaining reading – but only when you are sitting safe at home, with the doors locked.

Wall Street Journal reporter John Carreyrou's devastating exposé, *Bad Blood: Secrets and Lies in a Silicon Valley Startup*, recounts in chilling detail the ways in which Boies and his

firm intimidated and, in some cases, terrified a client's whistle-blowers.[1] Theranos was a private health technology corporation that raised more than $700 million by falsely claiming to have developed revolutionary blood tests that required only small quantities of blood. When the bad science behind the claim was exposed, investors sued. David Boies was on the board of Theranos. Boies Schiller Flexner represented the company in the case. According to the *New York Times*, Boies' partners sent letters threatening suspected talkers [informers] with litigation if they disclosed trade secrets or confidential information. One whistle-blower, a man in his twenties, incurred several hundred thousand dollars in legal fees.[2] Boies personally sent the *Wall Street Journal* a twenty-three-page letter 'advising' the paper not to publish Carreyrou's articles, raising the threat of a lawsuit if it did.

Carreyrou uses the word 'thug' to describe David Boies. In another case investigated by Carreyrou, Boies turned a business dispute between his client and the owner of a small Palm Beach lawn-care company into 'a federal racketeering lawsuit in which he accused the man and three of his gardeners of conspiracy, fraud, extortion, and . . . violating antitrust law.' The case was thrown out of court, but Boies appealed the verdict, suggesting that, in the US, you do not have to win a lawsuit to bring financial ruin on your opponent.

In 2018, when the documentary film-maker Alex Gibney decided to make a film of Carreyrou's book, he hit a brick wall. According to Gibney, David Boies 'had terrified everyone . . . [They were] convinced that if they talked to us and said critical things about the company . . . David Boies would sue them.' Gibney goes even further: 'David Boies likes to say that the law defends the poor, the infirm, the underdog. No. Most often the law is there to buttress the powerful. And that's how it was used

in this case, to silence the whistle-blowers. Nobody wanted to come forward. It was very hard.'[3]

In 2017, Boies was again in the news for having helped rapist Harvey Weinstein suppress or modify a *New York Times* story naming him in a series of sexual-assault allegations. With Boies' help, Weinstein allegedly paid a firm of private investigators, Black Cube, initially to follow women who had accused him, and later to help Weinstein scupper the publication of a negative article in *the New York Times*. The *New York Times* further alleged that Boies used ex-Mossad agents employed by Black Cube to carry out surveillance on the journalists working on the Weinstein story.[4] At that time, Boies Schiller Flexner also represented the *New York Times*. While employed as a legal adviser to the paper, Boies was personally involved in an undercover operation to smear Weinstein's victims and to deceive *New York Times* reporters. When the newspaper learned that he was also working for Weinstein, the editor fired the firm publicly, accusing the company of 'intolerable conduct, a grave betrayal of trust, and a breach of the basic professional standards that all lawyers are required to observe.'[5]

When I read this in 2017, I had a flashback. Soon after the *New York Review of Books* published my first article in 2009, I began to hear a loud intermittent 'click' while I was on the telephone in my upstairs office. It never happened on our other telephone line, which we used for domestic calls. At first, I thought it must be a fault in the line, then decided I was imagining things. But, when it persisted, I wondered whether my phone was being tapped. Again, I dismissed the idea and, after a few weeks, the clicks stopped. Now that I have read about Boies' methods, I feel certain that my suspicions were right. There must be ways to tap a telephone that are not audible to the person whose conversations you are illegally listening to. The clicks on my phone

were so loud I could not have missed them. I can only assume that whoever was doing it wanted me to know they were there.

In papers filed with the court, the Foundation said it spent at least $200,000 on private investigators to follow Simon. Listening to my telephone calls must have accounted for a minuscule amount of their budget. In general, their efforts were more comical than sinister. One afternoon in 2010, a dirty white van with blacked-out windows parked for hours outside Nick Rhodes's house. The same van returned to the same spot every day for weeks. One afternoon, Rhodes and Simon went for a walk. Soon, they became aware that they were being followed. One of the men in the van trailed behind them on foot with a camera and telescopic lens. What the investigators had not counted on was that rock stars are used to being followed and photographed. Rhodes had an instinct for spotting who was a fan or a paparazzo and who was not. Outside his house, you usually saw a gaggle of teenagers hoping to get his autograph, so the white van and its camera-toting gumshoe did not faze him in the least. In fact, Rhodes thought the whole thing so absurd that he wrote a song about it. 'Being Followed' is on Duran Duran's 2010 album, *Paper Gods*.

Chapter 26

A Mountain of Mud and Misinformation

IN THE SPRING OF 2010, pretrial depositions began. These are a vital part of the discovery process, the first time witnesses for both the prosecution and for the defence are questioned by counsel. Witnesses testify under oath. Their testimony will be used in the courtroom if the case goes to trial, so, if they lie, they can be jailed for perjury. For *Simon v. the Andy Warhol Foundation*, most depositions took place in the sleek New York offices of Boies Schiller Flexner, on the seventh floor of a prestigious building in midtown Manhattan.

Witnesses deposed on behalf of the Foundation were led into intimate, beautifully appointed rooms, where they were questioned in private. Archibald Gillies, former president of the Foundation, was interviewed in a small room that resembled the library of a gentlemen's club. But not Simon. He was steered into a nondescript space that looked like a theatre or a lecture hall. The lighting was harsh, and he was given a seat where the light shone directly into his eyes. Dozens of observers came and went while he was testifying, but Simon never knew whether they were employees, clerks, or perhaps law

students. The purpose, of course, was to make this witness as uncomfortable as possible. Other witnesses testifying for Simon were treated with civility and sat in ordinary offices. Sometimes, other participants were present, sometimes not. Everything was taped and a court stenographer made a record of every interrogation, which was then made available to both the prosecution and the defence. If Simon could not attend a deposition, the first time he learned what witnesses like Wachs and Fremont said was when he read these court transcripts.

Whenever the intervention of the court was necessary – for example, when there was a complaint by one side about the behaviour of the other – the scene shifted to the United States Courthouse, at 500 Pearl Street, in Lower Manhattan. Twenty-seven storeys high and with forty-four courtrooms, it is the second-largest courthouse in the US. There, the opposing parties assembled in a traditional courtroom, with benches on either side of a central aisle. Journalists and students usually sat on the left, facing the courtroom, with a divider between the 'audience' and the lawyers and court reporters.

As Redniss had foretold, lawyers for Boies Schiller Flexner showed no intention of fighting the case over the authenticity of Simon's painting. His first intimation that this would happen was during the pretrial discovery process, when they did not ask Simon to produce anything from the mountain of material he had accumulated during the years he had been researching the history of the portrait. Instead, they asked only for items related to his personal life – diaries, letters and emails to and from friends. Their strategy was to avoid the *Red Self-Portraits* entirely. In fact, they did everything they could to ensure that Simon's lawyers were scarcely able to raise the issue over which Simon had brought the case against the Foundation.

Just as they would do with Weinstein's accusers, in addition to

the phone tapping and surveillance, Boies Schiller Flexner hired private investigators to find dirt to sling at Simon when deposing him. The aim was to bury the real issue – authenticity – under a mountain of mud and misinformation. Simon's counsel, Brian Kerr, would describe his ordeal to the judge as 'a barrage of absurd false accusations and hurtful personal attacks designed to disrupt and derail [the] discovery process'.[1]

The main court dates coincided with the hottest days of an unusually hot summer. Simon was living at a friend's apartment on Central Park West. Each morning, he took a taxi downtown, and, if he was going as far as Pearl Street, he would sometimes stop in Chelsea to pick up Kerr, who sometimes slept in his office rather than make the long commute to his home in East Hampton. In contrast to Kerr's rumpled and unshaven appearance in the morning, Redniss always took care to be groomed, polished and dressed in style. If the deposition took place in Boies Schiller Flexner's offices, they would meet in the coffee shop opposite before walking in together – as though each needed the reassuring presence of the others.

Inside, Simon came face to face with the lead counsel for the Foundation. Nicholas Gravante Jr, a big, heavyset man with a fleshy face, is a feared and formidable litigator. Before working for Boies Schiller Flexner, he had been an attorney in the main law firm that represented the Gambino mob family.[2] He had defended mobster John Gotti and his colleague Sammy 'The Bull' Gravano in their trial for murder. When the Gambino family *capo* Michael ('Mikey Scars') DiLeonardo thought he was about to be arrested, the lawyer to whom he turned for advice was Nicholas Gravante Jr.[3] Several years after Simon's case, Gravante would be in the news for suing his own mother for defamation.[4] Now, his brief was to destroy Simon's credibility by annihilating his character.

Whether he had an outstanding legal brain I am not able to say, but, after reading the court transcripts, I can report that he has a gift – Shakespearean in its range and eloquence – for threatening witnesses by using imagery colourful enough to make their blood run cold. The first time I read his name, in an article about the case written for the *Guardian* by Adrian Levy and Cathy Scott-Clark, he was in mid-threat: 'We're coming after [Simon]. We'll extract millions in a counter-suit for wasting our client's time in fighting a spurious case.'[5]

One stark fact emerges from the transcripts of Gravante's interrogation of Joe Simon at the pretrial procedures. Not once in the many hours he deposed Simon did Gravante present anything like a serious or sustained challenge to the factual evidence proving the picture's authenticity, which was presented by Simon's lawyers and backed up by creditable witnesses. Instead, Gravante used his cross-examination to deride, denigrate, defame, libel and smear Simon.[6] He asked him if he was a murderer. He accused him of having stolen the *Red Self-Portrait*, of creating the fake 'Dollar Bill' collage himself and of being on Interpol's list of 'most wanted' criminals. Had any one of these charges been true, it would have been easy to prove. Given that the allegation regarding the Interpol arrest warrant was made in a federal courtroom bristling with policemen, Gravante could simply have called the police during recess. But Gravante hurled the accusations without offering anything resembling evidence to substantiate them. When Kerr objected that these wild allegations amounted to no more than a diversion from the issue of authenticity, Gravante scarcely broke stride.

At last, Kerr wrote to the magistrate in charge of the discovery process, the Honorable Magistrate Judge Andrew J. Peck, to complain. His letter vividly captures Gravante's style during the deposition. At one point, he describes Gravante's relentless

hectoring of Simon with a spurious allegation that there are warrants outstanding for his arrest in a foreign country for the murder of local teenagers. In fact, Simon had only been to that country once, ten years earlier, for a two-week vacation. Simon calmly replied that there were no warrants. It was a ridiculous suggestion. But Gravante did not desist. He did not amplify the question or add any details, but simply repeated it. As Kerr told the judge, it was pure nonsense. Had there been an arrest warrant, as Gravante claimed, Simon would have been detained on the spot. That is the law.

Simon never lost his cool. He denied each slur as it was delivered, and the more politely he answered, the more enraged Gravante became. The sheer nuttiness of Gravante's line of questioning made it possible for his victim to distance himself from his insults.

That was only on day one. On day two, Gravante badgered Simon to answer questions about errors in the material he had submitted to the Authentication Board. As before, Simon retained his composure, even when replying to the same question, over and over. Yes, he did make minor errors in haste, *but none of the errors in any way helped to support his case.*

Gravante had not asked him for that last observation – and he did not want it included in the court transcript. While Simon sat watching in amazement, Gravante had a public meltdown. A full-on tantrum. It happened after Kerr raised an objection to Gravante's behaviour:

KERR: . . . you [are] harassing the witness, you're physically shaking right now, so you can continue your examination without harassing him.

GRAVANTE: I'm not physically shaking.

KERR: No, he [Simon] has answered your questions.

GRAVANTE: Don't interrupt. He is volunteering information . . .

KERR: It's clear he answered your question.

GRAVANTE: He answered my question. That's not the point. He is also volunteering information that I did not ask him about . . .

KERR: I'm not going to argue with you.

GRAVANTE: You are arguing with me . . .

KERR: You're on the clock, so go ahead.[7]

At that point, Gravante started screaming, 'I'm on the clock? I'm on the clock?' He then threw his pen across the table. Next, he asked for a five-minute break, so he could regain his composure. After that, the deposition resumed.[8]

The purpose of Gravante's theatrics was to ensure that there was no time to discuss the substance of Simon's case against the Foundation. He spent a lot of time accusing Simon of not owning or being in possession of the Red Self-Portrait. So Simon submitted to the court the invoice from Michael Hue-Williams, the London dealer who had sold it to him.[9] Gravante claimed it was fake. He gave as his reason a small detail: the address on the typed invoice was incorrect. The street name was correct, but the house number wrong. Simon would not have noticed the error, because the invoice had been faxed to him. Under ferocious grilling by Gravante, Simon patiently explained that *he* had not typed the invoice, the art dealer's *secretary* had – and she had made a small error. Gravante didn't give up, overlooking the illogic of his line of questioning – for, had Simon been clever enough to forge the invoice, surely he'd have given his *correct* address.

Still not satisfied, Gravante insisted that, during the lunch break, Simon telephone Hue-Williams in London. That was

a miscalculation. Responding at once by email, the art dealer affirmed that he had sold Simon the picture and offered to fly to New York at his own expense to testify to that. The dealer became, in effect, a further witness to the authenticity of the painting, closing his email with the observation that the stamping of DENIED on the painting 'was a scandal – as they have damaged a real work by the artist which they have no right to do – I am frankly disgusted. I stand by the facts and would be happy to come and recount them in a court – should this be needed.' Gravante did not take Hue-Williams up on his offer.

This was because the whole performance had been staged. Gravante already knew Joe Simon owned the picture. He knew too that the invoice was not forged. In his deposition, Neil Printz admitted that he was fully aware that George Frei, his co-editor of the 2004 catalogue raisonné, had visited Simon's London home in 1996, taken photos of the portrait and completed an on-the-spot examination sheet detailing the size of the canvas and the condition of the picture. The Authentication Board possessed Frei's examination sheet and photos. Despite a clear court order to hand over all documents regarding the *Red Self-Portraits* or any other relevant works deemed by the Board to be fake, Gravante denied having 'any knowledge or information sufficient to form a belief as to the statements made by George Frei to the Plaintiff.'

On it went. The Foundation's lawyers stated that there was no proof Simon owned the painting before 2000, although they were fully aware that Frei had viewed it twice – once at Michael Hue-Williams's gallery on Cork Street, and again in Simon's home. Documents proving Simon's ownership were in a database belonging to the Foundation. Whether by negligence or design, these documents were never seen either by Simon's

lawyers or a judge. When King-Nero and Printz admitted the truth during their depositions, Magistrate Judge Peck said nothing.

The same thing happened with two computer databases relating to the catalogue raisonné, crippling the ability of Simon's lawyers to put his case to the court. Towards the end of the hearings, under court order, lawyers for the Foundation handed over exactly twenty-nine documents out of the tens of thousands they'd been asked to provide. Of those that were produced, many were heavily redacted. At no point during the proceedings did Magistrate Judge Peck sanction or even repri-mand the Foundation's lawyers.

Lawyers for the Foundation also produced 'evidence' of wrongdoing on Simon's part. The source of one of these slurs was particularly surprising. Horst Weber von Beeren was the former Warhol employee who had worked for Rupert Jasen Smith from 1978 to 1985. His hostility to the Board was public knowledge. Interviewed by Michael Shnayerson for *Vanity Fair*, he was quoted to devastating effect in Paul Alexander's article in *ARTnews* and he had appeared in the BBC's *Imagine* programme about the case. When Simon started his website My Andy War-hol, von Beeren had handed over documents and photos for him to post online. Simon was therefore stunned to learn that von Beeren had written an affidavit to the court stating that Simon had asked him to destroy these documents, an obstruction of justice. That was incorrect. Why would Simon destroy docu-ments he had already posted on his website so that as many people as possible could see them?

Simon needed to ensure that von Beeren had not been coerced into signing this affidavit, so his lawyers asked Boies Schiller Flexner to make von Beeren available for deposition. They refused, even though he was *their* witness. Kerr then asked

for von Beeren's last known address but received no response. For weeks, Simon's counsel tried to serve the printer with a subpoena, but he was nowhere to be found. When the judge complained that the court needed to depose von Beeren, Gravante claimed he had disappeared: 'We have tried to call him this week. We understand he may be in China'.[10]

The pattern was repeated in depositions on behalf of the Foundation. Fremont claimed to have deleted his email correspondence with Simon. That made it impossible for him to produce his emails in the pretrial proceedings. Yet, during his deposition, he quoted freely from the very emails to and from Simon he claimed had been deleted. These would still have been available on his hard drive, but, even so, they were not handed over as required by federal law. Magistrate Judge Peck did not appear to intervene or make any further disclosure orders. With Peck presiding, Gravante's flouting of legal procedure did not result in a mistrial.

Those who came to court in support of Simon were not attacked in the same way as he was, but they too were subjected to long hours of questioning. Rainer Crone flew in from Europe at his own expense to testify. The art historian was then sixty-eight years old, overweight, asthmatic and severely diabetic. During his testimony, he had to stop frequently to eat fruit and to breathe from a hand-held oxygen mask. Despite his infirmity, he was deposed from eleven thirty a.m. until seven in the evening. Yet Crone stood up to the lawyers, held his ground and had his say.

Paul Morrissey, seventy-two years old at that time, had recently come out of hospital after being hit by a car. Walking on crutches, ornery as a wounded grizzly, he too was subjected to a day of punishing testimony. The defence lawyer questioning him was courteous, but Morrissey did not bother to conceal

his irritation at the way he kept repeating questions that had already been answered:

> Keep going with more of your great questions. You're not vaguely interested in the painting and the problem of the painting and the fact that I was a participant in the creation of this thing. That's the last thing you're interested in, I realise. You don't want me to go there. I know about the painting. I know how it came about. What else would I talk about? That's what I'm here to talk about, but I'll never talk about it obviously unless I push it [into the testimony].[11]

Morrissey did not *care* why Warhol made the pictures, he said, or to whom the artist gave them. The only thing Morrissey had come to say during his deposition was that he had been present when Warhol gave the printer instructions over the telephone as to the colours to use, just as he had described in his letter to the Authentication Board. Morrissey would only testify to what he had seen and heard relating to the actual circumstances under which the pictures had been made. He also made it clear that he hardly knew Joe Simon: they had met twice, on each occasion briefly.

In fact, Morrissey said nothing he had not already written in his letter, except for the following enjoyable exchange: when asked whether Warhol's amanuensis Pat Hackett had typed up diary entries written by Andy Warhol, Morrissey snapped, 'Andy never made any diary entries. I don't think he could read or write. He talked on the phone to Pat Hackett and she made up diary entries.' Startled, the lawyer then asked, 'Mr Morrissey, is it your recollection that Mr Warhol could not read or write?' To which Morrissey replied, 'I'm not sure of it, but I'm pretty sure. He didn't do it easily if he did.'[12]

Neither Crone nor Morrissey gave an inch. Each had come to court to put his testimony on the record. What each had to say was crucial to Simon's case. Lawyers for Boies Schiller Flexner spent long, lugubrious hours grilling them, hoping to find inconsistencies or contradictions in what they had to say. They got nowhere. And what, after all this, did Gravante have to show for his efforts? He had certainly browbeaten Simon and any witness who appeared in support of his case, but, because his strategy had been to ignore the question of authenticity entirely, the Foundation had not even tried to elicit any testimony undermining Simon's claim that the *Red Self-Portrait* was authentic. Unless the Foundation hit on a way to bring the lawsuit to an end before the summer was over, it would go to trial before the other judge, Laura Swain, and they might all be held to account. They could not allow that to happen.

Chapter 27

Senior Moments

THEN IT WAS TIME for Kerr and Redniss to question witnesses for the Foundation. In contrast to Gravante, their questions focused on how the Foundation worked and how the Board went about authenticating Warhol's art. The questioning process was not easy, because BSF, the defence lawyers, had prepared those who appeared on behalf of the Foundation, allowing them to give their answers using what appeared to be formulaic wording that threw the gossamer veil of deniability over what was said. Reading transcripts of their testimony is a tedious and, for the most part, unenlightening experience. Time and again in their depositions, the phrases 'I do not recall' and 'to the best of my recollection' wrap their answers in skeins of evasion and circumlocution. From long experience, both as a lawyer and a politician, Wachs was skilful at parrying questions and avoiding giving clear answers.

At times, evasion is almost indistinguishable from perjury. When Brian Kerr deposed Joel Wachs, for example, he first established that Wachs had served on the Foundation's board of trustees since December 1995, becoming president in 2001.

Kerr asked Wachs a simple question about the chairman of the that board, Michael Straus: 'What was his background?' When Wachs seemed perplexed by the question, Kerr elaborated:

> KERR: He has a job, right, besides being chairman of the board?
> WACHS: I don't know all his background. I know that he practised law in Birmingham, Alabama . . . I don't know that he continues to practise. Maybe selectively. You'd have to ask him.

When Kerr insisted Wachs answer the question, Wachs replied:

> WACHS: I don't know, I really don't. I don't know . . . I don't know. My answer is I don't know.
> KERR: But is he a lawyer?
> WACHS: He is a lawyer.
> KERR: He's an antitrust lawyer, right?
> WACHS: He has familiarity with – with some – with some antitrust work, yeah.

Wachs knew what Michael Straus did for a living. The information was on the Foundation's website. Straus is an antitrust lawyer who was then a partner in the Alabama law firm of Straus and Boies. It was the name of Straus's law partner that Wachs did not want to utter in court. David Boies III was the son of the lawyer who was charging the Foundation, of which Michael Straus was chairman, about $450,000 a month to represent them in the case. I expect Wachs would not admit he knew this because, if he did, Kerr could bring up an issue the Foundation preferred not to discuss: a flagrant but undeclared case of conflict of interest.

Wachs, under oath, was true to form. Whenever an opportunity arose, he said or implied that those who challenged the Board's decisions did so with criminal intent. He knew, as everyone on the Authentication Board knew, that Simon had submitted the 'Dollar Bill' piece to the Board more than once. Each time, he had begged the Board to explain to him the reasons for denying its authenticity. On each occasion, the Board had told him to do more research, and then to submit it again. That's not what Wachs said. In his telling, Simon 'may have' forged the 'Dollar Bill' piece.[1] Kerr questioned Wachs about the Board's authentication of the Malmö-type *Brillo Boxes*, now known to have been manufactured after the artist's death. He asked Wachs whether, in that instance, Wachs would characterise the decision made by the Authentication Board as a 'mistake'. Wachs replied that although their opinion was wrong, their decision to verify the authenticity of 105 fakes was not a mistake.

For the Foundation to refer pictures to the Board for authentication, the correct procedure was to fill in and sign a submission form. Fremont did not have the authority to submit pictures to the Authentication Board, and he did not say who did. In the case of forty-four fake pictures, which will be discussed in the next chapter, the signature on the form was that of K. C. Maurer, chief financial officer and treasurer at the Andy Warhol Foundation.

The name was new to me. Maurer came to the Foundation in 1998, from NASA. At the time of her deposition in 2010, she was paid $365,131 per year, plus pension and benefits, not only to oversee the Foundation's finances, along with an outside firm of accountants, but also to appraise works by Warhol. During the hearings, Maurer always sat next to Wachs, never once leaving his side. For her first appearance in court, Maurer chose to carry

a handbag conspicuously imprinted with Andy Warhol's *Gun* depicting a handgun used so often in muggings and robberies during Warhol's lifetime that it was known in the street as a 'Saturday-night special'.

Kerr started by asking what qualified her to pronounce on the value of Warhol's work. Her reply was in keeping with the previous experience the Foundation required of so many of its employees: she had no qualifications whatsoever, except that she read Christie's sales catalogues. But Maurer did have experience as a high-powered executive, which meant she knew how a Foundation with assets – worth an estimated billion dollars, in 2010 – functioned. She understood the importance of following procedure. Just from reading her CV, my instinct told me she was not the kind of employee who would make a unilateral decision on a matter of such importance.

Kerr did not waste any time. He asked Maurer whether she was the person who submitted the forty-four fakes to the Board on behalf of the Foundation. Under oath, Maurer flatly denied it. Kerr then showed her documents listing numerous works in the Foundation's inventory which were submitted to the Authentication Board in the autumn of 2002. They included the forty-four fakes.[2] *Every single one had been submitted under Maurer's name and every single one bore her signature.*

Without missing a beat, Maurer calmly stated that she 'did not recall' having signed those submission forms. Notice her choice of words. To say that you do not 'recall' signing something is not the same as stating that you did not sign it. Incredulous, Kerr asked her the same question again. She repeated her denial. This time, she added that perhaps someone *else* had submitted the pictures on her behalf, presumably by forging her signature on the form. Kerr asked which staff members at the Foundation had the authority to submit works to the

Authentication Board. Her reply was unambiguous. Only two people had such authority: she was one, Joel Wachs the other.[3] Fremont had said the same thing, adding that he could only sell a picture with Wachs's approval. 'The fact is I can't sign off on a deal; the last person to sign off on a deal – a negotiation – is Joel Wachs, the president of the Foundation.'[4]

Was it Wachs? His testimony came next, and now Kerr asked him the same question he had put to Fremont and Maurer. Had he ever submitted work confiscated from Rupert Jasen Smith to the Board? Wachs appeared to be indignant at the very *idea*. He claimed that the Foundation only rarely submitted works of art to the Board for authentication. In her deposition, Maurer had mentioned a Warhol painting of a candy box as one of the pictures sent from the Foundation to the Board for authentication. Now, Wachs claimed that he had been *shocked* to hear that. So, Kerr changed tack. When a painting owned by the Foundation was submitted to the Authentication Board, 'is that something you need to approve?'

Wachs brushed the question aside without answering it. 'I'd like to be informed of that, at least. I don't have to be the actual physical person to do it, but I'd like to know of it. I just don't recall – I didn't recall the one instance [the *Candy Box*] that she mentioned . . .' Then, for the fourth time, Wachs stated categorically that, apart from the *Candy Box* – the submission of which had come as a total surprise to him – he could recall no other instances when the Foundation had submitted *any* works to the Board for authentication. Kerr looked at him in disbelief.

Chapter 28

Forty-Four Fakes

BRIAN KERR'S INTERROGATION of the dealer Vincent Fremont on 7 July 2010 was more focused than usual, in the sense that he mainly questioned the witness about a group of forty-four paintings which the estate of Andy Warhol had seized from their original owner on the grounds that they were forgeries. Primed with incriminating information he had found during the discovery process, Kerr never asked Fremont a question to which he did not already know the answer. Because of the specific nature of Kerr's questioning, Fremont realised – or suspected – as much. He was on his guard, but also under oath. If he perjured himself and the case was to go to trial, a lie would be exposed. Would Fremont risk that, or would he tell the truth?

To understand what happened in the next few minutes, we must go back in time to 25 September 1991, when Fremont, on behalf of the Warhol estate, wrote to Rupert Jasen Smith's executor, Fred Dorfman, and his heir, Mark Smith. Fremont's letter demanded that they hand over forty-four designated paintings from Smith's studio. A fine-art printer of genius, Smith's gift as a colourist far surpassed that of any painter of the period.

Good-looking, talented and amoral, he cheated Warhol and other artists by creating and selling unauthorised prints of their work on an industrial scale. Whether this group of forty-four paintings had been made during Warhol's lifetime or after his death in 1987 is not known. But, when Smith died in 1989, they had become part of the printer's estate. Fremont seized the pictures on behalf of the Foundation because they were 'not the work of Andy Warhol', and, as his letter went on to say:

> because of the similarity of the paintings to authentic works by Andy Warhol, their release might threaten the integrity of the art market and Andy Warhol's reputation. Accordingly, the Warhol Estate has requested that you relinquish any right, title or interest you may have in the Paintings and assign the same to the Warhol Estate . . . by signing this letter you confirm said agreement, release and assignment. We appreciate your cooperation in this matter.

As requested, Dorfman personally turned the pictures over to the Warhol estate, without asking for or receiving compensation. In his letter, Fremont wrote: 'the Warhol Estate came to the opinion that the paintings are not the work of Andy Warhol, and, as provided in the letter of agreement, a legend to this effect has been endorsed on the reverse side of each canvas'. In plain language, the confiscated works had been stamped with the word DENIED to reflect the estate's judgement that they were fakes.

But there was a catch. The Warhol estate's stamp was entirely different from the one later used by the Authentication Board to stamp Simon's painting. The crucial difference is that works such as Simon's painting were impressed with indelible red ink. Works owned by the Foundation, on the other hand, were

lightly stamped *Warhol Estate* using soluble ink, which could be easily removed with water if, for example, the Board changed its mind or if for any other reason the Foundation decided to sell these works as genuine.[1] In the Foundation's own words, the stamp could be made to disappear 'if circumstances warrant'.[2]

The forty-four works in question were paintings on canvas, including such famous images as Warhol's 1986 *Fright Wig* self-portrait, a large-scale example of which Sotheby's sold on behalf of the designer Tom Ford, in May 2010, for over $32 million.[3]

All this Kerr knew. His purpose in grilling Fremont was to force the dealer to say in his own words what happened next. Fremont could have lied. He could have said that he had no recollection of what happened to the pictures. But he didn't. Instead, he recalled that the more he looked at the works seized from the studio of Rupert Jasen Smith, the more he came to feel that they resembled 'other' (presumably real, or at least authenticated) works already owned by the Foundation. He began to feel that 'there was less and less there that was problematic – except for the signatures . . . and some sizes of some of the work, but they became, to me, worthy of review.' By 'review', he meant re-examination by the Authentication Board. 'I suggested to the Foundation maybe that these should be . . . reviewed again, by an independent body – not by me, but by an independent body, being the Authentication Board.'

This 'independent body' was, of course, chaired by Foundation president Joel Wachs, staffed by three full-time employees of the Foundation, and advised by Fremont himself – who attended every one of its meetings in his capacity as a 'consultant'. These forty-four works were no different from hundreds of others made by Smith, except for a few important details: the size of the canvases on which some were printed was different from that of their authentic counterparts, and all but three

of the pictures were fraudulently signed with Warhol's name by someone clumsily imitating the artist's signature. Whereas an argument could be made for authenticating a great many of Smith's illicitly printed works, the fake signatures on these paintings meant that they were made with the intention to deceive.

Fremont continued his testimony. On his recommendation, the pictures were sent to the Board for re-examination. In June 2003, Printz and King-Nero looked at the paintings again. When Simon's lawyer asked what happened next, Fremont replied that the pictures 'went through the normal process. Some were authenticated, some weren't.' Kerr asked Fremont point-blank whether he had ever *sold* work owned by the Foundation that its own Board had authenticated.[4] His reply was unambiguous: 'There's only been one occasion, which would be the Fred Dorfman paintings.' To my mind, this would seem to indicate bigger and wider problems for all involved. Kerr's next question sought to clarify the degree to which Fremont had been party to the deception. It required a yes or no answer. Were the works the Board authenticated at the meeting in 2003 authorised by Andy Warhol? Under oath, Fremont's response was, 'I don't know, factually.'

Yet, back in 2003, Neil Printz had told Fremont that the estate 'deemed' these paintings to be 'inauthentic', to have been 'created under false pretences' and to have signatures that were 'not good'. Knowing this, Kerr pressed Fremont to say what it was that made the works authentic? Fremont answered that the Board 'declared them to be genuine'. No other reason was given. Fremont, the person who confiscated the works as fakes, was the same person who advised the Board that authenticated them, and, of course, the same person who could and did sell them as authentic.

By the autumn following his deposition, Fremont no longer worked at the Andy Warhol Foundation for the Visual Arts.

Why did Fremont tell the truth? Because documents showing that these events took place had been handed over to Simon's lawyers during the discovery period. If he had lied, and if the case was to go before Judge Swain, he could have been charged with perjury. So he said it had happened *on only one occasion* – the one for which Simon's lawyers had documentary proof. There was one small detail omitted from his testimony. On another occasion, when the dealer Richard Polsky asked for a discount on a picture owned by the Foundation that Fremont was selling, the art dealer remembered Fremont saying, 'You're in luck – the Board is meeting this afternoon. I'll present your offer and see what I can do. Let me call you back around five o'clock.'[5] Fremont never acted alone. Before he could sell a painting, he needed the Board's approval. Furthermore, in his deposition, Joel Wachs stated that he personally approved every painting Fremont sold that was owned by the Foundation.[6]

The Foundation retained the sales, storage and insurance records relating to these paintings. In defiance of the court order, they were withheld during discovery. We therefore know that the sales took place, but do not have the dates or know to whom they were sold. If forgeries as relatively crude as these had been declared authentic, what about the thousands of Warhols with similarly dubious provenances *without* any obvious signs that they were created to deceive? It is hard to believe that, if some of the forty-four Smith works were authenticated, many others just like them had not been treated in the same way. A conservative valuation of these paintings is one million dollars each. Even if you halve that amount, the amount the Foundation made by selling the forty-four paintings was still colossal.

Armed with the knowledge that someone at the Foundation had sent the forty-four fakes to the Board, Kerr now stepped up his interrogations. The new information explained the unease I had picked up about the relationship between the Andy Warhol Foundation and the Andy Warhol Art Authentication Board. In his response to David Mearns's letter, Wachs made a point of insisting that they were entirely separate entities, even though Mearns had not questioned the relationship between them, or indeed referred to the subject at all. In his deposition, Fremont declared that both he and Wachs sat in on meetings of the Authentication Board in a non-voting capacity.[7] Why? Both men worked for the Foundation, not the Board. Was it possible that, when it came to the authentication and sale of Warhol's work, Board and Foundation were essentially one and the same thing? If that was the case, then what happened when pictures owned by the Foundation came up before the Board? Someone had to be in overall charge – and it was not Printz, Defendi or King-Nero. They were infantry. They did what they were told. Who was lying? Wachs or Maurer? My guess is both.

Chapter 29

'Inherently dishonest', 2003

BUT THAT WAS IN THE FUTURE. Kerr was unable to follow up his interrogation because the hearings were about Simon's painting, not the forty-four fakes. But the author of this book has no such constraint. Several years later I was able to read the minutes for the meeting of the Authentication Board held on 23 June 2003. This was the one during which Neil Printz emphatically rejected Fremont's suggestion that the paintings were authentic, the one when the Board refused to authenticate the paintings on the grounds, among others, that 'some signatures are bad'.

The minutes of that meeting take the form of swift jottings that are often left in fragmentary form, but clearly it is Printz speaking:

> . . . this is a grey area, paintings coming out of Rupert's studio that Warhol never saw. The signature is not so secondary in this case, the paintings all have the same problem. Why are these paintings different? Warhol did work that way, but the circumstances under which these were made was inherently

dishonest. Paintings: there is no clear edition [i.e. a specific group of paintings of which Warhol had been aware] so that RJS [Rupert Jasen Smith] was making the paintings without [Warhol's] knowledge, how many does RJS make – *should they be out in the world as Warhol's[?]* – *no, they should not be.* Conclusion: these paintings should be given a B letter of opinion [denied] or a studio of Rupert Jasen Smith letter' [meaning the work was made by Rupert Jasen Smith, not Andy Warhol].[1]

Any competent, independent art historian would have said the same. That should have been the end of the matter. But then something unusual happens. The notes for the meeting conclude with a postscript: the issue of the authenticity of these paintings is to be 'discussed again in the October 2003 meeting.' Why? The discussion was over. The issue should have been settled, the discussion ended. But it wasn't.

At the next meeting, on 23 October 2003, the Board concluded that, after all, most of the forty-four paintings were genuine works by Andy Warhol. Those that were not authenticated on the spot were once again 'held over' to be discussed at future meetings. Thus, setting aside Printz's objections, the Board oversaw their transformation from worthless fakes into original works by Andy Warhol. Fremont was now able to sell them as genuine, thereby enriching the Foundation with many millions of dollars, and taking a commission of as much as 10 per cent on each sale.

On what basis did those in attendance at the meeting on 23 October reverse their earlier conclusion? How did they justify their about-face? The answer is that we do not know, and that is the most corrosive evidence of all. Despite a federal court order to hand over 'all relevant documents', the minutes of the 23 October meeting are missing.[2] By law, Boies Schiller Flexner

was required to produce them on behalf of their client but, as it transpired, those crucial minutes would never be seen either by Simon's lawyers or by a judge.

The same individual or individuals overturned the Board's decision of the previous June. How that was done – by putting pressure on Printz, perhaps, or by overriding his objections – we do not know. Whether he acted alone or with others, only Joel Wachs had the authority to sign off on both the authentication and on the sale. Fremont merely conducted the transactions.

What about Printz? At the June meeting, he had insisted the paintings were fakes. If he acquiesced in the authentication of the same pictures in October, he might have been accused of being an accessory to a crime. Rather than put him in that position, perhaps he had been told to stay away. But that does not exonerate him, because he could have refused, or resigned, or both. We need to see those minutes to know what happened.

When I wrote about this in the *New York Review of Books*, for the issue dated 23 June 2013, I did not include the titles of the forty-four works, nor did I say how many had been authenticated. But, a few months later, I was looking through documents related to the lawsuit when I found myself holding a piece of paper that told me everything I wanted to know. It was a list of the forty-four paintings confiscated in 1991 from the Smith estate. It had been drawn up after the Board meeting in October 2003, giving the title of each painting and an 'approval number' indicating its status. 'A' was a certificate of authentication enabling the Foundation to sell the picture – potentially for millions of dollars. The 'B' rating meant it was not by Warhol and was therefore worthless. 'C' meant the Board had not yet made up its mind, so the work was in limbo. There was not a single 'B' on the list.

The Board had passed judgement on all forty-four paintings.

Of these, thirty-five received an 'A' grade, meaning that they were authentic. The nine remaining paintings were given 'C' status, so that the Board could, whenever it chose, wave the magic wand that only it possessed to transform the former fakes into authentic works by Andy Warhol. The next question was: did the Foundation sell these works? I looked again at Fremont's pretrial deposition. Asked whether he had ever sold work owned by the foundation and authenticated by its own authentication board, he replied that he had, once: 'the Fred Dorfman paintings'.

I published this information in the November 2013 issue of the *Art Newspaper*, which printed not only the list of the forty-four pictures, with the grade ('A' or 'C') next to each, but also the inventory number of every picture on the list. I assumed that someone on the Board or at the Foundation must have been tasked with washing off the inventory numbers, but I still hoped that owners who had acquired any painting directly from the Foundation, or from dealers who had worked closely with the Foundation after 2003, would be able to determine whether their work was among the fakes. If any had not been sold, then in theory publication of the inventory numbers would ensure that, if the Foundation offered them for sale, they would be obliged to provide a full provenance. Again, the inventory number would have been washed off, but perhaps some trace or smear might have been left in the process.

The person at the *Art Newspaper* who edited my article therefore inserted a single sentence at the end: 'We [at the *Art Newspaper*] also invite any concerned parties to contact us.' To date, none of the forty-four paintings has been securely identified.[3] This could be for several reasons. After the appearance of the piece in the *Art Newspaper*, the Foundation could have contacted dealers who bought regularly from Fremont, alerting

them to the problem. It was then up to the dealers to speak directly to any clients who had bought one of the forty-four paintings, offering to replace the painting or reimburse them if they were dissatisfied. Any such deal would have been contingent on signing a non-disclosure agreement. There is another possibility: if Fremont informed the dealers to whom he sold the newly authenticated pictures of their complex history, those transactions would not necessarily have been questionable.[4] But there is a further complication. Even if Fremont frankly told a buyer that a picture's status had recently changed from fake to real, how do we know that the dealers told *their* clients all the facts? And, if a dealer was aware of the picture's history and yet still sold it on without informing his client, which person in the chain is legally responsible?

Here's an example of how difficult it can be to assign responsibility in these cases. Among the emails handed over by the Foundation and included in Simon's letter to Judge Swain is an exchange between a representative of an auction house and Sally King-Nero. The auction house was about to hold an evening sale, which included a few works by Warhol. On 4 May 2007 the researcher who was writing the sales catalogue followed correct procedure and asked King-Nero about numbers inscribed on the reverse of a *Four Marilyns* painting which is dated 1979–86. The researcher was confused because it was stamped with the Authentication Board numbers 'B291.03' *and* 'A291.1'. She knew that an 'A' prefix meant the painting was genuine, and that the 'B' meant it was not by Warhol. In her reply of 14 May, King-Nero explained that the 'A' referred to the painting, the 'B' to the signature. OK. So the Board considered the picture authentic, but not the signature. So far, so straightforward.

Now watch what happens. Christie's then had a policy of giving owners of fabulously expensive pictures a guarantee that

they will receive an agreed sum whether their picture met its reserve price or not. That meant the auction house had a strong financial incentive to present the work in the best possible light. If we turn to the printed sales catalogue, the 'A' prefix verifying the picture's authenticity is recorded, but not the 'B' signifying that the signature is not Warhol's.[5] The catalogue entry states flatly that the picture is 'signed twice and dated "Andy Warhol 79–86" '. Of course, it *is* signed – but the signature is worthless.

Chapter 30

'Warhol is acknowledging the painting'

THE BOARD FIRST DEALT with the forty-four fakes made by Rupert Jasen Smith at a meeting in June 2003, and then met again in October of the same year – the meeting for which the minutes are missing. But there was a third Board meeting that year. It was held on 24 February 2003. The minutes for this one survive, and reading them is as close as outsiders will ever come to sitting in on a meeting of the Authentication Board. The chief order of business that week was the status of Anthony d'Offay's 'Bruno B.' *Red Self-Portrait*. Once again, the minutes are annotated, but the notes are fragmentary. They tell us little about who was present or what was said, and do not always identify the speaker. But the picture under review is certainly the 'Bruno B.' portrait because the notes contain the words 'good signature' and 'good inscription'. Vincent Fremont (identified by his initials) starts the meeting off by observing that, because the picture is signed, 'Warhol is acknowledging the painting'.

But no discussion then takes place. Someone – who sounds like Printz – goes through the differences between the self-portraits from the 1964 series and those of 1965. The same

speaker mentions that Warhol gave the film positives (acetates) to Ekstract, who hired Norgus to do the job. But that's about it. Printz shuts down the further dialogue by declaring that he and King-Nero have seen hundreds of works by Warhol and this one was made 'outside the studio', which, he adds, was unusual for that period in Warhol's career. The statement is presented as a decree, not a talking point. Art authentication by fiat.

It must have been a short meeting.

No one asks why the picture is included in Rainer Crone's catalogue – and, if so, what that might mean. No one questions how the fact that it was made outside the studio in the 1960s proves it wasn't Warhol's. Was that not normal practice later in his career? Was it possible that the 'Bruno B.' *Red Self-Portrait* was an early instance of this method?

Printz prevails – by sheer force of will. The meeting ends with a declaration that the 'Bruno B.' *Red Self-Portrait* owned by d'Offay should be given the status of a 'Warhol-related object' [i.e. denied] because 'it admits there is serious discrimination going on.' What does the phrase 'serious discrimination' mean, in this context? Used in conjunction with the word 'admits', Printz seems to be saying that he wants the picture denied so that the Board is *seen* to 'discriminate' between works Warhol painted by hand and ones made outside his studio.[1] Despite the apparent finality of this declaration, the picture's status was not settled. Rather the decision was 'held over' until the next meeting of the authentication board, in October.

This is the subject on which Simon's lawyers questioned Printz and King-Nero during the pretrial depositions in 2010. After the fog of memory loss and evasion in which Maurer and Wachs seemed to be groping, the efforts of Printz and King-Nero to answer the questions put to them clearly come across as welcome relief.

Printz admitted that, when he started to work on the cata-
logue raisonné, he knew very little about Warhol's art in the
1960s. After the publication of the two volumes covering that
decade, he began to research work of the seventies and eighties,
knowing absolutely nothing about Warhol's art in those dec-
ades. He learned how Warhol worked as he went along. In her
deposition, Sally King-Nero made the same admission.

To some degree, all scholars put on blinkers to focus exclu-
sively on the period or events they are studying, and this might
explain Printz's initial rejection of the 1965 series of *Red Self-
Portraits*. But, upon examining the 'Bruno B.' portrait, most
scholars would think again. The picture did not look like a
typical Warhol and it was not made in the way you'd expect at
that date. But, against this, the artist did everything he possi-
bly could to claim authorship. Printz could have asked Rainer
Crone about the picture – or Paul Morrissey, or Billy Name, or
Sam Green. Instead, he ignored them all, even when they vol-
unteered eyewitness accounts of what had happened.

After reading his testimony, I wondered whether Printz's
narrow focus on the work of the 1960s explained his inflexibility
over the *Red Self-Portraits*. It may be that he did not realise he was
looking at a pivotal work, a turning point that would lead to the
production methods of the next decade. But why, in the face of
irrefutable evidence to the contrary, did he persist in defending
his original verdict? To do this, he was obliged to discount a
simple explanation in favour of ones that are more complicated
and, in the end, much harder to believe. Here is Printz after Kerr
asked him why he had denied the *Red Self-Portrait*:

PRINTZ: Warhol was embarrassed by it.

KERR: In that case, what was the significance of the sig-
nature and date?

PRINTZ: It would usually refer to either when he signed it or when he thought he made it.[2]

KERR: If he was embarrassed by the picture, why had Warhol chosen the 'Bruno B.' self-portrait for the cover of the catalogue raisonné published in 1970 and then again for the revised editions of 1972 and 1976?

PRINTZ: Warhol did not realise what painting was on the cover.[3]

To make that claim, Printz had to discount Rainer Crone's eye-witness testimony as to how Warhol chose the *Red Self-Portrait* for the cover. What is more, Warhol's own photographer in New York supplied the photo for the dust jacket – where Bruno Bischofberger is credited as the owner of the picture. In any case, the difference between a painting in the 1964 series and the series of self-portraits made in 1965 is not hard to spot. Simon's shock the instant he saw his painting next to one from the 1964 series shows that the differences between the two series are blatant. It is not possible to mistake one for the other. How could Warhol *not* have known what picture, from which series, was on the cover?

Printz clearly thought of himself as an expert. Did he worry that, once an expert concedes they are in error, they are no longer an expert? I don't happen to buy that line of reasoning, because all experts learn from others with relevant experience, and the best experts are continuously honing their knowledge, which sometimes means admitting they were wrong in the past. Had Printz been willing to listen to those who were just as interested in establishing the truth as he was, this multi-million-pound waste of time and money might never have happened.

Sally King-Nero came across as a more down-to-earth

character, someone less ready to dismiss a difficult question as a foolish one. Asked who she felt had the highest level of expertise in Warhol's works of the 1960s, she replied, 'I would start with Rainer Crone because he basically wrote the first catalogue raisonné of Warhol's work.' She added that Bruno Bischofberger was one of the leading experts in Warhol's work of the 1960s.[4] Even as she spoke these words, she knew that Rainer Crone believed so fervently in the authenticity of the *Red Self-Portrait* that he'd flown from Germany to New York at his own expense to support Simon's claim. She could not have missed Crone's piece in the *New York Review of Books*. Yet her presence that day proclaimed, in effect, that she and Printz knew better than Andy Warhol what works of art he had and had not created.

When Printz was giving his reasons for denying 'Bruno B.' in the meeting of February 2003, he said something important. 'These self-portraits were done completely outside [Warhol's studio], there was no authorisation whatsoever.' This is the first time any Board member mentions the question of authorisation. Everyone agreed that the pictures were made without Warhol's supervision, but what if someone could provide evidence that Warhol had given his approval and instructions to the Norgus printers to create the series?

By the time the pretrial hearings were over, Brian Kerr and Seth Redniss had been conspicuously effective in their deposition of witnesses for the Foundation. That was in part because of the active participation of Joe Simon, who was usually on hand to pass them yellow post-it notes telling them what question to ask next.[5] With Simon's help, they probed Fremont, Wachs and Maurer in such a way that, were the case to come to court, no honest judge in America would credit their contradictory testimony. As each of its employees was deposed, the danger to the Foundation increased.

Chapter 31

A Mountain of Material

WHEN HE JOINED FORCES with Browne Woods George (BWG) in January 2009, Redniss trusted that the law firm had the financial and legal resources to take on a case of this complexity. That reassured Simon, whose legal team now consisted of Redniss, plus former Dreier employees Brian Kerr and Lee Weiss. For the next eight months, BWG both advanced costs and partial expenses connected with the case and handled the antitrust and class-action issues. But, over time, their backup support mysteriously dwindled, and with it the BWG attorneys' hands-on involvement with the case. Simon saw what was happening, but did not understand why. Mistakes were made with the depositions. Some were served incorrectly, which led to several witnesses refusing to participate. Fred Dorfman, a crucial witness, whose name was placed on the deposition list at Simon's insistence, turned up at the office of BWG for his deposition only to find no one there.[1]

By March 2010, Simon had come to feel the law firm was no longer giving his case their full attention. The obvious explanation was that they were representing Simon on a

contingency basis, and so were not being paid for their work. Their agreement with Simon did not prevent them from taking on other clients, so, when Lee Weiss dropped out of sight, Simon assumed that was the reason. Kerr continued to depose witnesses in court, but that was all. Simon and Redniss were left to move the case forward by taking on their own shoulders administrative work normally assigned to half a dozen assistants and paralegals.

If the case was to continue, Simon's lawyers needed to know what was in each day's depositions. After a long day in court, Simon personally prepared the next day's depositions, working until after midnight at the late-night photocopying service on West 72nd. He made five copies of every document – one for the court, one for the witness and three for the lawyers. The next day, he would start work at six a.m., spend the day in court, have dinner and then make photocopies until late into the night again.

Gravante made the work of Simon and his lawyers as difficult as possible. Back in 2009, both sides drew up lists of the documentary material they needed to see during the discovery period. That covered everything relevant to the *Red Self-Portraits*, ranging from office memos, internal and external correspondence, computer hard drives and telephone answering-machine tapes belonging to members of the Foundation and Board – in fact, all professional and private communications and photographs held by Wachs, Maurer, Fremont, Printz, King-Nero and Defendi. That adds up to a mountain of material. On 30 April 2010, Phil Iovieno of Boies Schiller Flexner confirmed in writing that all those documents had been transferred to Browne Woods George, as required by law. Kerr and Redniss accepted Iovieno's word that it had been done. But it hadn't.

In modern legal proceedings, the transfer of documents during discovery is done electronically. Lawyers upload them

onto a website built and overseen by an independent company which is bound by confidentiality agreements and other strict legal specifications. Lawyers for both plaintiffs and defendants then use passwords to access the documents posted online by opposing counsel. Each side signs both a service contract and a strictly enforced federal confidentiality agreement. They also agree to pay the website for the considerable cost of keeping the material online.

In early May, Kerr signed such a contract with the legal website Jones Dykstra & Associates. Boies Schiller Flexner transferred approximately 3,000 documents onto that website. But, before sending them, any potentially incriminating material – such as the minutes for the 20 October Board meeting – was absent. Many other documents were heavily redacted, with whole pages blackened due to 'attorney/client privilege'. Electronic discovery obviates the need for lawyers to haul box after heavy box filled with documents from one office to another, but it also makes it harder to detect when one side is not abiding by the legal requirement to hand over everything the opposing counsel asked for.

Boies Schiller Flexner fought tooth and nail to show Simon's lawyers as little as they could, and thereby made it impossible for them to do their job. The discovery documents uploaded in April were so scrambled that the material could not conceivably have been searched by date or by name. Documents were sent three or four times, to maximise the difficulty of piecing contiguous documents together. If a page ended in mid-sentence, Simon's lawyers might have to sift through thousands of unrelated pages to find its continuation. It was as though several jigsaw puzzles had been thrown in the air to scatter the pieces over as wide an area as possible. The intention was to comply with the rules of discovery, but as far as I can surmise, in a way

that the material would be useless to Simon's team in the limited time available to them. Simon and Redniss both used an Apple Mac, but BWG's contract with the website only allowed access via a PC. This should have been easy to change. Simon repeatedly asked the e-discovery firm to 'flip a switch' to make the database accessible with a Mac, but it was never done. To read the discovery documents, Simon was forced to use a public PC in an all-night internet cafe.

Not only was evidence withheld but its very existence was concealed. Redniss and Kerr only realised this during Neil Printz's deposition on 7 June.

Redniss was quizzing him about Gravante's allegation that Simon did not own his *Red Self-Portrait* before 1998. Was Printz not aware that, in 1996, George Frei had inspected Joe Simon's painting at his home in London?

PRINTZ: Yes, I recall seeing that in the database.

REDNISS: And which database is this?

PRINTZ: This is the Andy Warhol catalogue raisonné database. That would be the only database in which it would be recorded.

REDNISS: Where is the database kept?

PRINTZ: It's kept in our catalogue raisonné offices [in New York].

REDNISS: And you're aware that in connection with his litigation you're required to produce documents?

PRINTZ: Yes.

REDNISS: Are you aware of whether or not that database has been produced?

PRINTZ: I don't know.

REDNISS: Did you provide that database to your attorneys?

PRINTZ: It was there.

That was the first time Simon's lawyers had been told that an Andy Warhol catalogue raisonné database existed. Yet it contained information and correspondence on every painting King-Nero and Printz had examined, including the 1965 series of *Red Self-Portraits*. Given their critical importance for Simon's case, it should have been produced months earlier. Next, Printz casually mentioned a *second* hitherto unknown computer database. It, too, had been withheld during discovery. This one contained the documentation George Frei had begun to amass as early as 1988, when he started compiling the Thomas Ammann Fine Art catalogue raisonné.

As Kerr and Redniss digested this new information, Printz testified to the existence of a *third* undisclosed database, this one assembled and maintained by the Andy Warhol Art Authentication Board separately from that of the catalogue raisonné. Among other critically important documents, this held all the letters issued by the Board to owners of the *Red Self-Portraits*, as well as the Board's internal emails. That, too, was kept in the Board's New York office, along with a notebook or binder labelled *Fake Works* – records of the works whose authenticity the Board questioned. When Redniss called for the production of the Authentication Board's database, Gravante replied, '. . . just put it in a letter after [Printz's] deposition and we'll take it under advisement.' That database was never produced, and nor were any others. If there were any reasons for the refusal to comply, I am not aware of them. In fact, of the hundreds of thousands of documents held in all three databases, at the end of July, Simon received exactly twenty-nine pages from the database of the Foundation's catalogue raisonné.

I have seen no evidence or reasoning that Boies Schiller Flexner were compelled to comply with their disclosure obligations. For example the database for the catalogue raisonné contained

hard proof that Frei had inspected Simon's painting in 1996. That would likely demolish two of Gravante's main lines of attack: the accusations that Simon had stolen the painting and that it had not been in his possession before 1998. Kerr called repeatedly for these documents to be produced, but Gravante ignored him every time.

Over the summer, there was no let-up in the bombardment devised by Boies Schiller Flexner. Finally, Kerr had had enough. On 21 July 2010, he wrote to Magistrate Judge Peck on Browne Woods George letterhead paper, asking him to reject Gravante's most recent ploy to prolong the case by wasting time: a petition to seize Simon's laptop and recall him for further deposition. But Kerr's letter did more than that. It runs to twenty-six pages and, on every page, he paints a vivid picture of Gravante's behaviour in court. Over and over, Kerr complains bitterly of Boies Schiller Flexner's failure to comply with its legal obligation to transfer documents during discovery. Kerr's letter succeeded in preventing both the unnecessary seizure of Simon's laptop and a further useless deposition, but that was all it achieved. In terms of concealing and withholding evidence, Gravante was running rings around Simon's lawyers.

When, after the hearings ended, Simon sought an explanation for Peck's refusal to reprimand Gravante, he turned to the dockets (a record of daily proceedings of the court, including witness testimony and evidence presented on that date by both the prosecution and the defence) filed with the judge. These should have contained most of the evidence presented by Simon's lawyers, including Kerr's letter to Peck of 21 July.

The dockets had no trace of Kerr's or Simon's protests to Judge Peck. All evidence of Gravante's behaviour in court had vanished. In writing this book I was unable to find a copy of Peck's reasoning in order to be sure that I had reported court

proceedings fairly and accurately. I wanted to see what Peck had to say about them. That is now impossible.

That does not mean I didn't find what I was looking for, only that they were not preserved where, by law, they should be.

In writing to Magistrate Judge Peck on 21 July, Kerr must have been acting on his own and out of a sense of decency, because, twenty days earlier, on 2 July 2010, Simon had received an email from Browne Woods George withdrawing from the case, thereby leaving Seth Redniss as his sole legal counsel. Two weeks later, BWG informed Simon and Redniss that they were closing their New York office. Contracts with all associates and support staff providing legal services for the case had been terminated. Redniss and Simon did everything they could to persuade BWG to continue the case, not quite believing that a law firm of any repute at all could simply walk away from a lawsuit they'd been working on for two years.

Wholly absorbed in these frantic attempts to salvage his case, Simon failed to notice that a crucial deadline was looming. Back in February, he had given his BWG lawyers the names and contact details of three scholars who had agreed to provide written testimony supporting his case. Expert-witness statements are normal in this kind of lawsuit. If the case goes to court, they are read by the judge so that he or she can understand the issues under dispute in all their complexity. The only way to provide that level of detail is to ask notionally independent and impartial experts to explain and assess different issues arising from the dispute. When the case is heard in court, the experts who write these statements are required to give evidence. They can be cross-examined on their sworn testimony. If they lie, they can be arrested for perjury.

Simon had lined up three internationally renowned expert witnesses, none of whom asked to be paid for their testimony.

Sarah Whitfield had co-edited the catalogue raisonné of René Magritte's work and was a member of the authentication committee set up by the Foundation Magritte in 2000. She was also a member of the board of the Arshile Gorky Foundation and served on the authentication committee for the estate of Francis Bacon. The German scholar and art dealer Heiner Bastian had been responsible for Tate Modern's Warhol retrospective in 2002. He agreed to write a report affirming the *Red Self-Portrait*'s authenticity. Dietmar Elger, who had put together the Warhol Portraits Exhibition at Edinburgh and other venues in 2004, attested that the *Red Self-Portrait* series was not only authentic, but the hinge that opened the door into Warhol's hands-off working methods in the 1970s and 1980s.

Chapter 32

'The most irresponsible lawyering
I have encountered in twenty years of practice'

THE DEADLINE FOR FILING Simon's expert-witness testimonies
was 9 August 2010. In July, when Simon expected the reports to
be ready, BWG lawyers told him they had not even contacted
the witnesses. Without them, Simon's case could not proceed.[1]
Redniss and Simon scrambled to get the experts to complete
their reports in time for the deadline. Redniss drove out to
New Jersey, where Whitfield (who normally lived in London)
happened to be staying with her daughter. After helping her to
complete her report, he sent it back to his office via the local
photocopying shop. It was too late. Neither Sarah Whitfield
nor Dietmar Elger had been given the time or the material they
needed to write reports in the length, detail and format required
by the courts.[2] Redniss asked the court for a month's extension
of the deadline. Gravante strongly objected. Peck refused.

The failure of BWG to execute what the firm knew to be
a fundamental legal requirement bewildered Simon and Red-
niss. And there was worse to come. Although Browne Woods
George had not found time to put together the expert-witness

reports, and although they told the judge they were closing their New York office, they had recently taken on a colourful new client.

In the 1980s, Asher Edelman had earned a reputation as a ruthless financier, corporate raider and real-estate investor. He appeared to revel in his notoriety, even teaching a course at Columbia Business School called 'Corporate Raiding – the Art of War'.[3] Edelman's Wikipedia entry states that he was the inspiration for the character of Gordon 'Greed is Good' Gekko in Oliver Stone's 1987 film *Wall Street*.[4] As played by Michael Douglas, the character became a national symbol for corporate avarice, forever demonising Wall Street, and earning Gekko twenty-fourth place in the American Film Institute's 'Top 50 Movie Villains of all Time'. At the time he hired BWG, in March 2010, the seventy-one-year-old Edelman was running an art financing company. A profile of him published in *Forbes Magazine* the following year claimed he owed money to a bank, to creditors of a bankrupt gallery, to an investment partner and to his landlord. Although he denied that he was having financial difficulties, Edelman was also being sued by Emigrant Savings Bank for over three million dollars in defaulted loans collateralised by artwork.[5]

BWG opened a New York Office only in 2009, with Simon as its first client. The firm had no proven track record in cases involving works of art. What worried Redniss and Simon was that Edelman had chosen to hire *this* law firm, at *this* time. Alarm turned to fury when Redniss discovered that, without either his or Simon's knowledge, Edelman was giving lawyers for BWG advice regarding Simon's case. And not helpful advice either – in fact, advice that was so bad, it was guaranteed to sink his lawsuit. At Edelman's suggestion, BWG commissioned an expert-witness report from a man who, by his own admission,

had virtually no knowledge of Warhol's work. Had David Boies hand-picked an 'expert witness' whose testimony would inflict maximum damage on Simon's case, this is who he would have chosen.

Step forward Ron Cayen, sometime art dealer and photographer, whose daughter worked for Edelman. Redniss tracked him down in New York City on Friday, 13 August, three days after the expert-witness reports were meant to be filed in court. The two men spoke at length. Redniss took two pages of detailed notes on what Cayen said.[6] Cayen freely admitted he had no qualifications to be an expert witness in a lawsuit. He had never heard of Simon and knew nothing about the *Red Self-Portraits*. One week earlier, on Friday, 6 August, Lee Weiss, together with Asher Edelman, had paid him an unexpected visit. Their purpose was to commission, on Simon's behalf, the expert-witness statement that was due three days later.[7] Edelman, backed by Weiss, suggested that Cayen request a $5,000 retainer. By the time Redniss met him, Cayen had already presented a bill for that amount to BWG, which Simon was obliged to pay.

Cayen told Redniss that, far from being a recognised expert, he had not graduated from college. Although the report filed in his name described him as an art dealer, in truth he was having financial issues and so 'did photography' to pay the bills. He was eager to be a witness 'on something' in the case – but couldn't be more specific than that. Then Redniss questioned him on his knowledge of the lawsuit and of Andy Warhol. It emerged that Cayen had no grasp of the basic facts: he referred to the Authentication Board by the wrong name and had no understanding of its structure; he could not say how many paintings there were in the series of *Red Self-Portraits*; he confused the 1965 series with the one made in 1964.

According to the notes taken by Redniss, all Ron Cayen knew

was that Brian Kerr had drafted both the report and a CV, which had been submitted under his name. He had only spoken to Kerr a few times by telephone. Cayen signed off on the report before he had either reviewed the materials used to write it or spoken to the attorney in any detail.

Simon was in despair. He knew that, if Browne Woods George submitted Cayen's report, his case would be thrown out of court. Simon was never able to read the report and, to this day, does not know what it said. Throughout the pretrial hearings, Simon had clung to his belief that, when a judge read the powerful arguments in favour of authenticity written by three renowned scholars and then heard the same scholars testify under oath in court, the truth would come to light. That would not now happen. Because of a delay, two of his expert-witness reports had not been finished in time. The third, a learned essay by Dr Heiner Bastian, was complete, but was not submitted.

Devastated, Simon fired Browne Woods George. Redniss and Simon then learned that online access to the discovery documents Whitfield, Bastian and Elger needed to write those reports had been switched off. BWG had not paid the website's service invoice. The contract Kerr had signed obliged BWG to pay the website owner $15,000, but this had not been done.[8]

Meanwhile, Gravante focused his attention on Simon's one remaining attorney, the valiant but untested Seth Redniss. He sent the young lawyer emails threatening to destroy his career if he continued with the case. Boies Schiller Flexner would sue him for malpractice, and, if they won, seize his apartment and everything in it, including his dog. On 31 July 2010, they wrote advising him that they would seek to impose sanctions against his law practice, adding, 'I hope you have good malpractice [insurance]'.[9] The threat to the lawyer's livelihood was real. He had indeed made a mistake: there is a statute of limitations in

cases of fraud. Complaints must be filed within six years of the discovery of the deception. Redniss had filed Susan Shaer's complaint (which ran parallel to Simon's) after that time had expired.

The mistake left Redniss vulnerable, but Gravante's motion to sanction him was only pending. On 29 August, he wrote advising Redniss to dismiss Shaer's claims immediately. Unless he did so, the motion to sanction him would go forward. That forced Redniss to hire his own lawyer to represent him in court. The new attorney did a deal with Gravante. If Redniss told Shaer to settle, Boies Schiller Flexner would drop sanctions against his client. So that's what happened.

Although Redniss had filed Simon's case in time, he could no longer continue to represent him. On 1 September, he filed a formal motion with the magistrate saying that, unless BWG's motion to withdraw could be halted, he had no choice but to withdraw from the case. He was unable to work alone because he had neither the resources nor the antitrust expertise. On 16 September 2010, Redniss appeared before Magistrate Judge Peck again. On his new counsel's advice, he withdrew from the case. Indefatigable, Simon tried to object, but, at just this moment, Gravante filed a motion for Simon to post a million-dollar bond in support of legal fees in case he lost the lawsuit. This succeeded in drawing Simon's attention away from any attempt to retain counsel.

Gravante was doing the job he was paid to do. What I found troubling, though, was what he told Magistrate Judge Peck: that Browne Woods George had abandoned the case because the firm had discovered that Simon had stolen the *Red Self-Portrait* and had sought to have the Board authenticate a fake Warhol (the 'Dollar Bill' piece).

BWG had been eager to work for Simon on a no-win, no-fee

basis in January 2009. For eleven months, they'd prepared for the case and deposed witnesses. That changed soon after the Foundation dismissed Carter Ledyard & Milburn and hired David Boies' firm. It then became obvious to the head office at BWG that litigation was likely to be drawn out and expensive. Even if they prevailed, Simon's suit would cost them millions, and the Foundation would certainly appeal, leaving them vulnerable to further costly litigation. The sooner they bailed out, the less money they would lose. In August 2010, Lee Weiss told the judge that his firm did not have the resources to continue with the litigation.

When Simon fired BWG on 15 August, he told Magistrate Judge Peck that the firm was 'only nominally counsel of record, as they had stopped providing most of their legal services.'[10] The judge appeared to be so shocked by the way BWG had abandoned their client that he suggested Simon might have a claim for malpractice against the firm.[11] Peck then confronted Weiss with his firm's failure to pay the service charge on the website used to access the discovery documents. The lawyer readily agreed that BWG would settle the fees. They paid for the service up until July. After that, if Simon wished to examine the discovery documents, he would have to pay the monthly bill for maintaining the website.

In dismissing BWG, Simon had made a colossal misjudgement. It would have been wiser to follow legal procedure and complain to the court about the firm's behaviour. However understandable his frustration with BWG, the effects of the miscalculation hit home in the weeks to come. Simon contacted half a dozen New York law firms in the hope that one would take the case on. No one would touch a lawsuit that had been so grossly mismanaged, and none could afford to go up against an opponent with unlimited financial resources. When Peck

advised Simon to end the case, he put it like this: '. . . they've got the money and you don't.'[12]

That was an understatement. At just this time, the law firm charged with winding up the assets of Dreier, Simon's original – now bankrupt – law firm, contacted Simon to tell him that, because he was a former client of Dreier, receivers had put a lien on his case. Even if Simon won his suit against the Foundation, he would be required to hand over 100 per cent of the settlement in payment to Dreier's creditors. That meant he would never be able to find a law firm willing to continue the suit. Simon was forced to devote so much time to this new distraction that he found it impossible to meet upcoming deadlines. It felt as though each setback had been coordinated to arrive at the same time. One after another the punches came, until they finally knocked him out of the ring. The case was over.

And yet questions remained. What was Asher Edelman's role in the case? Why was he involved at all? In the aftermath of Simon's lawsuit, eminent lawyers spoke to him of their anger and disbelief at how badly the case was handled. One of the most distinguished, Judd Burstein, said in an email that he thought Simon was the victim of 'the most irresponsible lawyering [he] had encountered in thirty years of practice.' Another wondered out loud whether the case had been sabotaged from within.

Chapter 33

'The investigation I began had not been concluded'

IT WAS OVER. In November 2010, Simon withdrew his lawsuit, saying that he no longer had the financial resources to continue. In a statement made to the press on 15 November, he spoke with a dignity laced with bitterness, of his sadness at not being able to reveal the truth in court. Faced with threats of bankruptcy, continuing personal attacks and counterclaims, he had no choice but to sign the document that brought the case to a close:

> There was, I believe, virtually no limit to the amount of money the Foundation was willing to spend to ensure that this case could never come to trial. When my legal representation [Redniss] asked to withdraw from the litigation due to the enormous workload created by the mountains of extraneous motions consciously filed by the Foundation's legal team, I was forced to accept the reality of my position.

The Foundation required Simon to sign a document affirming that he had never been aware of any evidence that the

defendants had 'engaged in any conspiracy, anti-competition acts or any other fraudulent or illegal conduct in connection with the sale or authentication of Warhol artwork.' Simon added that he had 'not agreed to deny the authenticity of the *Red Self-Portrait*, as originally demanded by the Foundation.' He ended by thanking his supporters and asking 'those curators and scholars who supported me in private, but who were unable to speak out while the case was ongoing, now to come forward.' That last bit was hot air. No art historian could come forward unless they were able to read key depositions and transcripts taken during the pretrial hearings.

But, Simon being Simon, he kept a clear head and his focus on the future. Even at this time of unimaginable pressure and emotional turmoil, he set to work. I always thought Simon a person of exceptional talent, but what he did next showed a strength of character I'd not appreciated before. What set the events I'm about to describe in motion was a single sentence that lawyers for the Foundation insisted on inserting into the settlement Simon had to sign. It stipulated that, if in future the case ever came to trial, Magistrate Judge Peck would be presiding.[1] That turned out to be a serious tactical error.

The presiding judge was the Honorable Judge Laura Swain, the judge who, at the start of the proceedings, allowed Simon's complaint to be heard by the court. Conscientious and methodical, she was well known for her attention to detail. Had the case come to trial, it was she who would have heard the arguments and made the final ruling. But she had not been present at the pretrial procedures, even as an observer, so was unlikely to be aware of the ongoings and perceived failure to compel disclosure and produce witnesses. By stipulating that Peck should preside over any future court procedure, the Foundation made

it obvious that Peck was a judge they could work with. Did they really believe that Judge Swain would not notice?

Meanwhile, without telling anyone what he was about to do, Simon wrote an eighteen-page letter to Peck, dated 5 November 2010. On page two, he explained its purpose: 'I have kept to the high ground despite the vicious personal character assassination I have faced from the defendants. So I am writing this letter in an attempt to redress the balance with real facts.'

The letter reviewed the case, point by point, refuting the Foundation's false allegations: that he did not own the picture; that he had faked the 'Dollar Bill' piece; that he was a criminal wanted by Interpol. Every point was backed up with documents, each labelled as an 'exhibit'. I cannot say what happened to the letter Simon wrote. I can only say that it is not in the case file docket and that Simon believed it was legally excluded or perhaps destroyed or mislaid – as was all supporting documents he had asked Peck to preserve. Simon worried that something like this might happen, and so, in what I can only call a stroke of genius, he also sent a copy to Judge Swain.

Laura Swain, in turn, acted swiftly and decisively. She placed the letter and the supporting material in the public domain by filing everything at the United States Courthouse in Pearl Street, Lower Manhattan. Because she did this, the papers sat in the Pearl Street archive for several years, a time bomb waiting to explode in the Foundation's face.[2] Thanks entirely to her action, historians, students and scholars are able to learn what really happened, not what Gravante, Wachs and Boies said happened.

All that would come later. In the autumn of 2010, it looked to me as though the Foundation had won, hands down. Joel Wachs and the Foundation's chairman Michael Straus could now sit back, open a bottle of champagne and savour their victory.

But that was not enough. Not long after Simon's capitulation,

Wachs made a momentous decision. The Foundation would call the public's attention to the issue over which the lawsuit *would* have been fought *if* it had gone to court: the authorship of the *Red Self-Portrait*. Wachs was at it again. The issue of authentication was dead; Boies Schiller Flexner had buried it in concrete and dropped it into the East River. It slept with the fishes, and now Wachs wanted to give it the kiss of life. The Foundation, in all its pride and pomp, then summoned the world's media to join Wachs and Straus in a good gloat.

I could hardly believe what was happening. At a stroke, hope revived that I would have another chance to learn what the Andy Warhol Art Authentication Board had been up to, and with luck to engage the Foundation in a genuine debate. The most improbable chapter in what I had come to think of as the Warhol saga was about to begin.

Chapter 34

Expert Witnesses

WHILE THE PRETRIAL proceedings were still in progress, during the spring and summer of 2010, Boies Schiller Flexner never addressed the question of the *Red Self-Portrait*'s authenticity, concentrating instead on destroying Simon's credibility. But from a legal perspective the issue could not be ignored entirely. The law required both the Foundation's and Simon's counsel to commission expert-witness statements. The Foundation paid three expert witnesses a total of more than $600,000 to write statements supporting its case and then, if the lawsuit came to trial, to testify under oath that those statements were true.[1] No one apart from employees of the Foundation and its lawyers knew what was in those reports, because the case ended before they were needed.

There were three, each written by a different expert and each addressing a separate aspect of the lawsuit. The Foundation paid Dr David Teece, the co-founder and chairman of the consulting firm Berkeley Research Group, $458,487 for his report affirming that the Foundation had not engaged in antitrust activity. Since this was a dimension of the case in which I was not involved,

his report was, for me, the least relevant. British-born scholar John Tancock, who then worked at Sotheby's, wrote the second report. He charged the Foundation $103,412 to state that members of the Authentication Board were 'undoubted experts'. I had my own views on their expertise, but this was not something to which I needed to respond at that stage.

I was interested in one report only. The third witness statement examined the reasoning behind the Board's rejection of Simon's picture. For me, its value lay not in its conclusion, since the author was being paid to say that the Board was correct in its conclusion. What I ached to see were the documents the expert who wrote the witness statement would need to consult in order to reach that conclusion. It would be impossible to compile a statement rejecting the authenticity of the *Red Self-Portraits* without access to the research of Printz and King-Nero – at least, not if what the witness wrote was to have any semblance of legitimacy. If only I could read that report, I'd be able to follow the reasoning of Printz and King-Nero, step by step. So far, I had been shadow-boxing – I knew their decision, but not how they came to make it.

Back in November, when the case was settled in favour of the Foundation, I'd have bet a thousand dollars that Wachs would never let any scholar near that report. If it remained under lock and key, it was more valuable to the Board than plutonium. From now on, Printz and King-Nero could swat aside pesky challenges to their credibility by referring critics to the validation their work had received from an 'independent expert'. There was no need to tell anyone what that expert had said – nor that he or she had been paid to reach their conclusion. The report's very existence was enough to discourage people like me from asking questions about the validity of the Board's research. What's more, it was top secret. No one outside the

Foundation, not even Simon's lawyers, had read it. Now that the case was over, no one ever would. Of that I was certain. Once again, I had forgotten about Joel Wachs's genius for shooting himself in both feet.

The president of the Andy Warhol Foundation decided to stage a little victory lap. He'd paid a small fortune for expert-witness reports that, since the case would not now go to trial, the Foundation's counsel no longer needed. Why waste that money? Why not broadcast the experts' conclusions to a waiting world as proof positive that the Authentication Board had been right, and the Foundation justified in fighting Simon's lawsuit? So, a press release went out offering copies of all three expert-witness statements to anyone who asked for them. All you had to do was send an email to the Foundation requesting them. No restrictions were mentioned, not even an ID was required. Wachs and board chairman Michael Straus wanted as many people as possible to read the reports, in the belief that they proved the Foundation's integrity and the Board's exemplary scholarship.

I submitted my request and, the next thing I knew, page after page of all three reports were rolling out of my printer. My heart sang as I read the words printed on the first page of each report: 'CONFIDENTIAL – SUBJECT TO PROTECTIVE ORDER.' Inside, not a single word had been redacted. Late one afternoon, I poured myself a glass of cold white wine and settled down to read. With mounting disbelief and rising excitement, I found myself wondering whether anyone at the Foundation had bothered to read these documents from start to finish.

I started with the report defending the Board's decision to deny the *Red Self-Portraits*. At last, I would find out how the Board worked from the inside, and on what basis it made its decisions.

Chapter 35

The Affidavit

DR REVA WOLF, a distinguished professor of art history at the State University of New York, New Paltz, wrote the report. Her primary area of research was eighteenth-century Spanish painting, but she had also published books and articles on Warhol. *I'll Be Your Mirror* is a nice anthology of critical writings and interviews with the artist. *Andy Warhol, Poetry and Gossip in the 1960s*, is a genuinely original take on Warhol's personal and professional relationships with Beat poets like Frank O'Hara. Neither title suggested that Wolf possessed detailed knowledge of Warhol's working methods, and nor was it clear that she was an authority on the question of what constituted an authentic work by him.

Because her publications had not focused on the technical details of Warhol's creative techniques, I hoped that Wolf would lean heavily on the research of Printz and King-Nero. At the very least, she had their full cooperation and a degree of access to their files. I did not believe she *could* have submitted her report without their approval. Wolf's remit was to show that it was 'reasonable' for the Authentication Board to

conclude that the *Red Self-Portraits* were not the work of Andy Warhol. For this, the Foundation paid her $34,497.[1]

In addition to her top-of-the-range academic credentials, her expert-witness report certainly looked impressive: it ran to twenty-one footnoted pages, with seven pages of bibliography and references. A judge would note the author's qualifications and assume that the information in it was accurate. Wolf had also committed to testifying in court under oath that what she said in the report was true.

She started by declaring on the second page that she reached her conclusions in view of the new material that had come to light both before and after the Board's 21 May 2003 decision to deny d'Offay's 'Bruno B.' self-portrait. She also assured readers that she had evaluated evidence supplied by witnesses after the Board had denied Simon's picture. That should have included the information Rainer Crone provided in his long letter to the *New York Review of Books*. After that, the report said nothing I had not known. Wolf expanded on the obvious and openly acknowledged differences between the 1965 *Red Self-Portraits* and the 1964 series: cottons versus linen support, colour, evidence of hand painting, means of production, halftones and all the rest. But these facts were not in dispute. They accorded perfectly with what Paul Morrissey and Richard Ekstract had said about how the second series was created. Wolf added no new evidence, no new facts, and no new observations of any significance to this part of the debate.

But she ignored the testimony in favour of the picture's authenticity published by Rainer Crone in his letter to the *New York Review of Books*. After declaring that members of the Board were 'undoubted experts', she noted that experts are expected to combine physical evidence with 'a careful study of the documents' when determining the authenticity of a work of art.

'One of the most valuable forms of documentary evidence available to art historians,' she continued, 'is statements by those who knew the artist and observed him at work, especially at the time the artwork in question was being made.' I couldn't have agreed more. But, having emphasised the importance of documentary evidence, Wolf failed to introduce into her report the statements made by Paul Morrissey and Sam Green, let alone attempt to refute them. A judge reading her report would never have known that they had written to the Authentication Board and that their letters were on file. Instead, she produced a new eyewitness – one whose name I had never heard before.

Gus Hunkele was a printer employed by Norgus, the company in Madison, New Jersey which printed the *Red Self-Portraits*. In her statement, Wolf quoted a single sentence from a signed affidavit dated 19 June 2003, in which Hunkele declares, 'I have never had a communication with Andy Warhol or anyone acting on his instructions concerning the production of the silk-screened self-portraits, or anything else.' That statement, on the face of it, was more than enough to convince a judge to dismiss Simon's case. It was also a strong counterargument to everything I'd written defending the series. But what Wolf did next was highly unusual. In a footnote, she cited a second, revised affidavit signed by Hunkele, but did not quote from it. This second affidavit was dated 12 January 2004, about six months after the first.

Since the second affidavit would obviously not repeat the first verbatim, I wondered whether there was something in it that Wolf believed – or had been told – the Foundation did not want a judge to see. So, I found a copy. In it, Hunkele clarifies a crucial point: the reason he had no communication with anyone representing Andy Warhol was because he was out of the building, on a service call, when Richard Ekstract and his

colleague Herman Meyers arrived in the office. That meant all communication took place, not with Hunkele, but with his partner, Norman Locker. Hunkele further states that his company was asked to 'print several portraits by Andy Warhol for Andy Warhol and Richard Ekstract.' Here is the paragraph in full [italics are mine]:

Andy Warhol owed Ekstract a favour *and supplied the film positives* [acetates] *with written instructions, color swatches and canvases for us to print on.* We agreed to do the work . . . in the late summer or fall of 1965. Mr Ekstract met with my partner who then turned him over to our shop foreman to whom he gave Andy Warhol's printing instructions. As I was out of the building serving a customer at the time I did not meet Richard Ekstract. *Norgus followed their verbal instructions as well as the written instructions on the positives and swatches.* Norgus was always aware that these were being made for Warhol and Ekstract.

The words in italics show that Hunkele's testimony accords perfectly with Ekstract's – and differs from Morrissey's only in that he does not specify whether the 'verbal instructions' he refers to were delivered in person or by telephone, by Ekstract alone, or by Warhol as well. By citing the second report in a footnote, Wolf admitted that she knew what it said.

In the second notarised affidavit, Gus Hunkele added an unforgettable detail concerning the first document he signed [again, my italics]:

I did not meet Andy Warhol personally but my business partner met Ekstract . . . It has been 38 years since these [*Red Self-Portraits*] were printed in 1965. Now that I have had time

to recollect and recall the events of this matter, this is to the best of my knowledge and recollection the actual facts and I would like to correct the misinformation that was given on the original affidavit *which was written by the Andy Warhol Board on June 19, 2003*, and signed by me.

These words were so disturbing that I had to read them again to grasp their implications. Hunkele also said that he hadn't been given enough notice or time on the day to go through his records or check his facts. The Authentication Board then used the initial affidavit as evidence against the authenticity of Simon's portrait at the May 2003 meeting of the Board. Having corrected what he termed the 'misinformation' in the first document he had signed, Hunkele sent his second affidavit to the Board, where it was still on file, seven years later. Although Wolf knew of the existence of this second document, she did not reveal what it says in her expert-witness statement.

Chapter 36

Squeegeeville.com

WOLF'S LETTER UNINTENTIONALLY PROVIDED the answer to a question that had haunted me since Bob Rosenblum's death in 2006. I was still trying to understand how he and I had ended up on opposing sides over the question of the *Red Self-Portraits*. Aware of his absolute integrity, I wanted to know why he continued to support the Board's verdict on the *Red Self-Portrait*. Had he seen evidence that the pictures were not by Warhol? And, if so, what was it? The issue preyed on my mind. I would not be at peace until I found out.

For that reason, I started to go through the papers Simon sent to Judge Swain in 2010, paying close attention to any document that related to what the Authentication Board was doing in the early spring of 2003, when it passed judgement on the pictures of both d'Offay and Simon. Back then, I had not known about the existence of 'Bruno B.', and neither had Simon. I will simplify things here by referring only to 'Bruno B.', which at that time was still owned by Charles and Helen Schwab, who bought the picture from Anthony d'Offay.

I read every document from that period, in chronological order, starting in February 2003.

On 12 February 2003, I emailed Bob to ask him to look closely at the supporting documents Simon included when he submitted his picture to the Board for the second time. He replied that he would. On 24 February, the Board meeting took place, at which Printz was adamant that the 'Bruno B.' portrait was not Warhol's. Ten days later, on 6 March, Claudia Defendi signed a letter to the owners of the picture, Mr and Mrs Schwab: 'Further research is required, therefore the board would like to request that the painting remain here and be reviewed again at the next meeting of June 9, 2003.'[1]

This could mean only one thing – that, despite Printz's insistence that Warhol had nothing to do with making the picture, the Board came to no decision at the February meeting. Someone on the Board must have refused to rubber-stamp Printz's decision. Since the one formidable scholar sitting around the table was Robert Rosenblum, I felt certain he was the person who had withheld his assent. As a professor who had supervised scores of graduate students, it would have been natural for him to ask the younger colleague to provide tangible evidence that the picture was not Warhol's before the next Board meeting.

On 5 May 2003, Sally King-Nero sent a revealing email to Printz: 'Hi Neil . . . in my exploration of the world of silk-screening, I have discovered that the acetate as we call it . . . is in fact what is used to make the screen.' For Printz's benefit, she then described the research method she had employed to discover this information: she googled the term 'silk screen', which took her to a website called *squeegeeville.com*, and the internet revealed all. In his reply to his colleague, Printz appeared to have no greater knowledge as to how a silkscreen is created than she.

So, the pair only endeavoured to learn something about

the silk-screening process a full year after they had denied the authenticity of Simon's portrait for the first time, and more than eight years after they had been handed the authority to participate in the authentication of thousands of silk-screened paintings worth many millions of dollars. Why now? Why was King-Nero suddenly curious about the silkscreen process when she hadn't needed that information before? The only answer I can think of is that she wanted to be prepared in case Rosenblum asked her or Printz a question about the way in which the Red Self-Portrait was printed.

On 21 May, more than two weeks *before* the meeting at which the Board was scheduled to decide on the status of the Schwab painting, the owners received a letter telling them that their picture had been denied. Claudia Defendi usually signed communications from the Board. The person who signed this one was Neil Printz: 'It is the opinion of the . . . Board that the said work is NOT the work of Andy Warhol, but the said work was signed, dedicated and dated by him.'[2]

Printz had unilaterally denied the authenticity of the portrait. It looks like he did so without the agreement of the Board. Indeed, the Board meeting took place on 9 June, as scheduled. And far from endorsing Printz's letter, it ended, yet again, without reaching a conclusion – that is, without endorsing Printz's unsupported assertion that the painting was not by Warhol. That can only be because a Board member told Printz and King-Nero that the Board needed to see documentary evidence that what Morrissey and Ekstract said had happened was not true. Again, that person must have been Bob Rosenblum.

And then, conveniently, the solid proof Rosenblum required materialised. I knew where it came from. On 19 June, exactly ten days after that inconclusive Board meeting, Sally King-Nero wrote an affidavit or statement of facts giving an account of

the circumstances under which the series was made that was flagrantly partial. Along with Defendi, she drove to New Jersey and persuaded Gus Hunkele to sign it on the spot, without giving him time to consider its contents. Then she showed it to Rosenblum. Presented with apparent evidence that Warhol had had nothing to do with the creation of the 1965 series of *Red Self-Portraits*, he believed it.

At once, all the pieces of the puzzle came together. When I first started writing to Bob Rosenblum about the *Red Self-Portraits*, in February 2003, his answers were always cordial and often jokey. Over the summer of that year, the jokes stopped. By then he had become ill. He asked me not to raise the issue again because it 'distressed' him. This led to the estrangement that so bewildered me. Now, I understood its cause.

Chapter 37

Contagion, 2011

THE FIRST CASUALTY was Vincent Fremont. The Foundation managed his swift departure quietly. No reason was given for the parting of ways, but it wasn't hard to make a guess. Fremont had made the unforgiveable blunder of telling the truth. Faced with iron-clad proof, including the letters he wrote and signed to Dorfman and the minutes from Board meetings, he had had no other option. Because the case ended before it reached the courts, Fremont's enforced honesty proved to be unnecessary.

Then, the Foundation went silent. A year went by, and I had almost forgotten the case. But, on 19 October 2011, a press release from the Foundation dinged into my inbox. Michael Straus, chairman of the Andy Warhol Foundation's board of trustees, announced that the Andy Warhol Art Authentication Board was to close. First, I gave a little yelp of delight. But a few minutes' thought brought me back to reality. Straus used the word 'close', but, when I read the fine print, that's not really what was happening. Printz and King-Nero would no longer accept works submitted by the public for authentication, but they would continue to do the same job through their catalogue

raisonné. 'Closure' would give Printz and King-Nero a freer hand than they'd had before. Visiting experts like Rosenblum would no longer be on hand to call them to account – at least notionally – for their decisions. There would be no senior scholars on hand to correct their mistakes before the publication of each new volume.

Less than a year later, Straus announced an even more far-reaching intervention. The Foundation would divest itself of its remaining inventory of an estimated 20,000 pictures, prints, drawings and photographs from Warhol's original bequest. Christie's would hold a series of auctions, both live and online, over a period of about five years, until the Foundation no longer possessed any Warhols at all.

Christie's was to sell the more important works privately, the rest via their new online auction site. Landing a client as famous as the Andy Warhol Foundation was to have a huge impact on the online profile of Christie's. At a stroke, it turned its website into the 'go to' place to buy art online, leaving rival houses in the dust. Christie's waived their normal 12 per cent commission on works over three million dollars. When I read all this, my first thought was of Vincent Fremont. Back in 1990, Christie's had offered to sell the entirety of Warhol's bequest for the Foundation. The Foundation refused, and instead offered an exclusive contract to Fremont, who charged them almost a million dollars a year for services that Christie's was now providing.

The forthcoming Christie's sales were projected to add at least $100 million to the Foundation's $225-million-dollar endowment. The proceeds would enable the Foundation to increase grants to museums and other non-profit arts groups. Straus presented the initiative as an act of pure goodwill. Wachs, of all people, popped up to say that, from now on, the Foundation's

priority would be its 'responsibility to Andy's mission. Our money should be going to artists, not lawyers.'

What was going on? I understood that a Board riddled with scandal could no longer authenticate Warhol's work in the way it used to, but why, in uncertain financial times and when most financial experts considered blue-chip artists like Warhol to be among the safest investments, had the Foundation chosen this moment to sell such an enormous number of works? That was a rhetorical question. I thought I knew exactly why. After testimony by Fremont, Maurer and Wachs, the remaining works bequeathed to the Foundation had become a potential liability. It was now public knowledge that the Foundation sold fakes which its own Board had authenticated. Who was to say how many of its remaining holdings were also questionable? I doubt we'll ever know how many works the Foundation sold over the years that Warhol had nothing whatsoever to do with. As a renowned member of the art world had once told me, knowledgeable dealers had long been suspicious of the stock the Foundation was selling. Much safer for the Foundation to flog tens of thousands of works to less knowledgeable punters online and let the retailer take responsibility for their authenticity.

At the beginning, it felt as though there was a sense of urgency, verging on panic, about the sales. For, although the Foundation's supply of Warhols was diminishing, in the normal course of events, it would not have been exhausted for some time. Even taking into consideration the cost of storing and curating the huge number of works the Foundation owned, and even after paying Fremont and Hunt to sell them, the operating expenses incurred by the Foundation had always been offset by the inexorable rise in prices for Warhol's work. The sheer number of works being rushed onto the market now

risked impacting on those prices. The *New York Times* quoted one horrified collector who memorably described the sales as 'like sending masses of cattle to be slaughtered'. The simile was appropriate. That's what governments do to stop the spread of infections like mad cow disease.

That October, no one outside the Foundation knew what was in its holdings, nor how Christie's would catalogue them. In November, we found out. The sales began. Every item that came under the hammer was sold with a 'certificate of provenance' and a stamp proclaiming that the work originated from the estate of Andy Warhol and had been owned by the Andy Warhol Foundation for the Visual Arts. The auction house assured buyers that it would maintain a database of works purchased at these sales to substantiate provenance and to 'supply relevant information to the Andy Warhol catalogue raisonné.' This could easily be mistaken for a guarantee of authenticity. In fact, the only thing it guarantees is that the object was once in Warhol's estate. It gives no indication of how it got there or that Warhol had anything to do with making it.

Before the sales, the Board had refused to authenticate hundreds of artworks Warhol had signed and inscribed as birthday and Christmas gifts to close friends and domestic staff, on the grounds that they were 'novelty items'. Similarly, at a Board meeting on 13 September 2000, articles of clothing, including T-shirts imprinted with a dollar sign, were consigned to the category of 'Warhol-related objects' – that is, not by Andy Warhol.[1]

That was then. Now, Christie's online auction offered for sale a pair of ordinary men's boxer shorts, screen-printed with a yellow dollar sign.[2] The shorts were not signed, but the catalogue description confidently dated them 'circa 1982'. A learned catalogue entry about Warhol's use of the dollar sign in his art

looks impressive, but is in fact the purest twaddle. It serves to distract the credulous client from noticing that nowhere in the same entry does it say that Warhol was responsible for making the work or any part of it. The estimate for the shorts was between $8,000 and $10,000. The successful bidder paid $16,250, plus a 25 per cent buyer's fee to Christie's. Successful though the sales seem to have been, they were not quite the clearance sales I was expecting. Five years after they began, the Warhol Foundation's tax return for 2017 showed that only about half the Warhol bequest had been sold.

Chapter 38

'Nothing more than a sort of fraud'

IN THE WEEKS and months after the Board's closure, representatives of the Foundation and their mouthpieces in the media set to work. Articles appeared in the art press, blaming the Board's demise on Simon's lawsuit, and asking whether, in its wake, other authentication boards might now be reluctant to pass judgement for fear of triggering similar legal challenges. But Simon's suit didn't close the Board. Printz, King-Nero and their defenders did that themselves. Blaming the person who called attention to the Board's questionable decisions and clandestine activities served to shift the public's attention away from its own culpability.

Whatever spin the Foundation put on the closure and sales, the fallout from Simon's case was contagious. In the spring of 2010, before the pretrial procedures had even begun, Philadelphia Indemnity refused to pay costs arising from Simon's lawsuit, saying that the Foundation had failed to notify them, as their policies required, of 'any specific wrongful act' committed by one of its members – including the publication of material 'with knowledge of its falsity'.[1] At that point, no one knew

about the forty-four fakes, so the 'wrongful act' might refer to the denial of a picture the Board had reason to believe was genuine, or to the deliberate omission of the version of the *Red Self-Portrait* owned by Anthony d'Offay from the Foundation's catalogue raisonné.

The insurers further complained that the Foundation had not notified them when it changed its counsel to Boies Schiller Flexner, whose charges, they said, were 'well more than normal insurance defence fee rates'. They also accused the Foundation of 'stacking' – taking out policies with two different insurers. In papers filed in April 2010, they asked the courts to release them from their contract to provide coverage for legal expenses. They also sought to recover costs of work they had already done for the Andy Warhol Foundation, which, in turn, counter-sued Philadelphia Indemnity for fees of up to $10 million. Once again, the law firm the Foundation used was Boies Schiller Flexner. They eventually won, but the case dragged on for several years.

The *New York Review of Books* published my final article on the Warhol case on 20 June 2013. It brought readers up to date by reporting on the authentication and sale of the fakes confiscated from Smith's estate, as well as the subsequent closure of the Andy Warhol Art Authentication Board and sale of the remaining works in the Warhol bequest. The last four paragraphs outlined the suit and counter-suit between the Foundation and the insurers.

About a month after publication, Bob Silvers received a personal letter from Michael Straus, yet another lawyer whose chairmanship of the Warhol Foundation from 2009 to 2014 coincided exactly with Simon's lawsuit and its aftermath. If anyone followed the case with forensic attention, it was Straus. His ostensible purpose for writing was to point out an error in my article of June 2013. I'd stated that the Andy Warhol

Foundation had not yet settled with Philadelphia Indemnity. In fact, Straus wrote, an out-of-court settlement had been agreed three months earlier, in March 2013. The reason for the mistake was simple: the March settlement had only been made public on 26 June, by which time my article had already gone to press. For two paragraphs, Straus railed against the 'falsity' of my 'claim' and the urgent necessity for the *New York Review of Books* in 'conscience and fairness' to correct it on behalf of 'hundreds of artists, museums, writers, curators who depend on us for the lifeblood of their financing'. He concluded that this error 'fell far below the ordinary statements applicable in the profession . . .' I had in fact tried to contact someone at Philadelphia Indemnity; they refused to take my call. I also questioned a specialist in art law, Peter Stern, and even he had not known the case had been settled.

Bob Silvers, like me, shrugged off Straus's complaint. We were both inured to the huffing and puffing and protestations of injured innocence that lawyers who worked for or were associated with the Foundation went in for.[2] It was the rest of Straus's letter that was disturbing. For three years, I'd been asking the Foundation to answer one question: how was it possible to claim that the 'Bruno B.' *Red Self-Portrait* was not by Andy Warhol? Now that the lawsuit was over, and since Straus was writing to Bob personally, he had a chance to speak openly. Instead, he went back to square one by repeating verbatim Gravante's discredited line of attack. Again, he repeated the outrageous falsehood that the picture was stolen and made the now-libellous assertion that Simon was wanted by Interpol. This time, though, he added a few new accusations about me: that I had made up unspecified 'facts' and that I had 'colluded' with Simon. Even my wife's name was added to his list of those he held responsible for the debacle he'd presided over – a list

that conspicuously did not include his own name, that of Joel Wachs, or indeed anyone who worked for the Foundation. He ended with a flourish: Simon's lawsuit and my articles were 'nothing more than a sort of fraud'.

Nothing more than a sort of fraud. Those words were written by the chairman of a Foundation that had been caught red-handed authenticating previously denied paintings before selling them as genuine for tens of millions of dollars. I wrote a line-by-line rebuttal and sent it to Bob for his approval. To every lie and accusation, I provided documentary proof that what Straus said was untrue. But this time I did something else. I wrote the letter directly to Michael Straus, challenging him to explain why he had made accusations he must have known to be false. Bob liked the letter, but asked me not to send it. Lawyers, or perhaps a legal adviser at the *New York Review of Books*, cautioned against it. Straus's letter was addressed to Bob as a private individual. The best way to shut the correspondence down was for Bob to write a bland, formal reply, denying all Straus's accusations against me.

So that's what happened. Nothing in Straus's letter, Bob wrote, showed that I had been biased, if by biased he meant showing an illegitimate partiality or prejudice in Joe Simon's favour: 'On the contrary, it would seem Richard Dorment had an entirely legitimate desire to find out why what seemed to him an authentic picture was denied authentication . . . At no time did the *Review* have reason to doubt the accuracy of any factual claims put forth in his contributions.' Straus had ended his letter to Bob by putting forward a bold new idea, one that had just occurred to him: 'I personally would welcome the *Review*'s sponsorship of the kind of open forum . . . at which the utterly proper and entirely interesting question of "what is a Warhol" can be addressed . . .'

But his flash of good will came too late. On 11 December 2011, the International Foundation for Art Research (IFAR) sponsored an evening at the Grolier Club in New York to discuss the topic 'Warhol Board Stops Authentication: Issues and Fallout'. I had been invited to attend – not as a panellist, but as a member of the audience. Though I could not be there, I was delighted it had taken place.

That event and a second IFAR-sponsored panel discussion in Los Angeles were the first public discussions ever held about the process of determining the authenticity of Warhol's work.[3] They were also the last. To my knowledge, there has never been another.

After spending so many years trying to hold the Foundation and Board to account, Michael Straus's latest move to silence me was a step too far. Wachs and Straus tried to discredit Simon and then tried to discredit me. Malanga was denied authorship of his own work in court. When their employees made mistakes, they cost owners like d'Offay substantial financial loss, yet then evaded responsibility by attaching spurious phrases to those works, like 'Malmö-type' Brillo Boxes and 'exhibition copies'. Questionable works were put on the market and sold. They smeared those, like Paul Alexander and David Mearns, who tried to let the world know what they were doing. Owners were encouraged to submit paintings that they were likely to deny. They used Rosenblum's name to justify the inadequacies of their scholarship. But that's not the worst thing they did. Entrusted with Andy Warhol's posthumous reputation, they abused that trust – abetted by the silence of the trustees of the Foundation, art dealers and – unforgivably – curators and scholars.

And, to anyone who tries to claim Warhol would not have minded, I'll let Andy have the last word.

He made his feelings known about those who would deny an artist the right to the authorship of his own painting. In the last interview he gave, published in *Flash* magazine in April 1987, the interviewer Paul Taylor raised the question of appropriated imagery and copyrights. Warhol said he was having a problem with his *John Wayne* pictures.

AW: I don't get mad when people take my things.

PT: You don't do anything about it?

AW: NO. I got a little crazy when people were turning out paintings and signing my name.

PT: What did you think about that?

AW: Signing my name to it was wrong but other than that I don't care.

PT: . . . If indeed anyone can manufacture [a picture], the whole idea of the artist gets lost somewhere in the process.

AW: Is that good or bad?

PT: Well, first of all, do you agree with me?

AW: Yes, if they take my name away.

Epilogue

August 2021

IN THE AUTUMN OF 2010, Fremont left the job he had held at the Foundation for twenty-three years. Arrears in the rollover of his salary of close to one million dollars a year continues to be paid at the time of writing.[1] In February 2016, he was appointed CEO of ARTnews Ltd., the company that owns *Art in America* and other leading art publications, potentially making him a major figure in the art press. He stepped down from the post in 2018.

Joel Wachs and K. C. Mauer remain in their jobs.

The fourth volume of Printz and King-Nero's catalogue raisonné appeared in 2018.

The dealer Richard Polsky started his own authentication service. In a recent online posting, 'The Current State of the Andy Warhol Catalogue Raisonné', Polsky praises the thoroughness and accuracy of the scholarship so far and confirms that the catalogue is an indispensable tool for professionals. But Polsky also notes the omissions and the 'mystifying inclusions' of works that are certainly not by Warhol.[2]

I have no expectation that Printz and King-Nero will include

the 1965 series of *Red Self-Portraits* in any forthcoming volume – they have already made the series 'disappear' by failing to include it in the second volume. But what about the forty-four fakes confiscated from the estate of Rupert Jasen Smith? Can we ever be sure that the evidence they provide either for or against authenticity is reliable? King-Nero manufactured evidence against the *Red Self-Portraits*. How many other paintings have been denied because of similar subterfuge? In future volumes, will they own up to their mistakes? The fake 'Malmö-type' *Brillo Boxes* included in the second volume are now described as 'exhibition copies'. I suppose that, if it is made clear that an 'exhibition copy' was not made by Warhol, was not seen by Warhol and was not approved by Warhol, that will have to do.

Reva Wolf is still Professor of Art History at the State University of New York at New Paltz.

A few months after his lawsuit ended, Joe Simon went to a dinner given by American TV journalist Barbara Walters in her huge Manhattan apartment. Champagne clearly flowed, quite a lot of it down Simon's throat. In front of an audience which included David Boies and his wife, Simon and fellow guests Mike Bloomberg and Sarah Jessica Parker belted out the Village People's camp classic 'YMCA'. True to form, Simon greeted Boies warmly, and before leaving exchanged email addresses with Mrs Boies. Both, he reported, could not have been more likeable.

Simon arranged for his then-partner to work on Qatar's World Cup bid and followed him to Doha. Basing himself there, Simon became involved in new projects, such as curating a show of British fashion at the Qatari Museum and as consultant for firms such as the Italian football club Inter Milan, but expat life in the Gulf was not for him. Whenever he returned to New York or London, he lit right up, resuming a social life that appeared to be as frenetic as ever.

Simon always had a Zelig-like propensity for working with ideas and people that meant nothing to me when he first told me about them, but which, a year or two later, would receive blanket coverage in the media. He continued as a consultant for various firms, though just as I'd initially done with Warhol, I registered this news without much interest. He became involved with different projects, but the one that caught my eye was a company that made electronic voting machines. Recently I asked him to tell me his exact job title. It is a 'creative consultant on consumer tech' to the person who invented these machines, the CEO of the company, Antonio Mugica. The name of the company? Smartmatic.

In February 2021, Smartmatic, the global election technology company headquartered in London, lodged a defamation lawsuit against the Fox Corporation over their promotion of 2020 election lies. As this book went to press, Steve Bannon and Michael Flynn had been subpoenaed. The case continues . . .

It wasn't obvious if you didn't know him, but Simon had been scalded by his confrontation with the Warhol Foundation. Though aware that I was writing this book, he refused to read it until long after it had been sent to my agent. It is still a sore subject.

After I finished this book, an editor asked me whether I regretted becoming involved with Simon and his lawsuit. It is a good question. While it was going on, I sometimes wished I'd hung up on Simon's first call in 2003. For ten years afterwards, I lived in the shadow of the case, for the first time in my life encountering lies, threats, libel and intimidation. The constant anxiety it caused poisoned my life. Each time I thought the story was dead and done with, Wachs, like some human defibrillator, jolted it back to life. Against that, I believe that the 1965 series of *Red Self-Portraits* is among the most important works of art

Andy Warhol ever made. I am glad to have defended it. That is not exactly an answer, but it will have to do.

During the years I spent following the Foundation's attempt to deny Warhol's authorship of the series, I never thought of myself as a journalist – and still less as an investigative reporter. Throughout, it was as an art historian employing traditional research methods that I challenged the Foundation's attempts to delete the series from the body of Warhol's work. Without academic transparency and commitment to truth art history degenerates into a mere matter of opinion, or, more accurately, of self-interest. The Andy Warhol Foundation and Authentication Board had corrupted the discipline I'd dedicated my life to studying.

Bob Silvers' commitment to precisely those values never faltered. In the years following the Warhol story I continued to write for him. At the time of his death, in March 2016, he was editing one of my reviews. I hope this book honours his memory.

Appendix
The Silk-Screening Process

Paul Stephenson & Richard Dorment

I will simplify the explanation as much as I can by dividing it into three steps.

STEP I: THE IMAGE

Andy Warhol first chose the image, cutting a picture out of a fan magazine or tabloid newspaper, or else selecting a photo he had taken himself. He then sent this to a lab, where it was professionally transferred onto a small acetate, which is a slight enlargement of the original photo, now printed on a thin sheet of plastic. These acetates are sometimes called 'negatives', when, confusingly, they are film positives. That means the colours and luminance are not reversed, as they are in a negative.[1]

Once he had the small acetate/negative, Warhol made alterations to it, working with scissors and chemicals to give it the inimitable Warhol 'look'. He always did this in secret. Bob Colacello, who became Warhol's assistant in 1971, explained that the reason Warhol liked to work unobserved was 'to keep

his methodology secret, as mysterious as alchemy'. Colacello continued: 'Various steps of the process were done by hands other than Andy's. But only Andy, in all the years I knew him, worked on the negatives . . . What Andy did to the negative was like plastic surgery, though the result was magical: beasts turned into beauties. He simply took scissors and snipped out double chins, bumps in noses, bags under eyes, the shadow of pimples, the blackness of beards . . . '[2]

Colacello was wrong about one detail. Warhol never 'snipped' or otherwise cut into the acetate. He used the *point* of the scissors (or any other sharp implement) to scratch out unwanted areas. He also embellished the small acetate using a fine brush and a solution called 'printer's opaque' to add details such as the wisps of hair that break the rigid line of Jackie Onassis/ Kennedy's bouffant hairdo.

STEP 2: THE SILKSCREEN

When he was satisfied with the small acetate, Warhol sent it back to the same lab, where it was enlarged onto another thin sheet of plastic. This is the 'large acetate'. At this point, the printer transferred the image on the large acetate onto the fabric of the silkscreen, a process called 'shooting the screens'.

Working on a glass 'exposure table', the printer placed the large acetate underneath a silkscreen coated with photo-sensitive emulsion. When the table was then exposed to ultraviolet light, the acetate acted as a stencil, hardening the emulsion in the areas of the fabric where the image was projected. It was crucial that the printer got the exposure time right. An experienced fine-art printer who wishes to capture subtle gradations of light and shade in an image will expose it for two or three minutes.

STEP 3: COLOUR

Having now transferred the image onto a screen, Warhol (or his assistants) added colour, starting with the background. Throughout the 1960s and 1970s, they did this at the Factory by hand, using brushes and water-based acrylic paint. Doing it this way is not nearly as messy as screen printing, and it is cheaper than buying and then shooting additional screens. The other colours were added one at a time, each colour painted onto a separate screen – silver for hair, pink for flesh and blue for the eyes.[3]

HALFTONES

After the colours were laid in, the artist or printer added the halftones. These are the tiny dots responsible for the infinitely subtle gradations of light and dark which produce the illusion of three-dimensional form. Halftones are created by re-photographing the image through a screen which is empty except for thousands of black dots. The result is an image that now looks like it is made up of dots rather than 'continuous' tone. The halftone screen is used in the same way as each separate colour screen.

Now the silkscreen was ready for printing. The technician or artist poured ink onto the screen, pulled the ink across the screen with a squeegee to load the mesh with ink, and applied pressure to the screen (again using a squeegee), pressing down hard to force the paint or ink through the mesh of the screen, and thereby transferring the image onto canvas, linen or paper.

The job of creating the silkscreens is messy and time consuming. But, once it was over, making multiple copies of the same image was a quick, repetitive process, which could turn

out up to sixty prints an hour. The second and third prints looked almost the same as the first, but there could be several variables, such as the level of squeegee pressure applied by the printer, and multiple 'hits' resulting in stronger impressions, with more contrast. Sometimes, with repeated use, the screens got clogged as the ink dried into the mesh – which could make the images appear lighter and lighter, or patchy, until they were cleaned. Multicoloured prints required multiple silkscreens – one for each different colour. In addition, colours could be added to a printed image by hand in combination with silk-screened colour.

Acknowledgements

Thanks to Richard Calvocoressi, Chris Carroll, Kennedy Cheng Anthony d'Offay, Dorothy Girouard, David Godwin, Heather Godwin, Miriam Gross, Keith Hartley, Alexander Kader, Marie-Louise Leband, Anthero Montenegro, Geoff Owen, Nick Rhodes, Rachel Taylor, Hugo Vickers, Alice Waugh and Sarah Whitfield.

At Picador: Stuart Wilson, Laura Carr and Penny Price.

Paul Stephenson owns Warhol's original acetates for the *Red Self-Portrait*. My thanks to him for sharing his knowledge of the silk-screening process.

Bibliography

PUBLISHED BOOKS

Clark, Colin, *Younger Brother, Younger Son* (London: HarperCollins, 1997)

Colacello, Bob, *Holy Terror: Andy Warhol Close Up* (London: HarperCollins, 1990)

Feldman, Frayda, Schellmann, Jörg & Defendi, Claudia (eds.), *Andy Warhol Prints: A Catalogue Raisonné 1962–1987* (New York: Distributed Art Publishers, 2003)

Fraser-Cavassoni, Natasha, *After Andy: Adventures in Warhol Land* (New York: Blue Rider Press, 2017)

Kvaran, Gunnar B. & Malanga, Gerard, 'Long Day's Journey Into the Past' (Skira and Astrup Fearnley Museum, 2008)

Polsky, Richard, *I Bought Andy Warhol* (London: Bloomsbury, 2003)

Scherman, Tony & Dalton, David, *Pop: The Genius of Andy Warhol* (New York: HarperCollins, 2009)

Warhol, Andy, *The Andy Warhol Diaries*, edited by Pat Hackett (London: Penguin, 2010)

——, *The Philosophy of Andy Warhol (from A to B and Back Again)* (New York: Harcourt Brace Jovanovich, 1975)

ARTICLES IN JOURNALS

Dorment, Richard, 'What Is an Andy Warhol?', *New York Review of Books* (22 October 2009), pp. 14–18

————, 'What Is an Andy Warhol?', *New York Review of Books* (19 November 2009), pp. 64–5

————, 'What Is an Andy Warhol?', *New York Review of Books* (17 December 2009), pp. 99–109

————, 'The Warhol Foundation on Trial', *New York Review of Books* (25 February 2010), pp. 41–2

————, 'What Andy Warhol Did', *New York Review of Books* (7 April 2011), pp. 28–30

————, 'What Andy Warhol Did: An Exchange', *New York Review of Books* (9 June 2011), p. 73, and www.nybooks.com/u/4

————, 'What is a Warhol? The Buried Evidence', *New York Review of Books* (20 June 2013), pp. 24–75

————, 'Letter to the editor: where are the 35 "fake" Warhols later reassessed as authentic?', *Art Newspaper* (14 November 2013)

Ekstract, Richard, 'Warhol Under the Waldorf,' *New York Review of Books* (7 August 2011), p. 88

Hughes, Robert, 'King of the Banal', *Time* (4 August 1975)

Rose, Barbara, 'New York Letter: Andy Warhol', *Art International*, vol. 8, no. 5–6 (Summer 1964)

Wolf, Reva, 'What Andy Warhol Did: An Exchange', *New York Review of Books* (9 June 2011), p. 73, and www.nybooks.com/u/4

NEWSPAPERS AND MAGAZINES

Anonymous, 'Parton Portrait: Is it Andy's?', *New York Post* (19 November 2006)

Alexander, Paul, 'Warhol and Peace', *New York Magazine* (14 December 1998)

Cash, Stephanie, 'Chamberlain and Malanga Settle Fake "Warhol Suit" ', *Art in America* (16 August 2011)

Cowan, Alison Leigh, Bell, Charles V. & Rashbaum, William K., 'Lawyer Seen as Bold Enough to Cheat the Best', *New York Times* (13 December 2008)

Fury, Alexander, 'Carolina Herrera's Very First Show and What it Meant for Fashion', *New York Times* (16 April 2018)

Grimes, William, 'The High-Minded Road as the Path to Success', *New York Times*, 8 November 1993

Leigh, David, 'Is this a $2m Warhol, or a fake? Art world sees red over self-portraits', *Guardian* (4 December 2009)

Levy, Adrian & Scott-Clark, Cathy, 'Warhol's Box of Tricks', *Guardian* (21 August 2010)

Shnayerson, Michael, 'Judging Andy', *Vanity Fair* (November 2003)

Thomas, Kelly Devine, 'Authenticating Andy', *ARTnews* (September 2004), pp. 128–37

Thornton, Sarah, 'Rogue Urinals: Has the Art Market Gone Dada?' *The Economist* (24 March 2020)

Vogel, Carol, 'The Art Market', *New York Times* (21 May 1993)

UNPUBLISHED

Exhibit 1: Wachs deposition – Wachs admits the case is costing the Warhol Foundation $450,000 per month

Exhibit 2: Supreme Court of the State of New York County or New York Summons on behalf of Philadelphia Indemnity Insurance Company against the Andy Warhol Authentication Board, Inc., The Estate of Andy Warhol, Vincent Fremont and Vincent Fremont Enterprises, 28 April 2010

Exhibit 3: Judd Burstein email to Joe Simon, 27 August 2010: 'You are a victim of what I believe is perhaps the most irresponsible lawyering . . .'

Exhibit 4: Nicholas Gravante email to Seth Redniss, 31 July 2010: 'I hope you [have] very good malpractice policies'.

Exhibit 5: Letters to the Andy Warhol Art Authentication Board from Paul Morrissey, 1 November 2002; John Richardson, 1 February 2003. Billy Name-Linich, email to Joe Simon, 1 February 2003: 'the people who make these decisions were not there . . . I think it is a cruel joke'.

Exhibit 6: Michael Hue Williams email to Joe Simon, 9 January 2002: 'I am delighted to confirm that the Andy Warhol painting from 1964 [sic] entitled Self Portrait . . . had already been authenticated by Fred Hughes by that time. However, a few months later,

I had lunch with Fred Hughes and he reiterated that he had authenticated the above work in his capacity as executor of the Andy Warhol estate . . .'

Exhibit 7: George Frei examines Andy Warhol's *Red Self-Portrait* in Simon's flat, 17 July 1996

Exhibit 8: Neil Printz deposition – Printz admits the existence of databases in joint project for a catalogue raisonné at Thomas Ammann Gallery, Zurich and at Andy Warhol Art Authentication Board in New York. Simon's attorney asks, 'Did you provide that database to your attorneys?' Printz: 'It was there'. Gravante: 'We'll take it under advisement'.

Exhibit 9: 'Forged' Dollar Bill Piece: Boies Schiller, attorneys for the Andy Warhol Foundation: 'Defendants are entitled to question Mr Simon-Whalen about whether he personally created the forged Dollar Bills [in the] 'Warhol' and, if not, how he came to possess it.'

Exhibit 10: King-Nero email to members of the Andy Warhol Art Authentication Board, 16 July 2003, subject: 'Additional Dollar Bill Collage' – 'I believe the real collage was seen by the Estate in 1989 and what Joe Simon purchased is a forgery made to look like the original right down to the inscriptions.'

Exhibit 11: US Secret Service Agent Alfie Quinn email to Joe Simon, 23 June 2003 – 'I can confirm that Ortega was Treasurer of the United States and Brady was Secretary of the Treasury during the period when these federal reserve notes were produced.'

Exhibit 12: Von Beeren, 'May be in China', Court Record, 26 March 2010, p. 17 lines 21–2

Exhibit 13: Kelly Devine Thomas, 'Authenticating Andy', *ARTnews*, September 2004, p. 135 and Michael Shnayerson, 'Judging Andy', *Vanity Fair* (November 2003), p. 210. Horst Webber von Beeren helped Simon publicise the enormous number of unauthorised prints after Warhol that he and other printers made

Exhibit 14: Transcription of Court Proceedings, United States District Court, Southern District of New York, 26 March 2010, p. 17. Simon's attorney Brian Kerr requests that Gravante produce Horst Webber von Beeren so that he can be deposed. Gravante: 'We

will try to contact him. I'm not sure where he is at this point in time. I know he travels extensively out of the country, but we will undertake to . . .' Judge Peck: 'He gave you an affidavit a month ago.' Gravante: 'And we have tried to call him this week. We understand he may be in China'.

Exhibit 15: Adrian Levy & Cathy Scott-Clark, 'Warhol's Box of Tricks', *Guardian*, 21 August 2010

Exhibit 16: 44 acrylic silkscreen images on canvas: Vincent Fremont Deposition letter to Fred Dorfman and Mark Smith, 25 September 1991: 'The Warhol Estate has requested that you relinquish any right, title, or interest you may have in the paintings and assign the same to the Warhol Estate'.

Exhibit 17: Fremont Deposition, 7 July 2010; 44 fakes, p. 213: 'the more I looked at the ones that we deemed originally or the estate deemed originally as not authentic, there was less and less there that was problematic – with the exception of the signature . . . and some sizes of some of the work, but they became, to me, worthy of review . . . and I made a suggestion to the foundation maybe that these should be – you know, reviewed again, by an independent body, not by me but by an independent body, being the art authentication board'; 'they went through the normal process . . . Some were authenticated and some weren't', p. 209 lines 3–7; p. 200, lines 16–25. Kerr: My question is whether or not there are . . . at least some occasions when you're selling a foundation work, that the work first gets authenticated . . . before that sale goes through. That happens; right?' p. 16, lines 23–5: 'there's only been the one occasion, which would be the Dorfman paintings.'

Exhibit 18: K. C. Maurer Deposition: 'As I sit here today I have no recollection . . .'

Exhibit 19: Wachs Deposition, Andy Warhol painting owned by Tom Ford sold for, I think, $31 or $32 million

Exhibit 20: Fremont authenticates prints

Exhibit 21: New York Attorney General investigates Fremont and Foundation. Paul Alexander, Warhol and Peace, *New York Magazine*

Exhibit 22: Fremont Deposition, 6 July 2010 commission (6% Cap of $950,000). Wachs or Maurer also discuss Fremont's payments

Exhibit 23: Maurer Deposition – Maurer appraises works for sale with
 Sally King-Nero and Defendi

Exhibit 24: Printz Deposition, 6 July 2020, on Sam Green. Sam Green
 writes to Authentication Board, 30 January 2003

Exhibit 25: 7 July 2010, Printz Deposition on Bischofberger and the
 importance of the artist's signature and date

Exhibit 26: Printz Deposition on Crone

Exhibit 27: King-Nero's Deposition on Crone

Exhibit 28: Rainer Crone's letter to the *New York Review of Books*

Exhibit 29: King-Nero calling herself 'Professor von Silk Screen' to
 Printz, 5 May 2003: 'In my exploration of the world of silk
 screening, I have discovered that the acetate as we call it or
 the film positive as it is referred to by the silk screeners in the
 know . . . is in fact what is used to make the screen.' Neil Printz
 to Sally King-Nero, 6 May 2003: 'This helps, but several questions
 remain'. Printz clearly is hearing the term 'film positive' for
 the first time. He wants to know if there is a negative in a
 'film positive'. In summary, he asks King-Nero, whom he calls
 'Professor von Silkscreen': 'does acetate = film positive?' King-
 Nero to Printz tells him that is correct, 5 June 2003

Exhibit 30: Fremont Deposition. Fremont talked to Gagosian about the
 Red Self-Portrait

Exhibit 31: 'Andrew Johnson Warhol Wars: Legal Battle over
 Authenticity', *Independent*, 11 July 2010

Exhibit 32: Wachs Deposition, 9 July 2010. Wachs says he'd 'be upset' if
 a picture submitted by the Board for authenticity turned out to be
 a fake

Exhibit 33: Fred Hughes to Ronald Feldman, 3 January 1991, Re: Andy
 Warhol Self-Portrait with red background – silkscreen . . .
 authenticated. Estate agrees to purchase the work from Feldman
 for $64,123.29

Exhibit 34: Wachs Deposition, Employees of the Foundation are
 indemnified against lawsuits

Exhibit 35: David Leigh, 'Is this a $2m Warhol, or a fake – Art world sees
 red over self-portraits', *Guardian*, 4 December 2009

Exhibit 36: In legal advice printed at the back of Christie's and Sotheby's

auction catalogue under the heading 'Terms of Authenticity', the procedure is explained. In most cases an auction house will not sell a painting unless it has been approved by the Warhol Foundation. The exact wording is 'Warranty of authenticity states that if the standing Body of an artist says it's not right, we will revoke the sale.'

Exhibit 37: Adrian Levy and Cathy Scott-Clark, 'When is a Warhol not a Warhol? The $2 million self-portrait turning the art world on its head', Mail Online, 16 January 2010

Exhibit 38: Simon's letter to Judge Peck copied to Judge Laura Swain, 5 November 2020

Notes

CHAPTER 1: A VOICE ON THE LINE, 2003

1 Barbara Rose, 'New York Letter: Andy Warhol', *Art International*, vol. 8, no. 5–6 (Summer 1964); Robert Hughes, 'King of the Banal', *Time* (4 August 1975).

CHAPTER 2: LANGTON STREET, 2003

1 Andy Warhol, *The Andy Warhol Diaries*, edited by Pat Hackett (London: Penguin, 2010), p. 1009.

CHAPTER 3: 'DON'T EVEN THINK ABOUT IT'

1 This was not entirely true. Bianca Jagger successfully sued the Warhol estate for libel after the publication of *The Andy Warhol Diaries*. By taking the case to Britain, where libel is easier to prove than in the USA, she won.
2 No relation to the art dealer Thomas Ammann.

CHAPTER 4: WARHOL'S SILKSCREENS

1 Colin Clark, *Younger Brother, Younger Son* (London: HarperCollins, 1997), p. 99.
2 Richard Dorment, 'What Is an Andy Warhol?', *New York Review* (22 October 2009).

CHAPTER 5: JOE SIMON

1 Email from Simon to the author, 14 February 2019.

2 Ibid.

3 Photo republished in Alexander Fury, 'Carolina Herrera's Very First Show and What it Meant for Fashion', *New York Times* (16 April 2018); *Interview* magazine, December 1980, p. 117, Bob Colacello's diary entry for 13 November lunch with Joe Simon.

CHAPTER 6: WARHOL'S WILL

1 'Andy Warhol's Pop Empire: A Legacy of Greed and Mismanagement', in *Artlyst*, 23 June 2013. In addition, a memo dated 27 September 1995, 'Art Sales Agency Contract with Vincent Fremont and Tim Hunt'.

2 'Real Estate', *New York Times*, 11 November 1981.

3 Natasha Fraser-Cavassoni, *After Andy: Adventures in Warhol Land* (New York: Blue Rider Press, 2017), pp. 184–204.

4 *The Andy Warhol Collection*, Sotheby's New York, April 1988 and December 1988, 6 volumes.

5 Carol Vogel, 'The Art Market', Section C, *New York Times*, 21 May 1993, p. 24.

6 Paul Alexander, 'Warhol and Peace', *New York Magazine*, 14 December 1998.

7 As well as gifting the museum a collection valued at about $61 million, the Foundation's initial contribution to the cost of renovating the historic building that would house the museum was $2 million. 'The Andy Warhol Foundation for the Visual Arts 20-Year Report, 1989–2007', 2007, pp. 32–53.

CHAPTER 7: THE ANDY WARHOL ART AUTHENTICATION BOARD

1 Another issue was that, if forgers could fake a Warhol painting, they could also manage to imitate a stamped signature, although I have seen no evidence that that ever happened.

2 Ammann and Frei only collaborated with the Foundation on the
 first two volumes, covering Warhol's work in the 1960s.
3 Crone included neither the controversial *Studio-Type Elvis*
 series nor the now discredited 1990 *Brillo Boxes* series, which is
 discussed later in this book.
4 This does not include the separate volumes devoted to his prints
 and films.
5 Agreement dated as of 20 April 1995 between the Andy Warhol
 Foundation for the Visual Arts, Inc . . . And the Andy Warhol Art
 Authentication Board, Inc.
6 In 2005, two more academics joined the Board as outside experts.
 Trevor Fairbrother had been curator of contemporary art at the
 Museum of Fine Art Boston from 1991 to 1996. Judith Goldman
 was founding editor of the *Print Collector's Newsletter* from 1969 to
 1973 and curator of prints at the Whitney Museum from 1977 to
 1991.
7 Between 1995 and 1999, the Authentication Board ran alongside
 a body called the 'Authentication Committee'. This had two
 members, George Frei and Vincent Fremont. Realising that the
 committee and board were essentially doing the same thing, the
 Foundation dissolved the committee in 1999. Fremont's role then
 shifted to 'consultant' to the Board.
8 This 'guarantee' was no guarantee at all. Warhol collected fakes
 and rip-offs of his own work – for example, printed underwear
 and T-shirts he found kitsch. These kinds of novelty items found
 their way into his estate, and in recent years have been sold as
 authentic, if minor, works by the artist, and their 'authenticity'
 has been guaranteed by the Andy Warhol Foundation.
9 Agreement between the Andy Warhol Foundation for the Visual
 Arts (the Foundation) and the Andy Warhol Art Authentication
 Board, 20 April 1995.
10 Exhibit 38. Transcriptions of Printz and King-Nero's testimony
 during pretrial hearings.
11 Frayda Feldman's husband was a leading publisher of Warhol
 prints. While Warhol was alive, only the works he approved
 were included in the first edition of the Foundation's catalogue

raisonné of Warhol's prints. After his death, each revised edition of the catalogue has grown bigger because it included works which Warhol never saw or did not approve, including numerous works published by the Feldman Gallery. See Michael Shnayerson, 'Judging Andy', *Vanity Fair* (November 2003), p. 14.

CHAPTER 8: SELLING ANDY

1 Richard Polsky, *I Bought Andy Warhol* (London: Bloomsbury, 2003), p. 230.
2 Defendi is writing to Tim Hunt about Jason Edward Kaufman's article 'Challenge to the Andy Warhol Authentication Board', *Art Newspaper*, 1 October 2003. The article is one of the earliest to address Simon's challenge to the board's power: https://www.theartnewspaper.com/2003/10/01/challen-to-the-andy-warhol-authentication-board

CHAPTER 9: THE 'DOLLAR BILL' PIECE

1 King-Nero to members of the Andy Warhol Art Authentication Board, 16 July 2003. The picture King-Nero referred to may be the one that came up for sale on 16 May 2019 in Sotheby's Sale of Post-Warhol and Contemporary Art, lot 748. Measuring 14 x 14 inches, it is dated 21 April 1986 and signed, 'Sam Happy birthday Andy Warhol' on the overlap.

CHAPTER 11: EYEWITNESSES

1 Dialogue contained in an email from Matt Wrbican, archivist of the Andy Warhol Museum, to Joe Simon, 19 March 2003.
2 Richard Ekstract letter to the Andy Warhol Art Authentication Board, 12 November 2002.
3 Quoted by Scherman and Dalton, *Pop: The Genius of Andy Warhol* (London: HarperCollins, 2009), p. 277.
4 Tape 1241, marked 'Ondine 2', side A, c. July 1965.
5 The tapes were then $100 each, and he might need eleven for one

of his films. This would have been a huge cost at a time when he wasn't selling any pictures.

6 During the summer of 1965, Warhol wanted to avoid spending time painting backgrounds on ten paintings or paying an assistant to do the job. Instead, he got an unsuspecting Ekstract to do it. Ekstract was not a painter or a printer. When he turned up at Norgus, they told him they could screen the four background colours. That would cost an extra $200, a detail Warhol never mentioned!

7 Warhol had piles of debt. He was so cash poor in 1965 that it is perfectly possible he owed both his silkscreen manufacturers and his printer money.

8 Richard Ekstract letter to the Andy Warhol Art Authentication Board, 12 November 2002.

9 Exhibit 5.

10 Richard Ekstract, 'Warhol Under the Waldorf', letter to the Editor, New York Review of Books (7 August 2011), p. 88.

11 He used the video camera to film the party. Excerpts from that video are held by the Andy Warhol Museum in Pittsburgh.

12 Alan Fenton to the Andy Warhol Art Authentication Board, 17 October 1995.

13 When Morrissey spoke up for Simon, he went against his own financial interests, since, as the owner of 50 per cent of Warhol's films, he still has business dealings with the Foundation.

14 Many of the works for Warhol's *next* Castelli show were made off site. They include the *Cow* wallpaper made at Bill Wallpaper studio, silver helium balloons made by Billy Kluver, and the sculptures made at Knickerbocker's Machine and Foundry.

15 The retrospective opened on 8 October 1965.

CHAPTER 12: 'I SHOULD HAVE DIED.
IT WOULD HAVE BEEN BETTER', 1968

1 Quoted by Scherman and Dalton, *Pop: The Genius of Andy Warhol* (London: HarperCollins, 2009), p. 279.

2 When Solanas's first shots missed Warhol, several passed through a few *Marilyn* paintings. These are now known as *Shot Marilyns* and carry a hefty premium on their sale price.

3 As brilliantly described by Scherman and Dalton, *Pop: The Genius of Andy Warhol* (London: HarperCollins, 2009), p. 422.

4 Ibid., p. 428.

CHAPTER 13: ANDY WARHOL ENTERPRISES INC.

1 http://www.myandywarhol.eu/videos/videos9.asp Although the date of all the pictures in a series is the same, there are significant differences between works within the same series. After Warhol died, the Goldins took the flower paintings they'd retained to Vincent Fremont for authentication. He authenticated them all. The Board then reversed the decision. Around 2006, the Board again declared them authentic, enabling Fremont to sell them on behalf of the Foundation.

2 Bob Colacello, *Holy Terror: Andy Warhol Close Up* (London: HarperCollins, 1990), p. 478.

3 'Parton Portrait: Is it Andy's?' *New York Post* (19 November 2006).

4 Ibid.

5 Scherman and Dalton, *Pop: The Genius of Andy Warhol* (London: HarperCollins, 2009), p. 15.

6 Ibid, p. 17.

7 Sarah Thornton, 'Rogue Urinals: Has the Art Market Gone Dada?' *The Economist* (24 March 2020): https://www.economist .com/news/2010/03/24/rogue-urinals

8 After Warhol's death, the urinal was consigned to his Sotheby's estate sale. *Fountain* was buried in a volume devoted to prints and given a low estimated value of $2,000–$2,500. Some Duchamp scholars were outraged. Francis M. Naumann, who has published widely on Duchamp, argues that the additional urinals cannot be considered to be by Duchamp at all: 'For Duchamp, the signature was everything. It is the single most important element in the process of transforming

an ordinary everyday object into a work of art. In 2000, these unauthorised urinals were selling for $2.5 million.' See 'Rogue urinals: Has the art market gone Dada?', *The Economist*, 24 March 2010.

9 Michael Shnayerson, 'Judging Andy', *Vanity Fair* (November 2003), p. 14.

10 Kelly Devine Thomas, 'Authenticating Andy', *ARTnews* (September 2004), p. 132.

11 Ibid.

12 Colacello, *Holy Terror: Andy Warhol Close Up* (London: HarperCollins, 1990), p. 267.

13 In a letter to the Authentication Board, dated 15 October 2002.

14 Gerard Malanga in conversation with Gunnar Kvaran, director of the Astrup-Fearnley Museum in Oslo, published by Skira in 'Long Day's Journey into the Past'.

CHAPTER 14: THE *RED SELF-PORTRAIT* COMES UP FOR AUTHENTICATION

1 Bob Colacello, *Holy Terror: Andy Warhol Close Up* (London: HarperCollins, 1990), p. 267.

2 Ibid., pp. 474–5. The collaborative paintings were exhibited in Bischofberger's Zurich Gallery between 14 November 1986 and 17 January 1987: https://www.brunobischofberger.com

3 Frayda Feldman, Jörg Schellmann & Claudia Defendi (eds.), *Andy Warhol Prints: A Catalogue Raisonné 1962–1987*, Distributed Art Publishers (New York, 2003).

CHAPTER 15: BRUNO B.

1 The date of the inscription is 1969. In photographs, the '9' looks like a '4' because the top of the fully formed '9' is cut off by a tiny flap of canvas. In this instance, the date refers to the date of the signature and dedication, not to the date when the portrait was made.

2 Deposition of Rainer Crone, held in the law offices of Boies
 Schiller Flexner LLP, 27 July 2010, pp. 157–9.

3 13 March 1975.

4 'By kind permission of the Andy Warhol Foundation', which
 then owned the copyright. After the Board declared Simon's
 picture was not by Warhol, any picture from the 1965 series can
 be reproduced without the Foundation's permission – as, for
 example, on the cover of this book.

5 Fremont said the same thing to Richard Ekstract and art
 dealer Michael Kohn. To Kohn, he wrote, on 14 March
 1991, that evidence Warhol had contact with the work would
 be 'a signature, overpainting, etc.' or 'any circumstance,
 record or explanation [that] would permit us to form an
 opinion as to whether the work was made with his
 approval.'

CHAPTER 16: DINNER ON PARK AVENUE, MARCH 2009

1 William Grimes, 'The High-Minded Road as the Path to Success',
 New York Times (8 November 1993).

2 Ibid.

3 Ibid.

CHAPTER 17: A CRUEL JOKE

1 In 1990, Fremont wrote an almost identical letter to the
 art dealer Michael Kohn, owner of another of the *Red
 Self-Portraits*. Once again, he declares that the picture
 cannot be confirmed as Warhol's because it is 'not signed
 by him' and has no other indication of his direct contact
 with it.

2 Billy Name-Linich email to Joe Simon, 11 February 2003.

3 It is a telling difference between Crone's catalogue raisonné and
 the Foundation's that Crone did not include *315 Johns*.

4 Stephanie Cash, 'Chamberlain and Malanga Settle Fake "Warhol Suit"', *Art in America* (16 August 2011).

CHAPTER 18: FIRST ARTICLE FOR THE
NEW YORK REVIEW OF BOOKS, 2009

1 Richard Polsky, *I Sold Andy Warhol (Too Soon)* (New York: Other Press LLC, 2009, paperback edition, 2011), pp. 135–6.
2 Ibid., p. 136.

CHAPTER 21: LIES AND LIBEL, 2009

1 David Leigh, 'Is this a $2m Warhol, or a fake? Art world sees red over self-portraits', *Guardian* (4 December 2009).
2 Email from Sarah Crompton to Richard Dorment, 7 December 2009.

CHAPTER 22: THE WARHOL FOUNDATION
ON TRIAL, 2010

1 Findlay wrote again, this time identifying himself. His letter was published, but I didn't feel it needed a reply.
2 A few weeks later, the *New York Review of Books* received a second letter from Mr Findlay, disputing my statement that he had not mentioned his contribution to a book of essays on art law edited by the Foundation's lawyer, Ronald Spencer. That was because he'd sent that information to Hudson Street in a separate autobiographical outline, which I had not seen.
3 Kelly Devine-Thomas, 'Authenticating Andy', *Art News* (September 2005).
4 Crone omitted only one: the 'Studio-type' *Elvis* series. The Board now considers this genuine, but their verdict has been hotly contested by Gerard Malanga.
5 25 February 2010, https://www.nybooks.com/articles/2010/02/25/what-andy-warhol-really-did/.

CHAPTER 23: A COLD-BLOODED MURDER — A BRAZEN SWINDLE

1 Alison Leigh Cowan, Charles V. Bagli & William K. Rashbaum, 'Lawyer Seen as Bold Enough to Cheat the Best', *New York Times* (13 December 2008).

2 Six weeks later, on 8 December 2009, the Foundation issued a press release announcing the substitution.

3 Lawyers representing the Foundation from Boies Schiller Flexner were David Boies, Nicholas Gravante and Philip J. Iovieno.

CHAPTER 24: 'A PREMEDITATED AND UNDERHAND PLOY'

1 Shaer's lawsuit was filed using the same legal team as Simon's. The progress of the two suits was broadly the same. For clarity and concision, I refer only to Simon's case in these pages, although it is understood that Shaer was represented as well.

CHAPTER 25: THE DEFENCE

1 James B. Stewart, 'David Boies Pleads Not Guilty', *New York Times* (21 September 2018).

2 Ibid.

3 Lindsey Bahr, 'Sundance: Documentary dives deep into the fraud of Theranos', on AP News (25 January 2019): https://www.apnews.com/cb19fc49318f4d4f83ed24c255e2407d. Eventually, the movie was made when someone from inside the company came forward with film footage.

4 A select group of veterans from the Israeli elite intelligence unit.

5 Gillian B. White, 'The Law Firm Playing Both Sides of the Weinstein Scandal', *Atlantic*, 7 November 2017. See too https://www.theguardian.com/film/2020/jan/30/harvey-weinstein-black-cube-new-york-times.

CHAPTER 26: A MOUNTAIN OF MUD AND MISINFORMATION

1 Brian Kerr to Magistrate Andrew J. Peck, 21 July 2010.

2 Fredric Dannen, 'Defending the Mafia', *New Yorker* (21 February 1994), p. 87. See also: Katrina Dewey, 'The Producers: Nicholas Gravante of Boies Schiller', *Lawdragon* (22 February 2016).

3 'The American Mafia: the History of Organized Crime in the United States', Gambino Family Insider, DiLeonardo testimony: http.//mafiahistory.us

4 'Mob lawyer's widow claims her children tricked her into signing away $1.8-million vacation home', Mail Online (9 April 2016).

5 Exhibit 37: Adrian Levy and Cathy Scott-Clark, 'When is a Warhol not a Warhol? The $2 million self-portrait turning the art world on its head', Mail Online (16 January 2010).

6 Simon's lawyers provided him with a single piece of advice before his deposition: 'Sit on your hands and don't fidget.'

7 Brian Kerr to Hon. Andrew J. Peck, 21 July 2010, quoting deposition transcript of Gravante's interrogation of Simon, 30 June 2010, pp. 7–8 [I have somewhat condensed exchanges between Kerr and Gravante].

8 Ibid.

9 The sale was made jointly with co-dealer Jonathan O'Hara of Lang and O'Hara.

10 Exhibit 14: court transcript, 26 March 2010, p. 17, lines 21–2.

11 Unpublished court transcript, 'Uncertified rough draft, Paul Morrissey's Deposition in the Office of Boies Schiller and Flexner', 16 June 2020, p. 45, lines 3–10, and p. 46, lines 19–23.

12 Morrissey Deposition, p. 102, lines 3–6, and lines 16–18.

CHAPTER 27: SENIOR MOMENTS

1 Deposition of Joel Wachs in the Office of Boies Schiller & Flexner, 9 July 2020, p. 444.

2 The status of the works was still being reviewed in June and October of the following year.

3 Exhibit 18: Maurer Deposition, 28 June 2010, p. 73.

4 Exhibit 17: Fremont Deposition, 7 July 2010, p. 141.

CHAPTER 28: FORTY-FOUR FAKES

1 Between 1987 and 1995, such works were also initialled by hand, VF – for Vincent Fremont.

2 John Tancock, expert report on [among other topics] procedures used in art authentication generally and those of the Andy Warhol Art Authentication Board specifically, p. 40 para 3 and footnote 165: '. . . stamping is done with extreme care using water-soluble ink that is "reversible" . . . [so that] it can be removed if circumstances warrant . . .' This was true at the time that Tancock was writing, but not true when the Simon or d'Offay pictures were stamped.

3 Ford bought the painting directly from a show at Anthony d'Offay's gallery in London. He did not submit it to the Authentication Board. When the sums involved were this huge, big auction houses somehow discovered that the Board's stamp of authenticity was not necessary. The *Fright Wig* portraits come in different sizes. The one owned by Dorfman was nothing like the size of Ford's.

4 Remember, works owned by the Foundation were automatically accepted as genuine, because they were bequeathed to the Foundation directly after Andy Warhol's death.

5 Richard Polsky, *I Bought Andy Warhol* (London: Bloomsbury, 2003), p. 230.

6 Exhibit 32: Wachs Deposition, 9 July 2009, p. 173, line 3

7 In several meeting notes, Wachs is not present. Fremont always is.

CHAPTER 29: 'INHERENTLY DISHONEST', 2003

1 The italics in this quotation are mine. Minutes of the Andy Warhol Art Authentication Board Meeting, 23 June 2003.

2 The Board of a charity like the Warhol Foundation is legally required to take minutes.

3 This remains true today.

4 All information regarding the sale of these pictures should have been disclosed by federal order, but never was.

5 Christie's Sale 7406, Post-War and Contemporary Art (Evening Sale), 20 June 2007, King Street, London, 'Andy Warhol (1928–87), Four Marilyns [Reversal Series], Signed twice and dated "Andy Warhol 79–86" [on the overlap]; with the Andy Warhol Art Authentication Board stamp and numbered A115.992 [on the reverse]. Synthetic polymer paint and silkscreen inks on canvas, 36 3/8 x 28 1/8 in (92.3 x 71.6 cm). Executed in 1979–86. Provenance: Barbara Braathen Gallery, New York; Klabal Gallery, Minneapolis. Acquired from the above by the present owner in 1993.'

CHAPTER 30: 'WARHOL IS ACKNOWLEDGING THE PAINTING'

1 When I wrote about this incident in the *New York Review of Books*, I suggested that Printz may have been insisting that the Board deny the authenticity of the d'Offay picture because not to do so would be 'discriminating' in favour of a powerful dealer at the expense of small-fry owners of pictures from the same series. But the phrase would need a negative ('there is no discrimination going on') for that interpretation to make sense.

2 Exhibit 25: deposition of Neil Printz, 6 July 2010, pp. 22, lines 1–16.

3 Exhibit 38: Simon's letter to Judge Peck copied to Judge Laura Swain, 5 November 2020.

4 Exhibit 27: transcript of Sally King-Nero's cross-examination.

5 After this, the lawyers made Simon type up notes and send them by email before each deposition.

CHAPTER 31: A MOUNTAIN OF MATERIAL

1 Exhibit 38: letter from Joe Simon to Honorable Andrew J. Peck, 5 November 2010.

CHAPTER 32: 'THE MOST IRRESPONSIBLE LAWYERING I HAVE ENCOUNTERED IN TWENTY YEARS OF PRACTICE'

1 Letter from lawyer Dean Nicyper to Joe Simon, 7 November 2010.

2 United States District Court Southern District of New York Declaration of Seth Redniss, 1 September 2010.

3 Nathan Vardi, 'Greed Is So-So', *Forbes* (4 May 2011).

4 Kelly Crow, 'Asher Edelman: The Art World's Gordon Gekko. A former corporate raider is shaking up the market with brash tactics and big plans', *Wall Street Journal* (25 May 2020).

5 Edelman, in turn, counter-sued the bank for fraud in a case that is still pending.

6 'Notes on Cayen Meeting', Seth Redniss email to Lee Weiss and Brian Kerr, with copies sent to Joe Simon and Susan Mearns, 13 August 2010.

7 Ibid.

8 Transcript of court proceedings before Magistrate Judge Hon. Andrew J. Peck, 16 September 2010, p. 16.

9 Exhibit 4: Nicholas Gravante email to Seth Redniss, 31 July 2010.

10 Transcript of court proceedings before Magistrate Judge Hon. Andrew J. Peck, 16 September 2010, p. 4, line 19.

11 Ibid., p. 615.

12 Transcript of court proceedings before Magistrate Judge Hon. Andrew J. Peck, 10 November 2010, p. 7, lines 1–2.

CHAPTER 33: 'THE INVESTIGATION I BEGAN HAD NOT BEEN CONCLUDED'

1 Letter from Thomas Saunders to Joe Simon, 8 February 2011.

2 I've been told that, over the years, many of these documents have disappeared from the box they were stored in, reducing the cache Swain did her best to save. The ones I used in my later

articles for the *New York Review of Books*, and again for this book, were photocopied before those depredations began.

CHAPTER 34: EXPERT WITNESSES

1 Simon offered no payment to his witnesses.

CHAPTER 35: THE AFFIDAVIT

1 These figures are taken from the Warhol Foundation's 990 tax return, 2010, attachment 4A.

CHAPTER 36: SQUEEGEEVILLE.COM

1 The claim that further research was required was a pretence designed to make Mrs Schwab think the Board was considering the painting seriously. In fact, Sally King-Nero had already examined it in the San Francisco warehouse in the autumn of 2002. When they invited Helen Schwab to submit it, they knew it would be denied.
2 Anthony d'Offay gave the Schwabs a full refund.

CHAPTER 37: CONTAGION, 2011

1 These belonged to Kristof Freiherr Rüdt von Collenberg. See Andy Warhol Authentication Board minutes – 00134032.
2 Andy Warhol at Christie's, online, 26 February–5 March 2013, lot 39.

CHAPTER 38: 'NOTHING MORE THAN A SORT OF FRAUD'

1 Insurance Complaint 37, 77.
2 Ibid.
3 In Los Angeles, art historian Barbara Guggenheim staged a second symposium, which was equally well attended.

EPILOGUE

1 This is the result of three years selling work as a director of the Foundation, and working from 1990 until 2010 as its exclusive salesman of paintings.
2 www.RichardPolskyart.com.

APPENDIX

1 In addition, old-fashioned printers sometimes refer to them as 'ruby mechanicals'.
2 Bob Colacello, *Holy Terror: Andy Warhol Close Up* (London: HarperCollins, 1990), p. 89.
3 To ensure that the colours were aligned to the image correctly, Warhol simply placed a piece of carbon paper on the canvas. On top of that, he put the large acetate, 'sandwiching' the two together by taping them down so that the image would not shift during the next step. With the sharp point of biro, he then traced the outline of the image by pressing hard into the acetate so that the line passed from the carbon paper onto the canvas. These outlines were used as a guide for the colour registration – so that every colour was in the right place.

Index

The index uses the abbreviations AWF for the Andy Warhol Foundation and AWAAB for the Andy Warhol Art Authentication Board. Unless otherwise stated, the artworks referenced in the index are by (or are claimed to be by) Andy Warhol.